DIGNITY IN EXILE

DIGNITY IN EXILE

Stories of Struggle and Hope from a
Modern American Shantytown

Eric Weissman

Photographs by
Nigel Dickson

Foreword by
Domenic A. Beneventi

EXILE
editions

Library and Archives Canada Cataloguing in Publication

Weissman, Eric, 1961–

 Dignity in exile : stories of struggle and hope from a modern American shantytown / Eric Weissman ; photographs by Nigel Dickson ; foreword by Domenic A. Beneventi.

Includes bibliographical references.
ISBN 978-1-55096-299-4

 1. Homeless persons--Oregon--Portland--Case studies. 2. Homelessness--Oregon--Portland--Case studies. 3. Squatters--Oregon--Portland--Social conditions--21st century--Case studies. 4. Squatters--Oregon--Portland--Social conditions--21st century--Pictorial works. 5. Squatter settlements--Oregon--Portland--Case studies. 6. Portland (Or.)--Social conditions--21st century--Case studies. I. Dickson, Nigel II. Title.

HV4506.O76W34 2012 305.5'6909795090512 C2012-905878-5

Text design by Thank Heaven for Little Boys~mc. Typeset in Baskerville, Akzidenz Grotesk and Fairfield fonts at the Moons of Jupiter Studios. Cover design by Diana Dickson. Printed by Imprimerie Gauvin.

Published by Exile Editions Ltd ~ www.ExileEditions.com
144483 Southgate Road 14 – GD, Holstein ON, N0G 2A0
Printed and Bound in Canada in 2012; Publication Copyright © Exile Editions 2012

This book is a work of ethnographic-photographic journalism. All individuals who appear in this book, where required, have granted explicit permission to the author for their participation in this project. These are true stories; however, some stories and circumstances may have changed since the writing of the manuscript.

The publisher would like to acknowledge the financial support of the Canada Council for the Arts, the Government of Canada through the Canada Book Fund (CBF), the Ontario Arts Council, and the Ontario Media Development Corporation, for our publishing activities.

Any inquiries regarding publication rights, translation rights, or film rights should be directed to: info@exileeditions.com

Canadian Sales: The Canadian Manda Group, 165 Dufferin Street, Toronto ON M6K 3H6
www.mandagroup.com 416 516 0911

North American and international distribution, and U.S. sales: Independent Publishers Group, 814 North Franklin Street, Chicago IL 60610 www.ipgbook.com toll free: 1 800 888 4741

For my father Sydney Joseph Weissman,
who taught me how to read the water...
my grandmother, Irene Merle Wilks,
who steered me towards the humanities...
my friend, Pat Fortune,
who guided me out of the darkness...
and Rima Zavys,
who shared her commitment to her community in my films.

They are missed.

Acknowledgments

I wish to express my gratitude to the many people, too many to list here, who participated in my early films. Beyond this, I wish to thank several people who have helped me undertake and complete this present research project. In particular I want to thank everyone at Dignity Village in Portland, Oregon, who participated in this book. Being with them has profoundly changed my life. I am grateful to Barry Callaghan for his encouragement and for working intensively with me on a near daily basis during the last two revisions of the manuscript; to Domenic Beneventi for his succinct and clear foreword; to David Howes and the Special Individualized Programs (S.I.P.), now called the INDI Programs, at Concordia University in Montreal for providing a travel grant and many good conversations about the project; Darlene Dubiel from SIP for fielding my frantic e-mails and helping out with the many logistic problems; Kathryn Church for frank discussions about our "selves" as resources; to Andrea Weissman-Daniels, Mark Daniels, and my oldest friend Zev Daniels for considerable funding and moral support during all phases of this process; to Greg Nielsen, Eric Shragge and Satoshi Ikeda, my supervisory committee at Concordia. They have met with me regularly and often and have steered me in the right directions; to Diane Dyson and Pablo Escobar at WoodGreen Community Services for contributing to my research; to my publisher Michael Callaghan for being revved up about this project; to Lorne Tepperman for his enduring support and advice; Michael Levin for years of encouragement; Nigel Dickson for getting there and making these wonderful shots, and to Wendy and Heather at Kwamba Productions for tremendous support and chats about the life of the village and the work at hand. I also wish to thank Dolores Mosquera and Elizabeth Szekely in the Department of Sociology and Anthropology at Concordia for offering up advice and a friendly ear.

I am especially grateful to my mom Claire Weissman, for not worrying too much when I was away and for always answering the phone when I called. My mother has been inspirational and supportive in ways that words cannot express. Finally, my brother Peter, by excelling at life despite a physically disabling disease, has helped shape my understanding of what dignity and self-worth really mean.

FOREWORD

"The freedom to make and remake our cities and ourselves is," David Harvey writes, "one of the most precious yet most neglected of our human rights." The processes of capitalist privatization of spaces – from neighborhoods to entire cities, to national and global locations – have radically transformed human landscapes, and urban renewal is increasingly achieved through the "creative destructions" of financial, corporate, and state intervention. The appropriation of public spaces actively marginalizes the poor, who are increasingly subjected to "geographies of containment" (Kawash) in inner city slums, barrios, favelas, and the "shadow cities" of the world, to use Robert Neuwirth's term. Zygmunt Bauman similarly argues that the growing shantytowns of the Third World have become the repositories of disposable and redundant human beings displaced by economic, military, and natural disasters. The production of "wasted lives" is an inevitable outcome of rampant modernization and globalization, and the unhomed – through poverty, personal hardship, military conflict, or natural disasters – have become "the collateral casualties of progress," and these abject communities have become the "dark, shameful secret" of all production in a globalized marketplace (Bauman).

The exclusion of the poor and the homeless is primarily achieved through the stigmatization of their modest neighborhoods and homes, through the dehumanization of their "messy" bodies as they are made to conform to state regimentation in social service agencies, welfare offices and homeless shelters, thus becoming "practiced, docile bodies" in the sense described by Foucault. Dehumanization is also achieved through the accusatory language and representational codes used to attribute vice, sloth, criminality, and physical and moral destitution upon their bodies. Indeed, as David Sibley (1995) makes clear in *Geographies of Exclusion*, the poor have always been equated with the "residues" of industrial production, particularly since the 19th century, where the dirty environments in which they toiled tainted their bodies and, consequently, their social status. Thus, the desire to keep the poor at arm's length revealed much about the ruling classes, for "boundary maintenance became a concern of the rich, who were anxious to protect themselves from disease and moral pollution" (53).

In the contemporary context, not only are the homeless physically squeezed into shelters and pushed toward the twilight margins of the city's parks, alleyways, and slum areas, but their very bodies are symbolically contained in a social discourse that demands

their disappearance from public view. The embodied subjectivity of the homeless is often one of cowering – of covering the exposed, vulnerable areas of the body from external dangers and from the harsh elements of street life; of postures of supplication and need which elicits charity by invoking a common humanity; of bodily dishevelment that effaces particular markers of individual identity and thus creates an urban "type" whose ostensible anonymity protects the fragile self beneath. But each person on the edge has a story, a narrative trajectory that has brought them to this place of suffering.

This revealing, shocking, touching, and at times heartbreaking book, which brings together the ethnographer, the visual artist, and the residents of an alternative housing community, shows us that there are still slivers of resistance to the reorganization of people and places according to the dictates of capitalist exploitation and governmental control. Dignity Village is an experiment in rethinking social space, which takes into consideration questions of personal responsibility and mutual aid in a population that has always and continues to be stigmatized while being (badly) managed, policed, and "provided for" by a panoply of governmental agencies and various forms of charity.

This volume reveals that with the right approach – one of respect that sees beyond the worn bodies of society's outcasts – deeply resonant stories are revealed; stories that often speak to the extremes of human experiences of loneliness, addiction, pain, violence – but also salvation, retribution, forgiveness, and healing. More importantly, it allows a silent and silenced population to testify to their own narratives, and gives the lie to the notion that the homeless are perpetual victims – of the system, of their own personal demons, of economic precarity – and that they, in fact, have agency to act, create, and collaborate in self-representation. Because of the various forms of collaboration between the author and villagers, these images and stories are a kind of witness to the realities of extreme poverty that straddles the traditional boundary zone between ethnographer and subject.

What kind of questions, then, does this type of photo/ethnographic work raise about the ethics of seeing and of representation? Are we, as privileged readers, actively engaged in a kind of voyeuristic slumming in gazing upon these images and reading these stories? In what ways do these extreme lives – which can easily be our own, given the meanderings of (mis)fortune or circumstance – attest to lived realities of struggle and dignity? And in what ways do they create (at least in the mind of the average reader) a marginal community put on display – forever removed from the everyday and, hence, non-threatening to their own sense of complicity with the maintenance of class hierarchies? The evocative images of

residents of Dignity Village proudly standing before their dwellings recast the very notion of home and of citizenship to the mainstream public, and call into question what it means to "make it." In her seminal research on working-class representation in American literature, photography, and popular culture, Janet Zandy argues that "Class knowledge comes from experience and story, history and memory, and from the urgency of witnessing" (*Calling Home: Working-Class Women's Writings*). There is an urgency of witnessing here, whether it be in the testimonials of trauma, abuse, and recovery, in the narratives of collaboration and sharing, or in the more provocative possibilities for alternative forms of community in an increasingly regulated social order. One need only pay attention.

Domenic A. Beneventi, University of Sherbrooke

CHAPTER ONE ~ A PROLOGUE

"When did the war on poverty become the war on poor people?"

It is impossible to say exactly how many people in the United States and Canada are homeless. Estimates based on the ambiguous definitions used by various state and non-profit agencies claim that about 1% of the population, approximately 300,000 in Canada, and 3,000,000 in the U.S., fall under various official categories of homelessness.[1] Recently, a Canadian newspaper reported that for every person on the streets, 23 others are only a paycheck or two away from losing their housing.[2] For others, *homeless* is used because these people have no stable housing; they rely on hostels, shelters and other people's homes for temporary housing. The worst-off poor, the chronically homeless, are sometimes referred to as street people, or skid-row men and women. I refer to the participants in my fieldwork, whether they be homeless or not, as *informants* because they inform my work. The usage of *informant* is not meant to be derogatory and is common in the kind of work I do. A question I ask homeless informants in my research is, "How long have you been on the streets?" Replies contain a combination of time spent in hostels, shelters, church basements, squats, laneways, abandoned places, and jails. Frequently, they have been committed for psychiatric care, but rarely associate this with *being on the streets*. Time spent on the streets for my homeless informants ranges from a few days to over 25 years, and always includes experiences of several of these places. I consider the streets, therefore, to be the highly fluid arrangement of urban spaces that the chronically poor might use in the course of their homelessness: shelters, hostels, laneways, bridges, tents in parks, couches, squats and various temporary institutional residencies. Two things that all the homeless informants I work with have in common is some experience of street life, and the probability that they might end up there again.

Given both nations' difficulties in defining homelessness, it is not surprising that the scale of the problem is subject to debate. However, there is some agreement amongst street people and support providers that some of the numbers are increasing. One of the most

[1] HUD, *The 2009 Annual Homeless Assessment Report to Congress*; see also, Laird G., (2006) for a good discussion of the numbers. And see also; http://wellesleyinstitute.com/files/homelesscount2009.pdf

[2] Greenway, N., "Poorly housed Canadians face same challenges as homeless: study." *Montreal Gazette*, November 20, 2010:A-22

noticeable and disturbing increases is in the number of families and children on the streets, or dangerously close to being homeless, for the first time. Because Canada and the U.S. share these general trends amongst the population in terms of homelessness, maintain strong economic and political linkages, and borrow strategies for dealing with homelessness from one another, in my research I speak of the problem of homelessness as a common North American issue.

One area where our two nations differ, however, is in their tolerance for squatter communities. In Canada, such places, when they have emerged, have been met with disdain and treated as signs of the state's failure to provide. My documentary, *Subtext: real stories*[3], shot over 10 years, explores the demise of Toronto's "Tent City" shantytown as part of the debate amongst housing advocates and government over what kind of housing we, as a nation, want for the poor. Since the mass eviction of Tent City in 2002, Canadian cities have employed a variety of transitional and long-term housing programs as well as community-funded rental supplements, while generally restricting the rights of squatters. A large number of people remain on the streets. In Toronto, the number might be as high as 5,000.[4]

U.S. cities have shown more leniency towards grassroots responses like tent camps and shantytowns. Due in large part to rapacious foreclosure actions in the U.S. in recent years that continue to spike the numbers of persons entering homelessness for the first time, many municipal governments have had to learn to tolerate tent camps and large-scale homeless squats. Historically, this tolerance has been short-lived, and the police moved most squats or camps after a few weeks or months, to prevent their taking root.

In the last few years in a few cities, however, some homeless squatters have been granted a reprieve of sorts whereby mayors, city planners, the police, and city fire inspectors have helped temporary camps to stay longer in one place. More importantly, in some cases such camps are being granted 503-c charitable status and afforded the legal right to offer housing to the

Subtext: real stories – Part One looks at Toronto's Tent City (2001-2): the rise and fall of Toronto's shantytown, and the lives of ex-residents as they adapt to mainstream housing are examined after the mass eviction of the shantytown. Scan the QR with your web-enabled mobile device, or go to: www.tinyurl.com/TorontoShantytown

[3] Weissman, E., (2003, 2005, 2009). *Subtext: real stories*. The first film examines the rise and demise of Toronto's "Tent City" between 2001 and 2002. Later versions explore the relationship between mainstream housing and "self-worth."

[4] See www.tinyurl.com/possibly-over-5000

needy on a semi-permanent basis. Many of these emergency camps are becoming sanctioned, if not legally recognized, communities. To this degree, the emergency camp movement seems to be picking up momentum. I hesitate to call this recent trend a complete success for reasons discussed in this book. One is that while the quality of this housing is better than the streets, it as yet doesn't offer a long-term solution to street poverty. Another is that these places are still relatively few when one considers how much need for housing there is. Housing advocates who help the needy and the poor, however, have fought for the right to shelter, and these places, in that sense, represent an important successful political and moral claim. None of their success, however, could have happened, I argue, if it were not for the legacy of Dignity Village in Portland, Oregon.

In 2001, Dignity Village became the first city-sanctioned homeless community in North America. I have debated calling the village a *shantytown*. The origin of the word "shanty" is difficult to trace. Some argue that it is derived from the old French-Canadian word *chantier*, for a wooden shack in a lumber camp, a usage that was popularized beginning in the 1800s. [5] It seems equally reasonable to link the 20th-century common usage to the old Irish "*sean tí*," meaning "old house." The notion of the poor Shanty Irish was popularized in Jim Tully's (1928) novel, *Shanty Irish*. [6] However, there is no clear-cut etymology for the word. Most current popular definitions of the term "shantytown" are found on the Internet, and speak to the collection of shacks, rundown buildings and filth that poor people live in, usually in developing or Third World nations, but always near or in cities. In terms of its location on the outskirts of Portland, and because of its weak material base, that is, the poverty of its crudely fashioned structures and the villagers' reliance on donated or scavenged second-hand goods, Dignity Village is a shantytown. Lastly, my choice of that word is due in part to the fact that villagers refer to their homes as structures, which suggests that the concrete form of their housing is part of the psyche of the villager. They attach value and meaning to the type, place and style of their structures. The passage from couch surfing in a "commons" structure to getting a structure of one's own in the village is essential to the crafting of their identities as villagers and, beyond that, as dignified citizens. Their structures are rough, uninsulated shanties. They are shanty dwellers. This is a shantytown.

[5] www.thefreedictionary.com/shanty offers a solid range of the definitions and sources. See also item 7 below.

[6] Tully, J., *Shanty Irish* (Kent: Kent State University Press, 2009). Tully was a hobo whose education largely came from life as a vagabond. He was a commercially successful writer in the 1920s and 1930s. It is said his gritty style influenced Hemingway and others.

It is common these days to refer to communities built around specific goals, like housing the poor, for example, as "intentional communities."[7] Where communes, co-ops and eco-villages built by successful professionals rarely become controversial, shantytowns and tent camps raise a lot of questions for governments, communities, the press and social researchers. Always observed as a response to dire economic circumstances and abject poverty, intentional homeless communities fuel an imaginary continuum of debate about the self-determination and the rights of the homeless.

Homelessness and housing the poor have become part of a growth industry. Immense bureaucracies exist to deal with the poor. The highly privatized shelter industry is often to be criticized for maintaining worse than slum conditions. Homeless activists you will meet in this book suggest that when a city rejects a temporary camp's request for legal tenancy, the refusal is often motivated by private interests, lobbyists and developers, who are pushing for large scale, state-driven housing programs and a privatized shelter system — systems in which the homeless person's voice is largely silenced.

On the other end of the continuum, activist ethnographers write about claims on public space as the remnant of the noble actioning of needs by a unique street culture that interprets solutions for basic human rights in alternative and sustainable ways.[8] They often gloss over the potentially negative effect of people settling for less — less sanitation, less structure, less reliable food sources, and so on. It is difficult, for those of us concerned about social justice, to be critical of these communities in print when opponents of these places will use any negative information to further cast an air of doubt on the rights of the homeless. The ethos of poor people striking out and creating a place of their own is sometimes lost in the romantic notion of rugged citizens making claims as citizens, rather than critically examined as a compromised response to the utter failure of the "system" to provide adequately for the worst off.

As one informant, who had lived in two tent camps in Seattle, and at Dignity Village, told me, "I'm glad I have a place to sleep, but that isn't really the issue is it? This place is not a long-term solution to my problem. My problem is I have no work and I am homeless." In light of such statements, I argue that the polarization of state policy-makers and impassioned cultural storytellers can be mediated through an interpretive and critical field

[7] www.ic.org – *Intentional communities: ideology and alienation in communal societies.*

[8] DePastino, T., *Citizen Hobo* (Chicago: University of Chicago Press, 2003). Presents a thorough examination of various approaches to understanding homelessness in historical and critical perspectives.

methodology that pays respect to the admirable strides made by the poor in building their own communities, while not separating such stories from the broader social and political contexts that provide their subtext. This book is part of that mediation based on my own fieldwork. While questioning the motives of policy-makers, I also question the degree to which villagers are free and autonomous.

I would like it to be clear that when I write about Dignity Village I bring the ideas of Michel Foucault[9] about "governmental rationality" or what he called "governmentality" to bear on ideas put forth by other important theorists like Bruno Latour (1993, 2005), Erving Goffman (1963, 1959), Pierre Bourdieu (1958, 1972, 2004), Mikhail Bakhtin (1981,1993), Henri Lefebvre (1974) and others.[10] My argument suggests that, as a historically stigmatized group, villagers (squatters) maintain potent affiliations with others of their "kind," but must carve out ties to the mainstream through labor and activist outreach in order to keep their minimal housing space or move beyond it. They are better resourced than we in the mainstream generally imagine. In the village, a social setting exists where individuals with varying degrees of knowledge and skill become structurally aligned in the decision-making processes and social practices essential to maintaining the community as defined in its contract with city governance. Constantly surveilled by mainstream critics and opponents, the village and the villager must always navigate the conditions imposed by government, ideologues, and regimes of power,[11] and can never really be free.

Dignity Village has always represented itself as an alternative to mainstream society. I ask, however, if the village, by framing its codes of conduct in a legally binding contract with municipal governance, and by employing a liberal democratic model of political participation within the village, might actually be replicating a mainstream, self-governing citizen. In viewing themselves as homeless, as "not normal," the mantle of stigma attached to being un-housed becomes a self-limiting fallacy in which the "housed" villager complies with the rules or faces expulsion into homelessness. In short, the village helps the state by housing a

[9] Many works are relevant, especially "Governmentality," trans. Rosi Braidotti and revised by Colin Gordon, in Graham Burchell, Colin Gordon and Peter Miller (eds.) *The Foucault Effect: Studies in Governmentality*, pp. 87–104 (Chicago: University of Chicago Press, 1991).

[10] Other important influences are Oscar Lewis, (1966), Talmadge Wright (1992); Norman K Denzin (1997), Johannes Fabian (1983) and others. (See individual items in selected bibliography.)

[11] Foucault (1975) traced powerful "regimes" from "sovereign power" (1650-1789) to the roots of modern disciplinary power (1820-1968). I am suggesting regimes of power today successfully deploy illusory notions of freedom and autonomy.

problematic and highly stigmatized group of poor people. Beyond this, by providing a material attachment to a housing structure, villagers can buy into the illusion of freedom and autonomy. The flip side of this, of course, is that non-compliance with the codes of conduct becomes a "black mark" on the villager. Those already stigmatized by the mainstream come to stigmatize themselves, and each other, by invoking punitive measures that the village as an activist community was intended to rebuke. Despite the fact that Dignity Village is a learning experience for intentional community builders – and they have much growing to do – recent comments made by villagers in this book underpin my expectation that, for them, the route out of chronic homelessness runs dubiously parallel to the route that led them into it in the first place. They either become successfully "mainstreamed" or they disappear back to the streets.

It is important to understand that this position is drastically different than the impression I had of the village over ten years ago, when I had thought of the place as a grassroots Utopia. My current understanding has been conditioned by years of research and by being on site at different times in 2010 and 2011. I went to Dignity Village for the first time in late June 2010. I wanted to see firsthand what a real modern-day North American shantytown looked like. Located on the edges of Portland, Oregon, this "activist" community was the subject of a documentary filmed between 2001 and 2009 by Kwamba Productions,[12] a homeless advocacy research team who are now the village video archivists. Their footage has helped me construct my comparative documentary film *Subtext: real stories* (2003–2011).

In 2002, residents of Tent City recognized that Dignity Village could be seen as a model for what alternative emergency housing could become. Many ex-residents of Tent City still feel they could have developed into a community like Dignity, if they had successfully claimed and won a lease from the City of Toronto. Since 2002, I have continued my filmed research with ex-residents of Tent City as they move through rental-supplemented housing in various places across Metro Toronto. An exhibition version of this documentary ran at the Royal Ontario Museum's HousePaint Phase 2 exhibition in 2008–09, and it has become the foundational body of work that launched me into a doctoral program in Montreal in 2009.

Part two of *Subtext; real stories* looks at professionals, addictions and adjusting to housing after years on the street.
Scan the QR, or go to: www.tinyurl.com/AdjustingToTheStreet

[12] www.kwamba.com – Kwamba has produced *Doorways to Dignity*, the *Dignity Village Intake Video*, and the *Tent Cities Toolkit*.

Within my supervisory committee, there was some debate as to whether I needed to do any more actual research. With hundreds of hours of footage from Tent City and the rental-supplement programs, it was argued that the archival footage of Dignity Village might be sufficient counterpoint for a good comparative discussion of how different housing models give voice to the very poor. I felt, however, that I had to at least see the village and meet some of the residents in order to make that decision myself. I went there in 2010 to do some preliminary fieldwork in anticipation of the long-term participant observation I would complete in July 2011.

This present volume situates an intensive collaborative effort completed in July of 2011 between noted photographer Nigel Dickson and me within this broader fieldwork. My feeling is that, until now, few photos of the people who reside at the village transcend their impoverishment, and in so doing capture the humor, the pain, the love, the anger and the determination that these rugged individuals embody in their lives as villagers. Nigel took the majority of the photos in this volume. In some places, however, I have included photographs I took before he had arrived. I filmed Nigel working with the villagers. After I studied this interview footage, such things as staging, posing, joking and reviewing were revealed as socially choreographed and, at best, contemplated as dramaturgical and not merely mechanical. Nigel, however, said that he didn't see it that way, that the "shot" was often a function of "lighting and luck." But, watching his process over and over on video reveals an artistry and craftsmanship on his part that bridges the material with the social, and is performative, not simply magical. Or perhaps it is truer that artistic craftsmanship is always magical.

As far as my research goes, the photos have provided a medium for extending my fieldwork with villagers. I emailed Jpegs of the photos to the villagers. They have shared ideas and reflections about their lives and about the village based on what they saw of themselves in the photos. Some of the stories herein had to be completely rewritten only eight months later, as follow-up discussions by Skype and phone with the villagers revealed incredible changes in avowals of self-worth and emotional well-being. Some suggested that seeing themselves in that new light, what one had referred to as "a new American Gothic," had led them to reappraise their identities. While the photos provide a reflexive opening to informants – a kind of entry into the eye of the researcher – the phone and the Internet have facilitated the continuous exchange of thoughts and ideas beyond the traditional spatial and temporal boundaries of fieldwork, limits imposed by "being there" at a "certain time." The

stories presented here merge these reflections with my own that were recorded in my notes and on 70 plus hours of video.

We did not seek out images of substance use, nor its obvious effects. Such images tend to distract the reader-viewer from other important visual mindscapes; the relationship of persons to their homes, loved ones and the material environment. If we are witness to images of highly stigmatized and often extremely unabashed drug use, we are likely to see the homes, the relationships and the "culture" per se as emerging from the earlier conceptual subtext: drug use. The implication is that any attempt made to find self-worth must include the Promethean task of overcoming raging addictions. What I am more concerned with in my work is what self-worth means to the person I am talking to, addictions and all, and how living in the village satisfies this need. It is also true that not all the villagers use drugs. In this book when discussions of substance abuse arise, as they inevitably do in the story arcs, I present them as they naturally emerged in the videotaped discussions, and I reveal how they came to be part of the conversations by presenting all voices, including my own. I think, in doing so, that drug use – like dirt and chaos, so often the evil avatars of the homeless – will be seen as nothing more than part of their struggle, as part of personal anecdotes that include mental health issues, physical disabilities, troubled home lives, post-traumatic stress disorders and the hard-learned belief that a mainstream life is difficult to recapture after one enters homelessness.

Visual ethnography has a long tradition in the social sciences.[13] In using images to support and inform a process of writing about culture, important debates are stimulated regarding the positivist and interpretive value of images, and just what kind of information is conveyed by images in the service of ethnography, that is, in writing culture.[14] The debates become even more heated amongst academics and researchers when video, my chosen method of data collection and presentation, is tossed into the mix. This book does not address those debates head-on. It is my hope that by using Nigel's photos as a bridge between who we saw and the words they spoke, we can unite both positivist and interpretive qualities in an honest introduction into the lives of a unique urban culture.

[13] For a solid introduction to and critiques of visual anthropology see Jay Ruby et al, *Made to Be Seen* (Chicago: University of Chicago Press, 2011); and also, Sarah Pink, *Doing Visual Ethnography* (London: Sage, 2001).

[14] A defining moment, sometimes called the "reflexive turn" and "crisis of representation" in ethnography is embodied in Clifford, J. and George Marcus (eds.) *Writing Culture* (Berkeley: University of California Press, 1986).

Norman K. Denzin, an important scholar of communications and sociology, has suggested that the modernist commitment to visually study and re-present lived experiences "falters" because the worlds we study are created in the texts we write as participants in events that are always unpredictable and unique. In this book, for example, Steve not going to rehab, or Michelle's choice to leave the union, are lived textual representations of unique experience.[15] Bringing this perspective to bear on my own video research, I argue that visual studies often suggest a certain empirical truth and, therefore, a sense of actually experiencing something. For me, a better visual study of culture is made in the company of a good written account where theories, contexts and the role played by storyteller can be seamlessly interwoven into the text. What follows is a collection of stories that I am telling. My source material is the total range of color and tone that living with the villagers lent to my own emotions, moods and aesthetic empathy for the situations I engaged. In a concrete sense, field notes, filmed interviews and subsequent conversations with villagers provide my virtual link to experiences "gained from participating in the performances of others — performances turned into text."

The final part of the Tent City Story. Problems and benefits of housing are discussed. Scan the QR, or go to: www.tinyurl.com/ProblemsBenefits

[15] Denzin, Norman K., *Interpretive Ethnography: Ethnographic Practices for the 21st Century* (London: Sage Press, 1997) pp. 32-33.

CHAPTER TWO ~ ENTERING

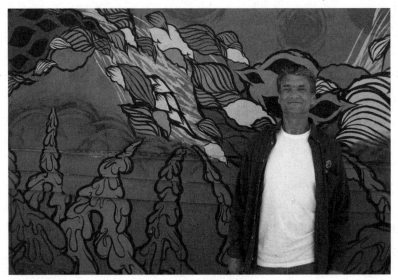

Brad Powell next to painted cobb wall. June 2010. (photo Eric Weissman)

When I started investigating Dignity Village, Wendy Kohn of Kwamba Productions suggested I speak with Brad Powell in order to set up a visit. Brad was the village chairman in 2010. Brad and I talked by phone a few times when I was making my plans to visit, and he fed me bits of information about what to expect. I read articles online and visited the village website. When I arrived in June 2010, I was entering a place I had been studying on video footage, by phone and online for over five years, so I felt fairly confident that I understood, in principle, that living there required people to be engaged in a democratically modeled political system, and social economy based on sweat equity. It was through these processes of positive and proactive community engagement, I surmised, that dignity was experienced. Still, most of the opinions and color commentary I had received up to that point was from one person, Brad. Brad occupied an important role in my research; he was a *gatekeeper*, a primary informant who introduced me to local knowledge about the place and to other informants. I arranged to meet with him outside the property when I arrived so that he could guide me and introduce me.

Brad was in his early 50s. He was a rugged character, missing a couple of teeth. Pretty much everyone in the village was shy a couple of teeth. He was about 6 feet tall with a full head of graying hair. He wore a plaid shirt over a T-shirt, faded jeans and a pair of running shoes, some American brand I wasn't familiar with. He had deep penetrating hazel-brown eyes and his skin seemed damaged by old age, or by rough sleeping, or by the simple stress of living in substandard housing. He was devoutly patriotic but critical of the corrupt regimes that govern his country. He valued his friends and his health above all other matters. He had no problem, at least with me, speaking of the idiotic things he did when he'd gotten high, or the trouble he'd got into over a weapon's possession charge some years ago. In short, his understated manner, coupled with his forthrightness, made me trust him.

Brad met me at the gate to the village. He was beaming and he walked up to me enthusiastically with an outstretched hand. It was a sunny, very bright and warm day in late June 2010 and apparently the sun was unusual for early summer. I was impressed by the view of Mount Hood from the front of the village. It was far away, 50 miles, but you could see the snowcaps. Brad obliged me with basic background material; a total of 60 persons living in 50 ad hoc structures on an acre of land, nine miles from downtown, with one phone and two hoses hooked up to the city water main. Electricity flowed to common areas like the office and commons room, but only those in medical need got electricity at "home." No regular plumbing, but five Portalets filled up quickly and were to be serviced twice a week, most of the time. There were no minors or families with kids there. Though officially recognized as an emergency transitional housing camp, no one had been forced out unless they'd broken one of five basic rules, and one man had lived there for 11 years. Of great interest to me was the fact that out of the hundreds of persons who had photographed, written and filmed in the village, no one had ever lived there. Then Brad suggested, as something of a challenge, that I actually come and stay – that I live there.

Another man, Jon Boy Hawkes, Brad's good friend, walked over, and we shook hands. His hands were rough and he had scabies or some other kind of rash on his skin. I later found out that it was seborrheic dermatitis and was a result of stress and a suppressed immune system. Jon Boy was missing a couple of teeth, too. His hair was graying and long and wild. Jon Boy was ecstatic

A short clip about the author's first visit to Dignity Village, a pre-study for future fieldwork. Thanks to Kwamba and the village. Scan the QR, or go to: www.tinyurl.com/FirstVisit

about living in the village. It was the greatest place he had ever been in. And he, too, suggested that I could come and stay there. "I don't think we ever had a Canadian here for any time, at all." He paused. "Well, wait, there was those two French girls who came through a few months back, eh Brad?" Brad smiled. They chuckled like young boys and showed their missing teeth.

The fact that Dignity Village had managed to weather bad press in recent years, and survived a minor exodus of the original leadership who had raised it, quite literally, from the dirt, were noteworthy facts. Many small communities in the mainstream of society wither and break up when the leadership and the community elders depart. Few if any small communities can survive without government subsidies and some employment, health facilities and so on. In the context of North American tent communities, bad press had usually been the deathblow. Tent City in Toronto had been extirpated shortly after the *New York Times* erroneously reported that a child had been born on the premises. Reports of homeless people living in the Con Eddy tunnels in New York had led to their eviction as well.[16] That Dignity Village had recently been the subject of several editorial critiques in the *Oregonian* and other local press media was not new in itself. But when we consider that people who are very poor inhabit Brad's community – people who come from homelessness and who are largely untrained to run a community – it becomes truly remarkable that they were able to navigate around the negative depiction of them in the press and by several right-wing community groups. They did this by being completely open, friendly and frank with strangers at the gate. They had a strong sense of "customer relations," and, as part of the "outreach" team, both Jon Boy and Brad were good hosts.

I asked Brad to explain how it was that they became what he claimed was the first city-sanctioned homeless community in the world. "Basically we started out under the Fremont Bridge. And it was just a group of protesters that got tired of getting kicked out of the doorways by the police and herded like cattle, told they couldn't stay places, and they just got fed up with it and they said, 'We are the public and this is public land, why can't we stay here?' And the city of Portland agreed that people had a right to live somewhere and there was no solution to the housing problem, so..."

In 2001, after the successful and highly publicized mobilization of some of Portland's street people, the city allowed the protesters to lease an acre of land on which to build a community of temporary transitional housing structures. Oregon state law affords munici-

[16] The film *Dark Days* (2000) examines this.

palities the right to two emergency campgrounds. Under the Fremont Bridge, homeless advocates and other partisan players exploited this loophole in their highly publicized battle for public land. The city chose to place these poor and largely immobile people on an asphalt tarmac, a toxic acre of former composting facility far removed from downtown and nestled between the Columbia River Correctional Institute, a few open fields and the PDX International and Air National Guard (ANG) runways, about a half mile from the mighty Columbia river. Out of sight and out of mind. The location was supposed to be temporary. The village was to be moved to a permanent, less toxic site, but this has not happened.

A few minutes into my filming with Brad, three F-series fighters from the ANG rocketed overhead as if on cue, a not so subtle reminder of where the priorities of the nation lie. At almost $30,000 U.S. an hour to operate and a cost of $30 million each, the value of the three jets I saw that morning alone could have built and maintained supported housing for over 200 individuals for a century or more. Brad pointed out to me, as the jets disappeared into vapor trails, that this was just for practice and training, not even "real missions... and you know it makes me mad when I think of us out here. It's not like there's a shortage of open spaces, empty buildings closer to... well, to life... Look at us – in the middle of nowhere, but never alone."

I asked what he meant by this.

"Well, we're less than a mile from the airport, and the fucking air force flies over us everyday, so you know Homeland Security has its eye on us. You know, all phones within ten miles of an international airport are bugged. So we aren't the city's problem really. Not any more. Way out here, the feds know more about us than the city does I bet."

The location of the village was so far out of the way that the cabbie who'd driven me earlier in the day, a native of Portland, had gone by it on NE 33rd for 11 years without ever seeing it. We took an hour and a half to find it even though my hotel was only a few blocks away. I had to keep insisting that the village was real, that it had not been closed years ago. After pleading with him that I had talked to real live people there, he finally asked, " Why would anyone want to go to a place like that?"

In my earlier walks around suburban Portland and in various chats at PDX en route to the village, I "spoke" with people about Dignity Village. Most people from Portland had heard rumors of its existence, or had seen something on the news, but few believed it still existed, and even fewer had an opinion about it. One person had remarked, "Well, if the

city says it's okay and they are making a go of it, I guess it's okay with me. But I have trouble believing it's still there." Strange, that a place touted by activists across the globe as the model of alternative housing for the poor should be so poorly understood by local residents.

But then, how much did Torontonians know about Tent City in the hours before 100 cops and private security staff forcibly evicted the squatters in 2002? To this day, people say they remember Tent City, but what do they really know? For the most part, even the newspapers got it wrong. In the three years I was onsite at Tent City, and the last eight years of follow-up research, ex-residents continued to complain about the "criminal" misrepresentation of the place and their lives by the press and by many so-called "serious researchers and filmmakers."[17] Dignity Village has suffered a similar misrepresentation, mirrored in the dichotomy between praiseworthy accounts of the alternative grassroots community in college essays and activist websites, and scathing diatribes against this den of iniquity by right-wing editorialists in prominent Oregon papers.

This disparity between knowing and knowledge is the reason that anthropologists and sociologists invoke various types of ethnography when studying even their own cultures.[18] As I mentioned earlier, my training in social anthropology has always suggested that the only sound ethnography is based on fieldwork, and fieldwork, following from Malinowski, means participant observation.[19] And so it was not surprising that a cabbie who has no interest in such places would fail to know much about it, nor should he.

On the other hand, those few people I met in the area who did know about the village were either very actively involved in it, by either visiting it or donating goods there, or were involved in various other community groups, churches and non-profit organizations. Several groups, religiously affiliated and grassroots alike, regularly bring food and donations to the village and to homeless folks camped under bridges across Portland. Community artists and builders often come to Dignity to paint murals on the structures or help make repairs.

[17] For example, June 16, 2002, the *New York Times* reported the birth of a child in the camp, which was false. The embarrassment of Toronto in the international press was the impetus for the mayor's decision to support the eviction of the squatters.

[18] A good reference and discussion of auto-ethnography, fieldwork and the ethnographic present is N. Halstead, E. Hirsch and J. Okely eds. *Knowing How to Know: Fieldwork and the Ethnographic Present* (New York: Bergham, 2008).

[19] Malinowski, B., *Argonauts of the Western Pacific: An Account of Native Enterprise and Adventure in the Archipelagoes of Melanesian New Guinea* (London: Routledge and Kegan Paul, 1922). Malinowski is "known" as the father of participant observation, but many anthropologist contemporaries of his, and later, have refined and redefined the practice.

Portland, itself, is very progressively pro-community development. The downtown neighborhoods are experiencing a renaissance; entire streets are being reclaimed by residents without city approval and transformed into art parks and quiet community gardens. I visited one where an herbal tea station for use by any passersby was unguarded, and there was no garbage or signs of disarray of any sort in the vicinity. If a shantytown were to be legal anywhere in the United States, it seemed to me that Portland would have been the place.

Back at Dignity Village, while my cabbie and I struggled to find our way out, while I had to finally tell him to turn off his meter or he wasn't going to get paid, a community art team was putting finishing touches on hand-painted windows for a passive solar greenhouse that was being built by volunteers from across Portland.

Ten years earlier, the original villagers had cried out against their forced relocation to the fringes of society, partly because of accessibility issues. At that time, they worried about how they would reach essential services and donations. They rarely had the bus fare and bus drivers, it appears, had not been too accommodating to indigents on the bus. It was a real problem at first, but in a short time, with all the publicity the village received, donations of goods and services flooded in, as did requests for shelter there. A strict limit of 60 people was imposed by the city. Having been led from city underpasses, 60 people settling into tents, lean-tos, trailers and buses, managed to lay the foundations of a community and to build, from scrap and donations, the 50 structures that are there today.

In its 11 years of existence, hundreds of hard-nosed rough sleepers, addicts, newly disenfranchised homeowners and other types of homeless people from all over the United States have managed to find shelter and relative safety within the confines of this one-acre plot of land, at little or no cost to the public. The last figure given by management was less than $2.34 a day per resident after the value of the lease was taken into consideration. An assessment undertaken by the city of Portland in 2009 suggests that about 75% of people who leave the village end up on the streets in chronic homelessness; while residing in the village, the health and mental welfare of people generally improves, as does their satisfaction with life.[20]

When I met Brad, the village had just celebrated its ten-year anniversary, and construction on the last two permanent structures allowed by city law was underway. All the buildings were now up to code and thus far the village had managed to pay its garbage bills, the maintenance fees for the five Portalets shared by the 56 people, and to meet the expense of

[20] Go to: www.tinyurl.com/villageassessment

a liability insurance that cost about $12,000 a year, and that the city demanded the village have in place. The fee was paid by residents, 20 dollars a month each, somehow.

This fee remains a problem for many residents. Some have to sell food stamps or use resources scraped from part-time jobs or social assistance to meet this requirement. A large number of people, however, do not pay on time, and this "non-compliance" continues to be a major source of conflict that threatens the long-term survival of the village. For residents, while their "rent" was covered by sweat equity, that is labor contributed to the village well being (ten hours per person per week), these other expenses are more easily met by the minority of residents who get social security or disability than for the others, and this was a problematic dynamic that remained hidden from most visitors to the village. Non-compliance with rules, fees, or sweat equity was being used as a tool for more powerful cliques of residents to use against villagers who had fallen out of favor, usually over drugs, personal disputes and other reasons, all unclear. These processes are discussed further on, but at this point it is important to remember that the village had rules and it had inequalities based on income that it was never supposed to have. These events were disconcerting to Brad.

Additionally, the village had been receiving so much in the way of donations over the years that some people had stopped working in the cottage industries that the village had started. A $10,000 hot dog cart that had earned up to $50,000 a year on the streets, for example, was collecting compost dust as flowers grew out of its nooks and crannies. With so many donations of various kinds coming to the village, Brad warned, "The village was in danger of changing from a 'hands on' place to a 'hands out' place. That would be a damn shame." I could see a complete transformation on Brad's face. His glow retreated into a deep furrowed brow and his eyes welled up, just a little bit. There was real fear inside him, though at that point I wasn't clear what it meant. He cleared his throat and simply said, "Well, let's keep on track. Let me show you around a bit."

The village arranged and hosted tours for outsiders, mostly school groups from all grades, to whom the village must have seemed fantastic. School groups were often asked to sit in the commons area, where they watched the village "intake video," something all newcomers must watch; the commons area, a fly-infested large room with soiled furniture was comfortable to the residents but, to outsiders, the grime and smell can be overwhelming. Brad and I looked around the room, and he provided, "You might have to stay in here if we don't have a structure for you when you come back." Furrowed brow. "Seriously?" I asked. He smiled. I asked him, "Have you been here since the beginning?"

"I've only been here for a little over three years. I was homeless, camping out on the [Columbia] river a little ways, on one of the sloughs, and one day, the city came in with one of their crews from the jail and took our whole camp… took everything, straightened the blades of grass out… I had nothing except for the backpack on my back… I had gone to a day-labor place to work and when I went home there was nothing there, and I had a friend who had lived out here and he told me about it. And I shared the same social stigma [towards it] about a 'dirty bum camp'. And when I got here I was amazed." He took me by the shoulder and led me towards the center of the village. We stood across from the communal worktables as a couple of villagers hammered the frame for a corrugated aluminum firewood container.

He went on. "Well, it's just my theory, but I believe that when you become homeless, you have no rules. So you have no structure. You're not used to being told you have to do this or you have to do that. When people come here to live, the only requirement used to be that you were homeless, and now the city has required us to pay a liability insurance and so, on top of the ten hours of work toward the upkeep of the village, now you're required to pay 20 a month for the insurance on the property… and the city has agreed to leave us alone and pretty much let us run the place as long as we do it in an appropriate manner, and I think after ten years we have shown that we can do that."

Brad was very insistent that daily routines and social structure were important (not to be confused with structure or structures, the terms they also use to refer to their shacks). Jon Boy, who had stood by this whole time and had nodded or shaken his head, had to leave to take a call, but he suggested we meet in his place later. I agreed. "It saved me. Saved him too," Brad said. "What exactly?" I asked. "Structure. Order, I mean rules, not being afraid of rules. I mean we make the rules here so it's better for us here than out there."

Brad gave me a quick rundown of the political structure and the residency procedure. Essentially, the village operates as a smaller version of an elected, democratic legislative assembly. But it starts with a homeless person becoming a member of the village. Basically, there have been three eras in the village, defined by changes to the way membership was determined. In the beginning, and according to the original articles, persons wishing to join the village would sign up on a wait sheet. They were required to check in every week to find out if a space in one of the structures or in the commons area was available. When a space became available, a hopeful member would be ascribed the status of *guest*. After fulfilling their sweat equity requirement for 30 days, they could, after another 14 days, ask to be a

member and that was it. In fact, people were expected to become members, but it hadn't been enforced. Membership was important to the design of the political structure. Membership came with the right and duty to vote on village business, and gave a resident the right to run for council. Council was supposed to have 22 seats, but only rarely have all these seats been filled. Hence, the village has not really been running like a real democracy, and the interests of only a few members who are successful in bids for leadership positions get served. This was the kind of political turmoil that Brad was speaking to. Cliques and favoritism were starting to be more important than rules and points of order, though Brad never spoke directly to this.

A few years ago, for reasons that no one has been able to explain, the village leadership managed to push through an amendment that required hopeful members to pass through an election, a confirmation of sorts, by other members after the residency period. The Village Intake Committee, that had always invigilated the entrance of new guests to the village, then became a supremely important organ of the system. Instead of "asking and receiving" member status, the committee and the other members were given power to determine a guest's status.

Faced with the possibility of rejection, many villagers were putting in a minor effort, fulfilling only basic sweat equity requirements because they understood that their destiny was based on the whims of VIC members and not on the merit of their performance. A lack of confidence was stewing in the community based on a lack of faith in the leadership, loopholes in the sweat equity model, and a community-wide doubt about the sensibility of making a long-term moral or political commitment to the community.

I was terribly confused by this, so Brad explained to me that, as a result, not everyone who had a housing structure was a member. In 2010, under the revised membership system, many residents had opted out, and participation on the council and in vital mandatory members meetings, where decisions were made, dropped off to the point where decisions could not be made. Instead of a politically motivated activist community, the village was becoming a housing project where mere shelter had become more important than engagement in processes that protected and helped the community evolve. Even the five basic rules that were posted in several locations around the village had become impossible to enforce.

"We have five basic rules. The first rule is no violence to yourselves or others. The second one is no theft. Those two we have zero tolerance on. If you get in a fight, the first per-

son to throw a punch, it's an automatic ejection (an 86). We have other rules we go by – no drugs or alcohol within a one-block area of the village."

I had only been there for a few hours at that point and I had seen empty beer bottles and I smelled marijuana. In fact, in ten years working on the streets for my film, it seemed to me that pot and drink were fundamental to the lifestyle. Almost everyone I had met denied it at first of course, but in short order they'd been open about it. With drugs and alcohol arguably the two largest leisure industries in the world, it seemed almost unreasonable to restrict their use here in the village. "So no drugs, even in your own structure?" I asked. "Well, we can't monitor that because we don't search at the gate. You know people have rights. And that's one of their rights here in the United States of America, the privacy of one's home."

Brad asked me to hang on as he walked over to someone's housing structure. I jotted down some notes quickly, some questions that had been gnawing at me. For some years now I had been reading about this alternative housing community. However, if this place followed codes and was regulated by the city, how alternative had it been really? Back in Montreal, my dissertation supervisor had had me reading volumes of Foucault and other social theorists in order to better debate what words like *autonomy* and *freedom* might ideally mean. In 1791, English philosopher Jeremy Bentham had published the details of an ultimate prison, the Panopticon, whereby prisoners were to be jailed in rings of cells built around a central guard tower. This structure offered maximum efficiency and perpetual surveillance and, he felt, could be equally applied to schools, hospitals and other buildings whereby control of "mind over mind" could be achieved. Ultimately, it was not built. But forms of this structure can be found in prisons today. Briefly put, in *Discipline and Punish* (1975), Foucault develops the metaphor of the Panopticon as a model for how modern Western society manages through various powerful scientific, social and educational institutions and practices to produce self-governed subjects constantly surveilled by and surveying the "other." Could it be that the sanctioning of the community by the city was really the state finding a clever way to convince the villagers that they were free and autonomous, free to self-govern and free to survey each other? Was this the ultimate expression of the Panopticon? What was that line from the film – *The Usual Suspects* – "The greatest trick the devil ever pulled was convincing the world he didn't exist"?

Someone slammed the door on Brad and I saw him smiling as he walked back to me. He picked up our conversation without missing a beat. "The other rules are you have to put

in your sweat equity, and…" – craning his head and leering at the door that slammed on him – "no constant disruption of village activities."

Brad and I walked the village a bit and he showed me his structure. But we did not go in because he motioned to a brightly painted structure in the far corner. One of many to have murals on them. Some are painted by residents, and others by local artists. On this one house, however, there was an unusual mural – a royal blue basecoat, impressionistically painted animals two by two, and an ark. Brad stopped dead in his tracks. He looked around. His eyes teared up. I sensed he was on the verge of an emotional outburst and that he was trying to suppress something he might have needed to get out. I had to "out" myself. "Look, Brad, just so you know, and it's not a big secret, but I do this kind of work because, well, you know, I was pretty fucked up for a good chunk of my life." He hung his head and nodded. "So I get this. I get some of the stuff I mean. I was pretty much homeless at the end, sleeping in a coma pretty much. All the time. When I went to rehab…" He looked up with red but curious eyes, raised brow. "Yeah, twice for almost eight months – and I was homeless, a total victim, and totally fucked. No shit, man. Seriously. So… thank God for my family."

Brad pointed to my camera. Then he nodded to me with a faint smile. His lip was trembling. I wondered if I should turn the camera on. But he insisted, flogging his hand at me, encouragingly, so I did. This structure, or rather the painting of the arc on it, held special value to him. As I was to find out, all the paintings have special meaning to the folks who live in their structures. Without missing a stroke, he went on. "And I have post-traumatic stress syndrome, from being homeless, well, just from life. And I have a hard time talking about 'Noah's Ark'… because it's a kid's…"

I put an arm around his shoulder and tried to comfort him. So many times in my work with the guys from Tent City or other street folks, moments like this had arisen where interview became confessional, and all my training as an anthropologist and all my sociological imagination were completely useless, and all that was left was a moment defined by its existence. I had to just be a person, no role but be present and decent to someone I hardly knew, who was opening up to me. Moments like this confirmed for me in the only ethical moment was the one that arises from the interpenetration of two unique souls in the event of being. There is no such thing as universal pain. For each person, pain manifests uniquely.

As a researcher in the field, confronting the pain and suffering of others has been doubly problematic for me. Was my line of inquiry causing Brad pain or harm, or was this leading to some necessary point of understanding?

Brad caught his breath and forced through a sob, "You know, it's the guy's last painting." The young artist who had donated his time to the village to paint the ark was in the middle of his last-shot chemo treatment somewhere in Portland.

"I've contacted most of the past chairmen and especially Jack Tafari, who started all this, and I thanked him for the chance to change the world," Brad somehow managed to say. He was fighting through heavy tears. I tried to console him. "There's a lot of pain, a lot of pain," I said. "But I can see that now," he replied. "And I have a chance here to show the world a different way to do things, and lot of people here don't even see that."

I ended the interview at that moment. We sat on the stairs to a structure and watched a few bluebirds digging in the melon blooms in one of the lush vegetable planters. The gardens were doing very well, full of bright green life, watermelon, cantaloupe, lettuce, herbs, tomatoes and such. A local nursery had donated most of the seedlings for these food crops. "But soon we will start our own from scratch, when the greenhouse is completed," he said. Then we got up and made our way to the commons area to see if I could get a DVD of my film to play on their system.

Later that day, I showed the residents an early version of my film, *Subtext*. It was a way for them to get to know me and how I saw things, and to decide whether they wanted me to come stay there. The response was surprising. Most notably, villagers felt they had seen mirror images of themselves in the squatters in Toronto's defunct Tent City. They were equally angry at the way Tent City was demolished, and several remarked that Tent City probably would have had a chance at it if only they had had more structure and were able to negotiate a lease with the city.

After the viewing, Brad remarked that he was even more grateful to have his shack. He, like most people in the village, dreamt about having a home or a subsidized apartment, but the odds against actually finding mainstream housing were high in Oregon, as they were in most of the U.S. And as Brad suggested, "I can see all kinds of possible drawbacks to having housing that I never imagined before, and it makes me think."

At dusk, after the village had quieted down, Brad and I concluded our first interview, though, looking back at it literally in digital form, it does not feel like an interview. If there was such a thing as conversational anthropology, this surely was it. I was convinced that I had to come back to the village if I were to speak with any authority about what the nature of being housed in the village was. I was fairly certain that these folks at the village were homeless, but that the painted shacks, the gardens, the flags flying and the smell of meals

being cooked on various barbeques were all symptomatic of a housed community. Brad didn't agree.

"I'm still homeless."

"But why, you have a house?"

"Technically, I'm homeless."

"According to whom?"

"The city, the state, the federal government."

"But what about in your state of mind?"

"Homelessness is a state of mind. Home is where your heart is, so you are never without a home."

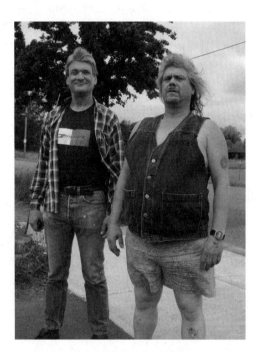

Brad and Jon Boy on the berm. June 2010.
(photo Eric Weissman)

The next day, I headed off into southeastern Oregon to a high desert river to fish with some fly fishermen I'd met on Facebook. The main reason I went fishing was because of the kindness and enthusiasm of my Facebook friend, Rich "Opie" Schaff, a photographer and great fisherman, who had set up the trip. Rich had come west some years ago, like many émigrés from the east, because of the mountains, the rivers, the fly fishing and the frontier spirit. He worked in a job he did not enjoy and he was really my first mainstream informant in Oregon. We talked about the general state of things, the dramatic economic anxiety in Washington and Oregon, owing to a slowed resource economy and other factors. He expressed the same frustration that most employed people felt about the homeless – an inability to find solutions, and a sense that such things could happen to anyone.

On the banks of the Owyhee River, sleeping in tents, eating on makeshift tables and cooking with a portable stove, we embodied in our own way the basic material culture of the village. Here and there, laid out over 20 miles of river basin, fishermen were camped

out in their cars, trailers or tents and were more or less living the same way, in a material sense, that hundreds of thousands of Americans were living at the very same time in temporary campgrounds, along river valleys and under bridges. While we were there in pursuit of leisure, these others had lost their homes to the bank, or their jobs to outsourcing, and their numbers were on the rise.

In the months that followed, economic downturns in Oregon and Idaho pressured a couple of the fellows with whom I was fishing. Each has had to move from their homes in pursuit of work. People all over the U.S. and Canada were moving from regions of poor economic performance to cities where the promise of work and, through that, a sense of self-worth might be found.

Rich lived with his wife Julie just outside of Vancouver, Washington, across the Columbia, about 45 minutes or so. He very much wanted to come to the village to photograph the place and meet everyone. He and his wife had clothes and other materials they could have used at the village. But, as these times would have – when nothing can be counted on with any certainty – Rich passed away very suddenly from cancer a few months after our trip. It was, of course, a shock. Opportunities and a life lost.

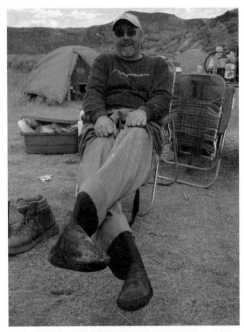

Rich at our tent camp. June 2010.
(photo Eric Weissman)

Throughout the remainder of 2010 and 2011, I kept in touch with the village by email and by phone. Jon Boy, who'd been elected the new chairman in a general election, something that happens each December, was excited that I was coming, and he'd assured me that one of the dorms would be ready for me. The dorms are about the size of a prison cell, roughly 8 x 8 feet. Each dorm was actually half of a larger, usually 16 x 16 feet unit. Like all village structures, the construction is crude. In addition to providing a modicum of privacy, they provide basic but reliable shelter from wind and rain. As larger structures become available, and if the villagers

moved beyond *guest* status, they can move into a personal structure. I was looking forward to living there, but I was nervous about the move into a tiny living space. Jon Boy was reassuring and reminded me during our phone calls that, "Nothing bad was going to happen to me or my stuff. That's the last thing the place needs. Can you imagine the press?"

Two weeks before I was to leave my home, I went online to www.dignityvillage.org, as I had done every month just to check things out. A notice saying that the village's site was not in service, but that a new one would be up, should have been my first clue that something wasn't going right. I called to check up on things and this time neither Brad nor Jon Boy was around. Folks at the village didn't give up much information to people on the phone. Clearly that would have been risky and, since many of the villagers desired anonymity during their humbling residency, speaking to others' whereabouts over the phone was a no-no. The acting vice-chair, Brian, took the phone and told me with a kind of nervous laugh, one that reminded me of a salesman trying to pitch me something for which I had no use, that "Well, there have been a few changes here, and Jon Boy can't speak with you right now, but we are all really excited about your coming." He asked me when I was going to get there. "I will be there in a week," I replied. He said, somewhat cryptically, "Well, good then, we should have a place for you by then." And he laughed that distinctive laugh again.

I was in Toronto at the time. I was staying at the lovely home of my sister and she had been sitting next to me during my call. "What's wrong?" she asked with a very seriously concerned look. "You're totally white right now, what's up?"

I replied simply, "Nothing. I guess it is just hitting me that I am actually going, finally." She sat back in her chair, arms at her side. "Are you worried?" she inquired.

"No, but I think you are." I said with a smile.

"I am. Of course I am. It freaks me out a little bit. I am your sister. Of course I am worried about you going to live there. Well, at least your color is back. Tell me. What is it that bothered you from that call?"

I cannot explain why I didn't tell her the truth. But I suppose I just didn't want to worry her more than she was. The truth was that I knew something was going on in the village that I sensed would come to bear on the plans that I had made. But I wasn't sure what it was. The fact that my two key informants were never available on the phone, and that a "place might be available" by the time I arrived had unnerved me. These were hardly the assured words I had heard all year from Jon Boy and, before that, Brad.

"How do we get in touch with you if we need to get a hold of you?" she asked.

I opened my laptop and emailed her all kinds of info.

"Okay," she said, "but what if – what if something happens to you? How will we know?" She had a reddish film in her eyes. She was really worried.

"Look, it's not like I am going off to the Trobriands or—"

"The where?"

"Islands far away from here. Never mind. I am just going to live with a bunch of heavily troubled folks in a shantytown. I bet I am more dangerous than some of them!" It didn't help. "Don't worry so much. Besides, I have my name and your contact info on everything and they will have it, and the university knows where I am, and…." I had to throw in my ace-in-the-hole statistic. "It's probably more dangerous flying there or driving to the airport than staying there, okay?"

"Probably, what do you mean probably?"

"Never mind, Andrea. All will be well."

CHAPTER THREE ~ EXILED IN DIGNITY

DAVE SAMSON

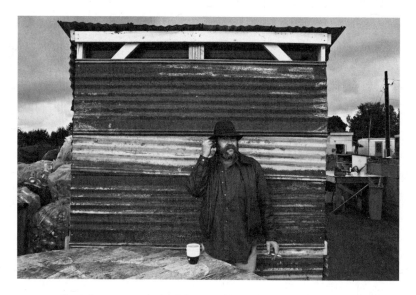

Dave Samson tweaks his hearing aid, Dignity Village. July 2011.

I arrived in Portland on the evening of June 19, and immediately picked up a rental car. A white Subaru Outback that was "on special" and had lots of room. I had reserved a modest hotel room at a Radisson near the village because I anticipated feeling things out for a couple of days. The car rental was planned some months earlier, but it was supposed to be temporary. I had acknowledged that possession of the car represented a vital resource, mobility, and that this could be a dynamic variable in my relationships at the village. So, I was only going to use it for a few days until I got my footing. However, troubled by the sense of doubt that the last contact I had with the village had given me, I elected to keep the car as a safety valve.

That night I went to the hotel restaurant and enjoyed a salad and fresh bread. A gourmet burger. I ate very quickly, as if I were afraid the food might disappear. I sat at the bar

and watched baseball and chatted with the bartender. Dignity Village was about two miles away, but he had never heard of it. The two businessmen from Austin hadn't either, but they had read about tent camps that had recently been swept by the cops in Texas and California.

My room was a standard single room. The bed sheets felt clean and smooth. At the time, I remember thinking it was merely exhaustion and the need for rest that made me enjoy the sheets so much. But in the following days I came to realize that this sensing of the material, the smell of the linen, the garlic in my salad, the purified air, were lingering sensual traces of the standard of living I was going to cease to enjoy, and so I had appreciated them more. That first night I charged all my camera batteries, called the village and told the person on duty in the security shack that I would be there in the morning. I asked for Jon Boy and she said, "Ha, now that's funny." And she hung up.

Next morning, I drove to the village under a cloudy sky with intermittent rain. It was cool, perhaps 12 degrees Celsius. The main access route, NE 33rd Ave., was blocked in two directions, so I had to negotiate some complicated detours to get there. The area was quiet. It was a Saturday and there was no business going on at most of the factories in the neighborhood. There was one aluminum products plant that was very busy and, as I drove by, I saw two men, who looked like they might be homeless, digging in the garbage and picking up cigarette butts at the side of the building. Employees walked by them as if they didn't see them or were used to their presence. There were signs up here and there, tacked to lampposts and doors, offering part-time employment. I made a mental note to find out if any of the residents worked at these places.

The security shed and the "Stumptown" cow. June 2011. (photo Eric Weissman)

As I was pulling up to the village, the first thing I noticed was that the large Dignity Village sign, though still readable, was hung on a slant, and one entire edge was draped to one side. It would only have taken a few minutes to pin it back upright, but it just hung there. There were five cars in the six-spaced parking lot. I pulled in, and one of the cars, a black beat-up Nissan, drove out quickly, and the driver paid me no attention. There was an out-of-service '87 Bronco and one of the cars was carefully draped under a skirt. I found it remarkable that homeless folks would own cars. There were very few people moving about. I managed to pull my Subaru into the tight tiny spot next to the chain-link fence that surrounds the village. On the other side of the fence was a brightly painted orange fiberglass cow.

As I entered the gate, a stout, firmly structured woman named Mary asked me who I was. She looked at me attentively, scanning me up and down, and her mouth dropped open as if she wanted to shout. She raised her left hand and snapped her fingers. Raising one arm she said, "Wait! You've been here before?" She kept her eyes fixed on me as she waited for a reply. "Last year?" I replied softly. Mary took a clipboard from the desk and flipped a few pages over. Names and addresses, phone numbers, information about visitors and residents' comings and goings. A logbook. "Oh yeah, Toronto! There was a rumor you was coming back. I remember you. Better come sign in then."

Mary loved cats. On the desk in the office was a cat, balled up in a mess of paper and garbage. She teased it and the cat dug its foreclaws into her skin. Mary seemed to enjoy it. She laughed at the struggling cat. She burrowed her nose in it and snuggled with it. "She's a real princess, this one." Mary had a small dark-brown purse slung over her other arm. In the days that followed, I would frequently see her walking with the purse. I saw her draw a hanky and a lighter from it from time to time, but its other contents remained a well-guarded mystery. There was some speculation that she kept a wad of cash she had saved in it, or some photos of her children, especially one of her son who had been deployed in Iraq. She smiled a lot, and under her breath she muttered words I could not understand. She was often angry with other people. At times she was involved in village-wide disputes — she just had that way about her. Everything was serious to her. She walked heavily. Her feet made solid stamping noises.

"Let's see now. Haven't been on security detail in a while. Oh yeah, name and time, sign here." She pointed to a space on a list with several other names. "We have to ask. It's the rules. People need to be safe," she added.

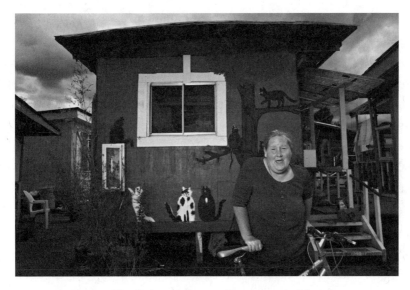

Mary and her favorite wall, part of her structure. July 2011.

In the village, two people were always on security. They worked in shifts. These hours went towards the sweat equity requirement. They kept an eye on who came in and went out. They made sure that newcomers only stayed in the common areas of the village and they more or less were there to call fire and ambulance when someone overdosed, fell or died. They monitored phone use and made reports when conflicts occurred. Everyone was supposed to do security duty at some point. But some shifts were better than others. Still, the role of security personnel was an important one to learn. It required people to use reason and interpersonal skills to deal with conflict. From the very first moment, therefore, that you entered the village, you were compelled to adhere to rules and structure. This applied to visitors and residents. Mary was on duty with a guy I had not yet met, named Dave Samson. He was somewhere else so I asked her, "Jon Boy around?"

She took a good four seconds to decide on how to answer that and then just laughed, "That figures. No one tells nobody nuthin' 'round here." She kept laughing and walked out of the shed onto the tarmac, yelling, "Samson! Samson? Samson!" I walked out and down the plank stairs, then over to the orange cow. There were tree stumps painted all over it. I heard the rumble of a jet taking off and I looked up to see if it was a fighter jet. Cloud cover was low, so I couldn't see it, but the jet sounded commercial. A voice from behind startled me.

"That is one of Portland's other names, Stumptown, Bridge City. I'm guessing you're Eric?" David Avery Samson was a stout man. He had a lot of brownish red hair everywhere and a thick beard with gray tips. His fingers were rough and his nails had deep black dirt burrowed into them. He wore a khaki-colored outdoors shirt, a safari-style hat, and a brown leather bomber jacket. All good stuff. Not the filthy remnants of clothing I have often seen street guys wearing. He looked somewhat of the adventurer. Dave walked closer, not afraid of my space, and apparently not too respectful of it. *He is like me,* I thought to myself. I am guilty of the same encroachment in general, a close-talker, but often in fieldwork I forget that space is value-laden with expectations; it's just not appropriate to stand too close or too erectly, or to turn one's back on an informant. Different cultures inhere beliefs about courtesy and body language. The worst things one can do with folks who had slept rough, and duked it out with the bullshit handed out to them on the streets, was back away or reject a handshake. Never turn your back on someone, especially if you are engaged in an argument. The Dr. Phil crap about establishing boundaries might work in suburbia, but not here. Handshakes, a straight look in the eye, are elements of a basic social economy on the streets. This sensibility translated from the streets to the village easily. Dave was right there, inches from me with a bucket of coffee in hand. It was 36 ounces. He put it down on the porch because it was far too round to sit on the 2 x 4 rail. He took a long chug of the coffee, and I heard it. He swallowed the coffee as if it were vital; as if it were something he just would not do without. He coughed hard after he swallowed and wiped his hand on his leather jacket, paused and reached into his pocket, finding a small plastic baggie full of some foul-smelling stuff.

At first, I thought the smelly herbal bits were pot and I was surprised at his brazen behavior, but in the wind I caught a whiff, and it was not pot. One of the familiar but nauseating smells on the street was the acrid, repulsive odour of used cigarette butts. At several dollars a pack, most guys on food stamps cannot buy packaged cigarettes so they roll their own from collections of discarded butts they find on the street. They call this "sniping," and it was something they looked forward to, especially if it had been sunny and dry for a few days. That kind of weather "cures the butts well, and no rain means the flavour stays locked-in. Locked-in goodness in every bite," Dave said.

In Dignity Village, guys go out and snipe for butts in the driveways and sidewalks of the nearby warehouses and malls. Sometimes they buy real rolling tobacco from the store with their food stamps, and sometimes they mix the two. It was one of the most foul smells on

the planet and, as an ex-smoker, ex-addict, I knew it well. As Samson struggled to light the butt, I thought of all the effort that had gone into getting those butts, probably three guys out for four or five hours to gather enough butts to divide up and smoke for a day or two. He laughed, then coughed and caught phlegm in his hand.

He wiped the residue off his hand and reached for mine. "We like our java," he said. He leaned into me as we shook. "Don't worry, an orange cow is not the weirdest thing you will experience here." He grabbed one of my camera bags and started walking towards the common area, as I secretly drew my hand against my damp rain jacket. I reminded him that I had been here before, that was how all this started. "Yup. Yup." He nodded. I repeated myself. "Yup. Yup," he nodded. I repeated loudly: "I was here before, last year. But you weren't here then." He looked to me and explained, "No, I was out experimenting with alternative living arrangements. Didn't work out too well." I nodded and shrugged. "You ain't in Kansas anymore, Dorothy," he added.

Dave seemed to be looking for someone, as he looked in various spaces and lanes. I asked him where Brad was. In addition, where was Jon Boy? He paused and turned to me with a look of utter disbelief. "What? No one told you?" I was at a loss. "Told me what?" I asked. "Yeah, yeah," he muttered, not answering my questioning, then chuckled and walked along.

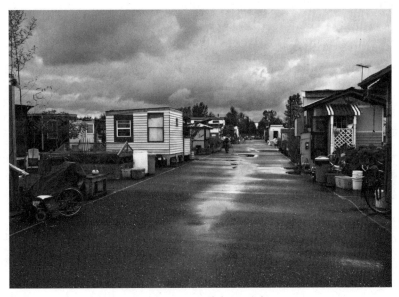

The main drag, wet and dreary. July 2011.

At first glance not much had changed in Dignity. The buildings were in the same places. They could not really be moved without violating fire codes. The last structure to be built, the greenhouse, had been finished a year ago and, at a glance, it appeared to be the same place. Rundown, though. It had rained hard earlier that day. The puddles were muddy. Dirt seemed to be clinging to things. Like wet mascara, it ran down the edges of windows and door trims. (I look at my video to see if it was the same back in 2010 and I am confident that it was not.) I saw a few villagers here and there going about their business. Mostly they just hurried from the commons area with large mugs of coffee, rushing back to their structures without saying much. It was late morning and coolish, damp even. The sky was gray and oppressive. The weather on the coast moved in and out quickly and dramatically. Like northern British Columbia, if you do not like the weather, just wait five minutes.

Unlike a year ago, the planters that had been so full of life were now strangled with weeds and the food crops that they had boasted about seemed starved for light and fertilizer under the cover of dandelions and crabgrass. Even so, the village had some very intriguing rainwater planters that trapped water as it ran off the rooftops and, as it trickled through these planters that hang or are suspended near the rooftops, not only were plants watered and nourished, but the water was purified and trapped in a basin for washing and watering other plants. Water was a resource here. It rained a lot. Last year, the planters were thriving and it was suggested that all the structures would have one or two or more of these "green" water purifiers to help reduce the cost of water that otherwise would have to be metered in on the waterline from the city. Since there was only one sink and only two faucets drawn from the city main line, access to water was difficult, and it cost the village money. None of the structures had their own water or plumbing. Rainwater collection systems had always been touted as a means of reducing reliance on the city, and for distributing water to individual structures. By the front gate the planters were broken and falling apart. Dave looked at me with a look of complete amusement as one literally crumbled into pieces in a heavy gust of wind. In an English accent, one of his "go-to" voices, he said, "There you go, guvnor, a bit of dramatic metaphor upon your arrival! I believe that's what they might call foreshadowing." A year ago at 11 in the morning the place had been alive and buzzing with construction and maintenance; this year, it seemed like somewhere else, a hopeless place.

The rains kept the dust down, but next to the village, the city compost piles were higher by some metres. Dave and I watched the tractors turning the piles so that large whiffs and plumes of methane gas steamed violently into the air. I could smell it. David took a deep

breath and walked over to a garbage can. He spat out a ball of phlegm. He looked at me with quiet regret, but really what could he do? This toxic airspace was one of the things that villagers had been fighting against for years and this toxicity was one of the reasons that the village kept asking for a relocation to a permanent, safe and non-toxic location. Residents were edgy to begin with. They'd come here out of unpleasantness that we in the mainstream would find hard to imagine, and then, once here at the village, they had to cohabitate with rats, flies and toxic pollutants. "Don't worry, Eric, there's about a hundred [asthma] puffers in the village, so if you have a seizure someone will be able to—"

"Charrrouggh!" From within the commons building a few metres away, a wretched and horrifying cackle, so loud that it sounded like a small motor was about to blow. Fred, a man with remarkably long and thick gray and white hair, walked out of the commons, gagging and coughing, "charrrouggh." Fred seemed as used to having these fits as Dave was to seeing them. "Right on time," Dave said, as he faked a turn of the wrist to an imaginary watch. He spilt a bit of coffee on my camera bag. "Whoops!" Fred gripped the porch rail. His arms shook and his torso convulsed. He looked to be a rough 75 years old or so. But he was only 51, my age. His clothing was stained and well worn – a filthy white dress shirt, black pants drawn tight with a rope, and worn black cowboy boots. His thick gray and white beard had a bright yellowy-tan stain that matched his fingers. Had I ever, I wondered, been that filthy? I had a good idea what it took to reduce a person to the point where they stopped caring about how they smell, or look, or that their spit had pus and blood in it. I had been there. I understand now that part of me still lives in my distant past, where drugs and booze had taken me precipitously close to the edge of homelessness, and worse. My sensitivity to the sight of spiritual decay is, in part, due to seeing myself in the bodies of the worst off.

Fred leaned over the rail next to the communal lunch tables and, without a hitch, he violently gagged out clear mucousy gobs that hung like icicles from his mouth. On the asphalt below him were several deposits from earlier in the day. I felt sick to my stomach. Fred caught me staring at him and turned away, but not before giving me a look that said, "Fuck off, what are you looking at?"

Fred and I did become acquainted, and we talked frequently. But it took some work. He would not let himself be photographed or filmed until five weeks later, when I was leaving, and then only in the company of two young women who lived in the village. He called them his "daughters." I remember snapping the two photos of him with the girls, and feeling creepy. None of the villagers understood exactly the nature of his crimes, committed

many years ago, and he would never tell me, but they were of a "hideous sort of nature" that kept him from leaving the village. He told people he was a bank robber, a soldier, a rail man and a "connected" guy. It was all bullshit. Some of the villagers, who knew guys in various prisons, had heard that Fred was a rapist, a violent sexual predator. This was his dark secret. I came to know that he was afraid that the families of people he had harmed many years ago would still be looking for him. The two photos I had shot may be the last record of him. He died in his cabin of respiratory and cardiac failure two months later.

Dave pulled me aside. I finally saw, under his hair and hat brim, a cheap sound amplifier fixed into his left ear. "I was going to say that if you stayed here long enough, you can experience that glorious part of village reality first-hand, but looks like you are getting a preview." He struggled through a few good gags of his own. He coughed into his hand again, in what must surely have been a conditioned response to the pervasive respiratory damage that smoking too much and living in the polluted dampness of the tarmac produces. "How nice," I replied. He lifted his hand to the earpiece once again, and then asked, "What's that? Nah, don't worry, it takes at least three months to get the asthma. You're only going to be here for a month." He pointed a thumb at Fred and, laughing, he said, "Besides, that ain't asthma. I don't know what the fuck that is exactly, except really gross."

At first, conversing with Dave was exacerbating. This was not because he could not understand, or had little of interest to say. Rather, because both his ears had cochlear blockage, he missed many of the aural cues. He often reminded me that sometimes he wondered if it was a good thing that he did not hear all the gossip, or the stupid quips people made. He wondered, also, if he were to be fortunate enough to one day get hearing aids, if he could adjust to hearing normally, and to losing that excuse to remain marginal and disengaged from most conversations. Since he had no health insurance, and no other recourse to open the calcification that was rendering him deaf, it seemed a moot point to him then. He figured he would have to raise one hand to place the device in the direction of people talking to him for the rest of his life, if he was lucky. He had developed a sort of vocal tick, a response to things he could not hear. "Yeah yeah, yup yup. Yeah, my life sucks, homeless and now deaf." Sometimes he just nodded agreeably, even when he had not heard a word. So I repeated, loudly, "DAVE, what didn't I hear? What do YOU MEAN NO ONE TOLD ME? TOLD ME WHAT?"

"Well, how should I put this? Oh wait, I know. Jon Boy doesn't live here anymore!" Dave laughed. I was stunned.

A few weeks earlier, Jon Boy had been 86'd for assaulting TC, another resident. The argument that had led to the fight was over two issues that threatened the village on a constant basis. The first was favoritism and the second was drugs, in this case methamphetamine. They had got into a fight over drugs and Jon Boy had beaten the crap out of TC. TC's followers had made sure that Jon Boy was out by clinging to the non-violence code, while at the same time protecting TC from any alleged drug involvement. So Jon Boy, who had been a good friend to many of the other villagers, was out – automatic 86 – out of the village for life. His departure had cast a pall on the village that was fresh and palpable and it was that malaise that I had sensed when I'd entered the village. Factions and alliances had to some extent always had a role in the village political dynamic. But, by the time I arrived to stay there, villagers were operating under the fear and expectation that their days might be numbered too, if certain connected members were crossed the wrong way.

Folks were scared and depressed. The planters and their crops were untended, the grounds unswept, and the villagers unkempt, because the collective will of the village had been damaged by this drama, a cataclysm for a small and tightly knit society. And this was the first I'd heard about it, bookended by gagging homeless guys and pajama-clad villagers dashing in and out of a halo of toxic methane vapour. It was also then that Dave told me that there was no structure for me to live in so I would likely have to stay in the dreaded commons area.

My first thought was: *No way*. How would I camp out on a flea-infested couch with $25,000 of equipment with any degree of security? He said, "Much as I like him, Jon Boy was my friend – still you know, but the rule's pretty clear. He had to go. Anyway, the interim chairman is a mellow guy – he was here when you came last year I think. Do you know JD?"

I followed Dave, and the legs rather went out from under me. I was in shock. I was in a homeless camp and I didn't even have a structure in which to sleep. Homeless, in a homeless camp. I remember chuckling at this absurdity and then, as Dave turned to look at me, he said as if psychic, "I know, it strikes me as humorous too, but don't worry. If it means anything, the commons is relatively cleaner than most of the structures."

Walking past all the structures and looking at the filth around me, I did not say anything, but in my head I was calculating how much of my research per diem I had left, so that I could perhaps stay in a hotel until a structure became available. Part of me wanted to stay in the hotel, but the other part correctly knew that such a luxury for any extended

period would have diluted the ethnographic value of being at the village. What was I going to do? Hang out during the day, and then go back to my hotel room? Was that not what all the others had done? Took a dose of the village and then retreated into comfort?

Dave walked me down the tarmac to the end of the village that was furthest away from the center of action. I started noticing more details. My recollections of the year before became more salient. Little things, a flowerbed moved here, or a flag pole torn down over there. A small wooden sign nailed into one of the structures said "Shakedown Street." This was the section of the village where JD and his wife Ruth lived. I noticed that some of the structures had been repainted. One of my favorite paintings from a year earlier, a traditional aboriginal-styled mural of fish, had been repainted, covered over by a mural of humpback whales. I also noticed recyclable goods such as cans, bottles and paper gathered up in large bags or bound up neatly, but stashed to the perimeter of the village, where they gathered dirt and dust and were of little value.

Shakedown Street. July 2011.

JD was in his structure, a standard size for the village. About 16 x 16 feet. One floor. Windows on three sides and a covered porch. I could smell pot wafting through the open shades. Dave knocked and JD answered, opening the door just a crack. Dave told him he had a visitor. JD was unprepared. He closed the door quickly. I could hear the sound of air

freshener being sprayed behind the door. This sound was to become a memorable part of the soundscape of the village. And I have never understood what people try to accomplish when they spray with air freshener. First, it doesn't hide the smell of pot. Second, spraying the stuff simply confirms the suspicion that people are trying to hide their drug use, that they believe it is a violation. That they are being wrong.

JD reopened the door. I had to tell him that I did not care about the smell of pot. "But I wouldn't want ya thinking that's what this place is about. It's important that that rap isn't all we got, and that's all we hear about these days," he added. JD had a marvelous voice. I enjoyed listening to him. It was as if I was in an old western movie. He had a Colorado-Oregon drawl – and he corrected me very quickly for mispronouncing Oregon as "OAR-IH-GONE." It's "OAR-GUN." He also confirmed that he did not know where I would stay. He suggested that perhaps I should stay in the commons since most newcomers do. "If you want to really go through the same crap we all do, you know, if you want to really live like a homeless, hobo kind of person, maybe you should camp out some nights in the commons."

I looked to Dave for some retort, but, left with no help, I simply said the inevitable truth. "JD, I don't think that anything I can do here will let me experience the actual life of a 'homeless person.' That would be a kind of misdirection, you know? A lie. I need to write about what it is like for me, for my transition to living here. The fact is, I know I am going home in a month or so. I really want to write about what it is like for me being here and hopefully be able to relay what the people who live here say about stuff. If I have to stay in the commons, I will, but I have a ton of material and equipment." He followed with an offer to stash my gear in the office or in someone's structure but I wasn't comfortable with that.

"It's totally safe in there," he tried to convince me.

There was a short pause. I had to think about my safety. Ethical considerations in the field are not only about protecting the people we study from physical, emotional or other harms that our work might produce. They apply to us as well. I did not feel safe. Moreover, I knew my cameras and other equipment were not safe, period. I told JD straight up how I felt about that. Samson, feeling the tension, spoke up and suggested that if push came to shove, I could use his shack.

"Can I lock it?" I asked.

He smiled. "Yeah, you can lock it, but it's not like if you fart too loud, you won't blow the walls off it."

We all laughed. A ball was forming in my gut. Did I really want to be here?

"'Fraid it's true, though. We're kinda in a cluster-fuck now that Jon Boy's gone. And with Brad sick and all…" JD looked down, truly embarrassed. There was information in his stance, indignation, sadness, remorse. "I mean, we all sort of knew someone was coming. Brad knew. Jon Boy said something about it. But since his accident, I haven't really talked much to Brad. He's 'out of it' anyways. So we weren't too clear on who or when."

I smiled and, trying to be light, I suggested, "Guess what, it's now."

"Yeah, guess it is," he replied. He did not really offer up any solutions to my housing problem so he agreed to the idea of using Samson's dorm. "And Dave can sort of fill you in on things."

I kept quiet. It all seemed far too casual for my liking. I felt that they didn't appreciate how far I had come. Or how much effort had gone into this trip – or the expense.

While I was stuck in my own perception of the problem, JD was concerned that I might piss off some of the folks on the waiting list if I took up a dorm space out of turn. "Just hope nobody says nothing about your taking up a spot," added JD. Nevertheless, he also recognized that I was there under "special" circumstances. There was a pause in our discussion and it looked like neither of them had an immediate solution. So, I suggested I would stay in a hotel for a few days. I reminded them that at some point I would have to live in a structure, if I was to write about what that kind of housing means to one's sense of dignity. They both laughed hard at this. Dave was pretty animated in his response. He shook and jiggled when he laughed. It started at his shoulders and soon his head was bobbing like a bobble toy on a car dash.

"Holy, you're gonna fit right in here," JD quipped. "Dignity, shit!"

Dave laughed, "Yeah yeah, yup yup."

Dave offered to show me his shack. It was over by the commons area near the center of the village. "Do you want to say hello to Brad?" he asked. I wanted to, but I wanted to know what to expect. "Oh, nothing too extreme. JD's just a little cryptic when he is stoned. Lots of cryptic people around here. It's really a matter of a truck, and a man, and a collision, some pins and blood and bedpans. You'll see, it's nothing." Dave ushered me along and I suggested that I might take some video of the buildings along the way. Unlike subdivisions, every structure in the village was differently constructed. And I was starting to see how some of the structures had changed from last year. So I wanted to shoot a record of them. "Probably best if I ensure the squire is awake and available to entertain," he said once again in that English go-to voice.

STRUCTURES

About ten yards from Shakedown Street was Brad's structure. Dave knocked on the door. He always shuffled and fixed his hat brim, or a belt buckle when he knocked on a door, making himself presentable. And he always made sure his hearing aid was adjusted properly and pointed straight ahead so he could hear if someone was coming to the door or not. I walked off and starting shooting footage of the village. Luckily, there were only a few people outside and so I didn't seem to be putting anyone off. It was only my first day and I was trying to be cautious. They had granted me permission to walk about the whole village, a privilege restricted to members. If you were not a member yet, perhaps a visitor or a resident guest, you had to stay in the common areas along the main drag. With most of the villagers inside their structures, I didn't want anyone feeling I was being intrusive with my camera, so I tried to be subtle.

The village contained a surprising variety of structures and no two were exactly alike. The homes ranged from simple rectangular box frames to an octagon-shaped cottage and even one that looked like a castle, with a turret. Of the 50 structures, 44 of them were residences. There were six non-residential structures in the village. There was the security house at the front of the village. It was only about 10 x 8 x 10 feet high, its walls were cobb, a mixture of straw and plaster, usually 8 to 24 inches thick, common in many places around the world. Cobb stands up well in different climates and is resistant to wind, rain and shifts in the ground, like earthquakes. Cobb walls have one drawback, especially in Dignity. The rats burrow easily into them. Sometimes, I could hear them running inside the walls of the security shack and another structure, and we could see them peeking their heads out of the small holes they chewed. Cobb structures have become popular in the northwest, since they are considered ecologically friendly, and there is a strong eco-friendly movement attached to community development practices. I came to enjoy the ambience of the broken cobb walls in the security shack, and by the end of my stay I would regularly just hang out in the security shack. Cobb is also very temperature friendly, providing some insulation from the cold and the heat. The security shack housed the only communal phone, a landline that was available for anyone's use. The shack had a comfortable porch with a slight A-frame roof, and it was a common place for residents to hang out and check up on village news.

Across from the security shack was the donations structure. It was a larger building, a slanted roof on a large wood frame. Two 3 x 7 foot sliding glass doors with hundreds of

handprints painted all over. Inside, it was jammed to the rafters with soaps and sundries, dry goods and clothing, food and even a few electronic devices. There was not a huge demand for such things because most people did not have electricity in their units. Several of the residents used car batteries to provide electricity for their lights and radios, and others pitched in on shared gas-operated electric generators so that they could watch TV or have lights at night in their structures. The generators were loud and they produced an annoying buzz that exacerbated the relative poverty of the have-nots in the village.

While all the villagers were poor by mainstream standards, the village was not a commune. There was no rule about collective wealth or sharing of resources unless individual residents felt like sharing. So, some people who'd had injury settlements or social security, for example, had more wealth than others who might have only been living off of food stamps and donations. Those with sufficient income bought goods outside of the village and, because they had electrical power to actually use donated electronics, they had claimed them from donations. Those who did not benefit from the generators hated the noise. But, in mid-summer heat, those who did have them – tucked inside their air-conditioned structures with the fans blowing – did not hear the bitching and, after a few days, the constant droning of the machines faded into white noise, almost imperceptible to the rest of us.

Close-up of cobb wall. July 2011.

Reselling donations was supposed to be a revenue stream for the village. Next to the donations hut was the village store, another simple structure filled with the trinkets and sundries you find in a dollar store; these made their way to the village via supporters who wanted the village to make some money. While I was there, because of construction on NE 33rd, only a few people, regular supporters, had come to shop or donate. The village also sells these and other goods on eBay. The eBay system, however, had been the subject of controversy and allegations of malfeasance. A grant that was given to the village to support these endeavors had been "misplaced." Accusations flew. No one was punished or any answers found. The store, like the gardens and the eBay site, had become disorganized and visually embarrassing.

Other non-residential structures include a single propane-heated communal shower room. There are supposed to be two, but only one works. The propane cylinders run out frequently and often people will use the tanks from their barbecues to fuel up the hot water. At such times, before the last bit of hot water runs out, friends and other villagers can ask the owner of the propane to tag up on what hot water remains in the tank. I bought a large cylinder of propane for the village. It lasted a few days and then we had cold water again. Cold water, however, was better than none. At other times, we all shared the one sink that was hooked up to the city water system. Here, we brushed our teeth, washed our clothes and ourselves and cleaned our pots and pans. The villagers argued that this was fresh, clean water from the Mount Hood water table, but I looked at it several times in

The communal sink. July 2011.

black colored cups that provided a good backdrop, and I saw the otherwise imperceptible oily film on its surface. I was convinced, despite water tests by Portland University to the contrary, that compost and jet effluents were in the water system. I washed in it. I washed my

clothes in it. I did my teeth with it. I bought large containers of drinking water, however, to drink.

The sink was next to a sheltered communal cooking station where, once again, propane fuelled the stove. It was not very often used. And it was not a real structure, more of a roofed shed, like the tool shed and other utility stations. While I was there, most people ate packaged foods like chips or canned beans. A few times a week, restaurants, charitable groups and local supporters brought full meals and leftovers to the village. No one went hungry, as on each of these days people furiously filled up a few plates, enough to get through the next 48 hours. One of the groups, The Three Amigos, was a Christian fellowship group that came every Thursday. Rich's wife, Julie, had started working with them. And Mary from the village often went out with them to deliver meals to the hundreds of homeless men and women who were and still are stuck under bridges and in laneways across downtown Portland.

In the same vicinity were the five portalets. The village rented these outhouses and paid for maintenance. The money was supposed to come from personal sponsors' donations, grants from donor agencies, and from sales of goods, but while I was there the payments were in arrears. 56 people shared five outhouses. They filled up rather quickly, and there were always anxious moments when someone had to sit down if the trucks were late. Of the six weeks I was there, the trucks were late six times. To truly understand dignity, I think, requires understanding sanitation and hygiene and the very real limits that extreme poverty places on these basic needs. The city refuses to plumb the village, but insists that they use portalets. They neither fund the portalets nor offer any other possibility of sanitation. I can honestly say that one of the most humbling experiences of my stay there was the necessity, each morning, to start my day inches from someone else's waste.

This experience was just one of those "it just is" experiences that I heard people speaking of on the streets. Near my home in Montreal is a small laneway that connects the Lionel Groulx subway to rue Delisle. This unpatrolled corridor between a church and a retirement home serves as a smoking-up site, a toilet, and sometimes a barracks where I have seen as many as three homeless men sleeping under a staircase. After a while, we passersby come to accept that what goes on in the laneway just is. Really, what could one say? People have to go. One guy at Dignity said, "At least we have outhouses. Can you imagine if we didn't? In winter when it is cold and damp, people shit and pee in buckets in their structures. Them outhouses freeze your ass off, literally. It can get to being pretty damn foul." On several occa-

sions, visitors to the village – a student journalist, a photographer, a couple of tourists – asked me if it was safe to use the portalets. I once replied, "I don't know. How do you feel when people ask to use *your* toilet?" I knew very well what they meant, but after a few weeks of being in the village I had come to understand, the portalets "just is."

The largest structure in the village was the commons building, an 800-square foot or so A-frame with front and back doors, a wheelchair ramp, a microwave and a coffee maker. This was an important location in the village where villagers gathered to prepare simple foods, divvy up donated groceries, and watch movies and television on a big-screen TV. It was the community center. Business and political meetings took place around it or in it. The commons area was always intended to be a meeting place and a lounge for villagers. Additionally, it was there to provide emergency shelter for as many as 11 homeless persons to use in times of extreme heat or cold. It was supposed to be a temporary squat for those with nowhere else to go. The couches had given a sense of comfort to many passersby, even just tourists hitchhiking around who had heard of the village and wanted to check it out. Lately, however, the villagers have frowned upon letting people directly from the street stay overnight. There was some debate in the village about whether or not this contradicted the charter of the village. In a city with overwhelming numbers of people on the streets – one of the greatest percentages in the U.S. – and with a great deal of precipitation, the commons area was large enough and dry enough to help people in dire need. While I was there, it was not used once for that emergency housing purpose. This retraction of help to the poor was creating new divisions in the village.

One night at around 10 p.m., a car with a man and his girlfriend and their two toddlers drove by and they asked to stay the night. They were living in the car. She'd been turning tricks to pay for food, drugs and gas. He had been driving and watching the kids. But the village had to turn them away because the city strictly forbids infants from being on the grounds for any reason, even to visit. There were no available shelters in Portland, and they had already been ushered away from Vancouver, Washington, on the other side of the Columbia River. I remember walking to my structure later and listening to the guys laughing at some film in the commons, and asking myself how it was that people so used to breaking laws, now saw fit to adhere to them? I mean, that night, somewhere on the streets of Portland, two toddlers were sleeping in a parked car with their homeless parents. Some minutes later, one of the residents suggested calling Children's Aid services or the cops, because it "ain't right for them youngsters to be scooted about like that." No, it wasn't right. They

could have had my bunk. But as Bubbles, one of the more outspoken village men, rightly observed, "That's all we need. If the city knew we had children sleeping here, they'd shut us down in a heartbeat." It started to rain that night. I could hear the loud drops pelting the tin and wood roof of my structure. I could hear the pitter-patter on the roof of the car as I closed my eyes.

Because of the wet climate, all the roofs but one, the office, are built on a slant. The office was actually a construction trailer that was donated to the village, but it was in the process of being replaced by a prefabricated unit that was more appealing and roomy. So, there were many types of mostly crude structures of various sizes and shape, using different construction methods. While they all looked different from one another, they shared certain deficits. First, they were not properly heated. A few units had propane heaters that the fire marshal had supplied. There were no candles or burning of other materials allowed in the structures, but smoking was a common hazard. None of the structures had plumbing. They all needed some form of repair, a shingle here, a roof plank or stair there. In many cases, holes in the walls, floors and ceilings had let insects and vermin in.

Dave steered me towards Brad's place. On the way, we stopped at a structure that was not being used. We examined it briefly. It was made of cobb. A good size. Ten x 12 feet. Plenty of room, but full of one of the villager's stashed goods. He was living in a structure with one of the other residents, a young girl. The structure had been so infested by rats and cats that it was uninhabitable. "You could stay here, I guess," Dave said. I was shocked at the suggestion. The really unfortunate truth was no one, not just me, could live in that mess.

Portland has a sometimes harsh climate of high winds and heavy rains and snow, where the winter can be minus 20 Celsius, and the summer 30 plus Celsius. These simple structures are noisy when it rains, cold when it's cold, and hot when it's hot. Some of the interiors have been insulated with FEMA-issued emergency blankets, remnants of Fiberglass Pink, and other materials. They were all raised off the ground on bricks or studs. This allowed for moisture to run under the structures and for the air to mediate between the asphalt tarmac and the floors of the structures. Residents were required to keep their living area clean, but very often the area around structures was as cluttered and messy as the interiors were. About half the structures I visited were cramped with clothing and other donated goods that villagers were hoarding.

BRAD POWELL REVISITED

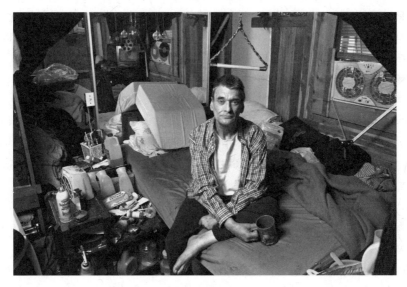

Brad Powell in his structure. July 2011.

We made our way to Brad's place, a 15 x 15 feet bungalow. Brad has a small porch and one door, three good-sized windows and an air conditioner. An old wheelchair sat on the porch. A bedpan full of piss was next to it. The breeze threatened to toss the flimsy cardboard cover off it. "What's up with that?" I asked Dave. "Yup yup…" I asked again, in a louder voice, "No seriously, what's up here?" A ramp had been built into the porch. "I told you. It has to do with a truck, a man and a bunch of pins in his legs." Our footsteps made loud thumping noises on the wooden ramp.

Dave knocked on the door. A muffled voice from inside invited us in. I could smell pot as Dave opened the door. And there was that air freshener again. I felt the cool air blowing hard from the window fan; it carried the putrid chemical air freshener; the pot smell was preferable. The room was a mess. It had become far more cluttered. Brad told me a year ago that the large mirrored doors that separate the structure into two rooms were not there "for anything sexual or anything like that. They just make the room bigger, and less lonely." The first three vertical feet of the entire structure was stacked with stuff. Most of it, he claimed back in 2010, was stuff that he was storing

in his place for other villagers, but he just had never organized it. And the piles seemed to have grown.

Dirty plates and food containers, big stationary ashtrays full of butts and roaches, three full urine bottles – the white plastic kind they use in hospitals – were on a nightstand next to a queen-size bed. A bag of Oreos and some soda in a two-litre bottle nestled in his bed sheets. At least he'd been eating. A small TV played an Oregon news event show. Then there was Brad. He had scabs and scratches on his forehead and his arms. His right leg was strapped into a brace. He couldn't stand up; he had to remain on his back. A few months ago, he stepped off the curb at a bus stop and a truck hit him. He had 19 pins put in his right leg. Two long scars stood out against his pallid skin. I asked him why he was so groggy, and he read off a list of different drugs and painkillers. His medical bills were stacking up. Of the several vehicles involved in the accident, the insurance from one was covering his medications and trauma bills, a tiny portion of close to $200,000 U.S. in total. He lay in bed. Dave and a few other friends brought him food. They wheeled him around from time to time. But he didn't go out much. His eyes were set in deep shadows. He was high on pot and Vicodin all the time. He had lost about 25 pounds. I had seen the look before – too much dope and not eating well. And it was not easy to see him that way.

In the months leading up to this, I had had some frank conversations with Jon Boy. I found out that even when I spoke to Brad a year earlier and he had looked happy and vital, he had been using more methamphetamine than he let on. It was suggested by others later on that Brad was even dealing the stuff when he was in office, but I didn't care to entertain such conjecture. When he had talked to me the year earlier about home and the heart, he had been getting high on meth. But he had been deeply involved in his office as Chair: the village was his life. So it did not really bother me what he did or how much. Not in a general sense. Whatever drug use he did had not been getting in the way of his objectives at that time. That was no longer the case.

Pablo Escobar, a senior manager at a current, professionally managed transitional housing project in Toronto,[21] has suggested we ought to refrain from thinking of substance *abuse* and start thinking of it as substance *use*. If we do that, we can start to address how the use, regardless of the amount or type, gets in the way of a homeless person's goal. If we do

[21] First Step to Home is one of the first professionally managed transitional housing sites for homeless men and is operated by WoodGreen Community Services who have a long history of working with Toronto's homeless. www.tinyurl.com/First-Step-To-Success

not address the goals with the substance use, then it is unlikely that the person's life is really going to improve. Like the mainstream population where prescribed mood modifiers, alcohol and hard drugs, sometimes get in the way of living, homeless persons use, too. But for the poor, obtaining legal scripts often happens only after extreme traumas like Brad's. In other cases, medical treatment in prisons or psychiatric institutions often offers prescription medications that we also take for granted. For the street poor, they have to get injured, arrested or committed to obtain drugs to treat anxiety and serious physical or mental illnesses. It was no wonder that the street poor use solvents, rubbing alcohol, mouthwash, variants of methamphetamine and other cheap fixes to appease the various symptoms of post-traumatic stress disorder that most of them exhibit. It was not that street poor don't have goals, but how do you deal with achieving goals when you can't get a hearing aid, or treatment for anxiety?

The harm reduction approach I hear about most commonly seeks to make using drugs safer for users, and that includes finding a way to keep them housed while addressing their usage. In 2010, when I met Brad, if he was using street drugs he still seemed together and highly motivated. Nevertheless, in 2011, saddled to his bed and wheelchair, popping Vicodin like candies and smoking a freezer-bag load of pot each week, he was a shadow of his former self and admitted to feeling lonely, disconnected and desperate.

Jon Boy's exile had hit him hard too. They had been friends. They were, still. And when Brad got hurt, Jon Boy had been there for him. Brad was the reason that Jon Boy found the village in the first place. In 2009, Jon Boy was sleeping in a friend's backyard when Brad told him about the village. So, when Jon Boy was kicked out of the village in 2011, it was hard on Brad. But Dave and Brad were also friends. They had known each other since Dave's first tenure at the Village in 2007, when Dave had been the security chief. Since Brad's accident, Dave visited several times every day. Dave brought Brad food. And he cleaned out his pee bottles and his shit from the bedpans. Mostly they hung out and smoked a lot of pot. Dave admitted to this because he wanted me to know that one of his goals was to get off the dope and to stop drinking altogether. He told me about his depression. He looked over at Brad, and said to me, "Except looking at *him*, my problems seem pretty insignificant, I imagine."

Brad stared at the television: a weather report. There were five sun balls on the screen. "Looks like it's going to be a hot week, finally," Brad said. Dave uttered a meager "Yup yup" and rolled another butt out of the ashtray. Brad just stared. It was really depressing. Brad

had been a huge reason that I had such high hopes for the village. And then, well, I couldn't stand the mess, the clothes, and the chaos. I couldn't listen to him telling me he was not hooked on meth. He was thin and pallid and no one looked like this on pot and Vicodin alone. Brad was telling me about how a lawyer had taken on his case and he had expected a good payoff from a lawsuit against the driver of one of the vehicles. They expected over half a million dollars. Brad had no plans though. Dave lit the cigarette. He coughed hard and a deep gray, full plume of second-hand smoke shrouded me.

Shards of light bled in through the ratty curtains. I could see the dust and other particles in the air. I felt claustrophobic and suffocated. "Well, I think I will take advantage of this light, and go walk around and take some shots," I offered. Brad nodded. Dave smiled. I moved towards the door. "We gotta get you outside, Brad. With this nice weather. You need it," I said. I opened the door. Dave and Brad turned away from the bright light. The rush of air was clean. My chest was tight. My head was ringing. I was angry. What was happening here? What the fuck was going on? What happened to Dignity?

I walked directly to the parking lot. As I passed the gate, the security person on shift, Melissa, asked me to sign out. I went into the security shack, signed the sheet. She read the name. "Who are you, anyway?" she asked. Laura, a woman resident I met there the previous summer, and who had seen *Subtext*, piped in through the open window, "That's the Canuck, Eric, the filmmaker. He's alright. He tells the story like it is." Then she was gone. Melissa was standoffish, jumpy. She rubbed her nose a lot, and I guessed that her drug of choice was speed or meth.

Outside the security shack, I watched Laura limp away down the tarmac. Apparently she had had surgery on her Achilles' tendon and was healing up. She had disability coverage. She was one of the lucky ones. She limped back to her structure, the one with the turret. Some residents had started to mill about, coming out to enjoy the sunshine. It was close to five o'clock. I was hungry. I told Melissa I would be back the next day. I walked out to my rental car. I walked slowly, but I wanted to run, sprint even, into the car. It was very clean inside. It smelled of new car. I sat there breathing deeply and running my fingers on the clean upholstery. I could feel the warmth of the sun on the side of my face. My appetite that had disappeared with Fred's phlegmy chortles had returned. *Salad. I need a fresh salad*, I thought to myself. I turned the key, reversed carefully, and pulled out of the parking lot. A large jet took off from the airport. It made a wide turn in the sky and I watched the trails heading northeast, perhaps on its way to Toronto.

HOME

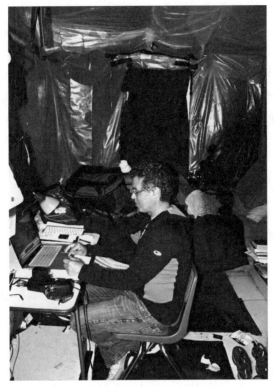

At work in my cleaned up dorm. July 2011.

For five days, I stayed in hotels near the village. They were all Name Brand joints, the kind where you meet tourists in transit – travelers looking for reasonable accommodations near the airport. I had several conversations with people who worked in the hotels because they found my cameras and my comings and goings curious. None of them knew about Dignity Village. It was such a bizarre concept that they did not really have opinions about it either way. The bartender at one place where I had eaten felt particularly that it seemed reasonable to him. He too had moved to Portland about 19 years ago. He told me, "In a city that's as tattooed and as artsy-fartsy as this, I can see that happening here. Bunch of homeless dudes putting up tents and calling it home." He suggested he would "love" to see it, so I offered to take him there. However, something came up, of course, and he never went. I did

meet two Swedish tourists who had recently been to India. They were shocked to think that there could be shantytowns in the U.S. We talked briefly about their experiences in New Delhi, where millions of poor migrants from rural areas lived in cardboard structures and worse. When I described Dignity Village to them, they remarked that it sounded more like a vacation town or a trailer park. They even suggested that I reconsider the use of the word "shanty." They regretted not having time to come and see it, but they were sure that I did not really know what a shantytown was. Their comments reinforced my own feeling that, as nice as my accommodations were, I was feeling that I was missing out on life at the village.

Back at the village, Samson had agreed to let me use his shack. Each of those five days, I went to the village early in the morning and stayed late into the evening to meet people and be "present." I did some interviews and drove around Portland, getting to know the lay of the land with Samson and a couple of other villagers. I hung with Dave most of the time. He was an intelligent man. Nice to listen to, instead of the cussing and the bickering I was becoming accustomed to hearing. I suppose that since the village feels like "one big happy family" to most of the villagers, they don't feel the need to hide their arguments. It was probably hard to do so on one acre, I imagined. Samson could quote Descartes and Einstein, chapters of several religious texts and even Dan Rather. Well spoken. He explained to me, however, that he had terrible A.D.D. and was "awfully moody." He also was a villager "and not a scholar." Routine and structure seemed like good ideas for a villager, but they became difficult to maintain after suffering homelessness. Villagers construct time very differently from those of us with jobs and careers.

Dave moved very slowly. It took six days for him to clear out a room not much bigger than a walk-in closet. I did not push him, except on the sixth day, when I had to tell him that I had no more money for hotels. So, he let me help him pack and move his stuff. "Actually I just need to be pushed," he said. I asked him if he minded going to crash on the couches in the commons area and he said, "Dude, look at me. I've slept worse, believe me. Actually, I think what you are doing is important for the village, and it's not like anyone else is going to step up. No, my fine Canadian friend, if you are willing to sleep in that shit, literally, it's my pleasure."

Dave had retained some remarkable items. There were various native art pieces hanging from a nail hammered into a strut, a geologist's rock hammer and a canteen. For a while he had been an amateur geologist. Something else we shared, an interest in rocks and minerals. His Facebook page has him posed over a giant piece of Crysacola somewhere in the

desert. (It had always been something I tried to note; those things we managed to carry through our homelessness and stints at rehab. For me, one of the few things I had managed to hold on to was a small box of World War One medals that had belonged to my grandfather, Alec. Nothing else remained by the time, almost 20 years, from start to finish, when I'd made it back from the fringes. There is something very important to be learned from the material possessions we manage to cling to despite all our and the surrounding madness.) In Dave's place, neatly rounded up in a small pile on the table, I found a stash of what looked to my hurried glance like common pebbles. They would have easily fit into a pocket or a baggie. I was about to sweep them away when Dave interrupted me. "Don't, don't!" he cried out. He scrambled for a couple of bits before they fell through a seam in the floor panels. "Rock hounding is something I intend to return to someday," he told me, as he picked up the small bits; a chip of Carnelian, a bit of Sodalite, some Basalt, and some petrified wood. He put them on the porch rail. A couple of them fell. He looked at them, shrugged his shoulders as if their falling was some kind of fated action, and continued to show me the interior of the place.

He had two wooden cabinets fastened to the plywood wall and a stud with nails and some hooks from which he hung clothing and belts and so on. The cabinets were stocked with soups, beans, and all kinds of donated foodstuffs. He had two milk crates nailed to the wall: they held his toiletries, writing materials, notes, and magazines. He had a small bench that also acted as a bookshelf and on it were various authors and works of note – Lao Tse, William James, the King James Version of the Holy Bible, even the *Cambridge Companion to Michel Foucault*. I held that in my hand like it was a piece of evidence – exhibit "A." I looked at him quizzically and he said, "Come on, you must have read that." I answered, "Yeah, I have but I mean, why are you reading this?" He took the book from me and flipped through it. "Don't act so surprised, guvnor," he replied. "Bloke's got to do something to keep his brain from melting in this place. I am quite the interesting type, really."

The shack was rough though, and dirty. Truly, what the tourists from Sweden had suggested was true. This was not a cardboard shack, or a lean-to made out of textile remnants surrounded by a hundred thousand other structures, with raw sewage running by in exposed gutters, alongside other structures next to a rail line. No, the slums of New Delhi and Lima are worse than this. They are slums simply by their intense population density and abject poverty. Dignity Village was not a slum. Not by *those* standards. Not by a mile. For me, it was more of the image of a shantytown than the slums. The population density alone

distinguished them. In Dignity, there were 60 people on an acre of land, where in most of the slums that Mike Davis (2006) talks about in *Planet of Slums* as many as 500 or more might occupy the same area and in far cruder, less serviced shelters than Dignity. My feeling is that these other places ought to be called slums, not shantytowns, since the shanty arguably has its origins not in abject poverty but in modest, albeit crude, frontier settings. Dave's structure, in fact, reminded me of a simply constructed fishing camp much like one I had stayed in on the Gander River in Newfoundland. Like Dave's, that structure had been put together with 2 x 4s and a collage of wood board. As insulation, the builders of Dave's structure had jammed FEMA emergency blankets into the walls. The blankets were made from compressed and recycled fabrics and sprayed with fire retardant. If the dust particles produced by this foul matter didn't make you sick, then prolonged exposure to the chemicals embedded in the materials to render them "safe" would.

Old, exposed fiberglass insulation was stuffed into the base of the walls. The animals loved it and the cats had sprayed all over it. The smell was so foul that I preferred his cigarette smoke. There was a single-sized, deeply soiled mattress with dripping, dirty watermarks in brown and yellow. A stain like dried blood was soaked in just where you would rest your head. No pillow. And in the damp air, the mattress turned sponge-like, and it soaked in the odour of cat piss. Dave had slept on this mattress with years of other people's filth without a mattress cover. Surprisingly, there were no nasty bugs except for a few ants and swarms of flies. "It's just impossible to keep a place clean here," he said. "What with the city composting 20 feet from here and all the dirt around here. And it's not like we can shower everyday – well, we could shower everyday – but we are basically asked to take a hit for the village, ya know? There's only one shower and it's gas heated, so we aren't supposed to shower every day. Hell, sometimes we shower like once or twice a week. Don't worry, you'll get used to the smell and dirt and filth," he laughed. I moved a few more books and his drawing kit – composed of pens, pencils and various pastel chips – fell on the floor in a heap. Some pages fell out. Sketches of fantasy worlds, odd sexual figuratives set on psychedelic landscapes. His line was mature and steady.

When the room was finally emptied of his gatherings, I had a small dinette table and a chair, a filthy mattress on a fixed bed frame like a big shelf about 18 inches off the ground, a set of cupboards, and one small window that opened about six inches to let in the air. There were holes in the floorboards big enough for a rat to get in, but the cats that pissed and fucked under my shack kept that from happening. I think. The floorboards had layers

of grime and tar on them. Small finishing nails stuck up through them. Every so often, I got a good piercing. Kept me on my toes. The regular-sized door locked from the outside with a padlock. But at night, I would put the lock on the loop ring because I was afraid of being locked in. I can't explain that. With people joshing me about all my gear and electronics, theft was not a worry, whereas getting beaten up was, or fire. These shacks were like tinder-boxes.

At Toronto's Tent City, a firebug had set intentional fires to structures and two people had been severely burned. Also, one man had died in an accidental fire. This was a real fear I had. Fire was one of the main concerns that cities and communities had with these tent cities and shantytowns. Often, fire violations were cited in decisions to move or shut down tent cities. Municipal by-laws can be seen in this light as tools for controlling the possibility of permanent tent cities. Cities restrict the plumbing, electrical and other service these camps enjoy, cast them off to the margins, and then expect them to comply with codes that are hard to manage. As several of the housing activists I met reminded me, fire codes, like rules about drug abuse, go largely unenforced in homes and cottages of the rich where compliance is assumed, while poor communities are intercepted and sanctioned on this basis every day.

In Dignity Village, the fire marshal's inspection was a big event. Failure to meet up with the minimum codes could shut the place down. During my visits in 2010, they were cleaning up for the inspection. In 2011, as Dave and I worked on his shack, another Dave, Dave M., was painting the fire lines along the perimeter lanes of the houses, part of the city fire code. Pursuant to some of the codes, all the structures are a minimum of five feet apart. The main lane that crisscrosses the village is 20 feet wide. They had to paint the lines every year, because the heat of the tarmac and the dust from the composting obliterated them. In my unit, a small propane heater donated by the fire department had been used during the winter. To my knowledge, none of the units had ever burnt down, but at night, when I closed my eyes, I saw the piles of charred lumber scattered all over Tent City back in 2002.

And there was also the time in the Buena Vista rehab in Merrickville, back in the mid-'90s, where I had heard a most dramatic story of fire and street life. One of the other fellows at the rehab had been on a tear back in the '80s in Halifax, Nova Scotia. Like many of the street people I have known, lost and sad, he had been looking for somewhere warm to sleep. He had been drinking cheap liquor and had crawled into a dumpster for shelter from the snow. He'd lit a small fire to keep himself warm, a small fire *inside* the dumpster. When

he awoke, his sleeves were on fire and he could hear sirens. I had seen the burns once while we were together in rehab. That was enough.

On the first or second night in Dignity, I remember waking from my sleep and storming outside to my porch. I was gasping for air. The next day, people to whom I relayed this experience told me it was probably the compost dust, the asthma, or the dampness. I had thought it might have been this latent fear of fire. Part of me recognized what happened as a panic attack. Whatever its actual cause, since that night I have had difficulty in small places. I have them, even back here in Montreal. There were times when my dorm just seemed too small, and I had to get out. While other street people might have wished to get into a dorm like this, I struggled with the sense of confinement, and I understood why some of the residents rather than sleeping in a dorm, preferred to sleep in the commons, were anxious to get a real structure, or sleep in the nearby forested hills. The dorms reminded them of cells.

As I mentioned earlier, the dorms were about 16 x 16 feet and split down the middle. So, the room I slept in was about 8 x 8 feet and adjacent to another man's space. A 3/8-inch wallboard was all that separated us and he smoked a lot of pot. At night, the smell of his pot would fill my room and I probably got high. It worried me. I have been in recovery for over 15 years or so, and I wondered what breathing in that smoke would do to me. My neighbor's name was Bobby Jo. He came by to check me out while I was being moved in. He was suspicious of me. Within hours of my moving in, there was already a rumor going about that I must be a cop or a narc or working for the city. His story was, by his own volition, quite short and to the point.

BOBBY JO, THE ROOMMATE

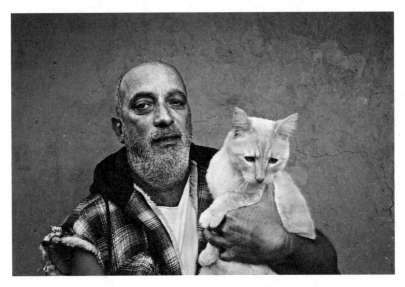

Bobby Jo and Nugget. July 2011.

Several years ago, a broken-hearted Florida man, in a rage, was tearing his home apart. The neighbors alerted the police to the ruckus. Eventually, seven cops lay wounded on the man's lawn, victims of self-defensive assault. Bobby Jo had been a commercial fisherman, and he came home one night to find out that his wife had cheated on him and, having anger issues, he'd decided to take it out on his own property. This was Bobby Jo's process. "You know if anyone was there, I was gonna hurt 'em. I didn't want to hurt no one. Damn! I told the cops to just leave me alone. It was my home, my property and I just needed to work it out of my system." Bobby Jo took a dozen or so Taser hits that night before his menacing 240 pounds were brought down. He did six years. When he got out, he left his life as a commercial fisherman behind and, like so many of the folks scattered along the margins, he worked odd jobs and donated plasma for 60 bucks a week to survive an unpredictable navigation from town to town. Finally, he had ended up in Portland. Bobby Jo was in his second go at life in Dignity Village. He usually wore his cycling gloves and tooted around Portland on his mammoth downhill mountain bike. He used to tell me that, being Canadian, I spoke with a funny accent, and, "Y'all say 'aboot'

and 'eh.'" I would respond in his heavy southern drawl, "Dammmmmn," just to bug him.

Occasionally, his distrust of strangers overtook him and several times he'd taken me aside with a grim look on his face and asked, "You sure you ain't no cop? I mean, damn, why would anyone wanna be stuck here with us, in this place?" But Bobby Jo and I ended up being friends. He took one of my cameras away with him and went to all his favorite spots from his journey on the streets. He filmed the hedges next to the golf course where he'd slept, the drainage ditch next to the slough, and other places. His lifestyle confirmed for me the definition of the streets as something more than hostels or shelters, temporary housing, jail or lanes and bridges. The streets are not an idealized space defined by any specific location. "Hell, the only reason people think we live in shelters or missions is because that's where they talk to us. We only get donations, or food, or clothes, if we go to those places. Sometimes we gotta sign our goddamn name. That's how they keep track of us. Imagine. To get food! I ain't never slept in a shelter. I may have gone to a mission or two to get food, but hell no. I pick where I live." Despite his suspicions, he was frank. And despite his large size and brute strength, he was easily intimidated. He often became angry by the bullshit and bickering, but had learned long ago, from the guards and other prisoners, to walk away and hit something inanimate. He couldn't do that in the village. It was against the rules. So he'd often been seen stomping out of the village. "Damn, damnnnnnn," he'd say, as he went out to the curb to punch something.

I did tell Bobby Jo about my fear regarding his pot smoking. And he kindly tried to not smoke when I was in the dorm. When that became difficult to do, he'd spent a good two hours taping up the seams, cracks and holes in our wall. I never worried about Bobby Jo hurting me, and after he and I had established a rapport, I stopped worrying about getting beaten up or burnt out by anyone else. He'd become somewhat protective of me. Bobby Jo loved the village. On one occasion, a guest had become unruly and had hit someone, and Bobby Jo stepped over, picked the fellow up, and carried him out to the curb, like a golden retriever bringing a duck to its master. Undamaged. No harm done.

Except that someone who did not like Bobby Jo threatened to write him up for acting violently. It was a weak charge, but it was enough to have scared Bobby Jo. The village was all he had, and he had tried hard to participate. He had even been acting as Master of Arms at the village meetings, and was considering the possibility, for the first time in his life, that he might be worthy of taking on a council job. No community had ever made him feel as

deserving or as competent as the village had. No, sir. No one was going to mess with me, his dorm mate. "Wouldn't look too good to the village, damn."

Bobby Jo had done up his little place. He had a cooler, a small credenza and a neat and clean bed. There was a small TV and a battery source. Even with this much stuff, sitting in his half of the dorm was comfortable. And he had a cat, Nugget. His cat was his friend. Bobby Jo would spend hours outside the village searching for the cat if he couldn't be found. I only ever saw Bobby Jo worried beyond despair twice. One was a few nights before I left, after he had an argument. One was the night I'd come home late from a "night off," and Nugget hadn't come home. I had tried to calm Bobby Jo down. We'd driven around a bit to see if the cat was nearby. No luck. At the village, someone said they had seen Nugget, and Bobby Jo had become even more anxious. I'd offered to let him into my shack to watch a DVD on my computer or something. "I have a damn TV," he scolded. When we got back to the structure, Nugget was toying with a rat under my stairs. Bobby Jo was rapturous.

ADAPTATION

The village agreed to let me pay for a direct line of electricity to power my laptop and to charge my cameras. Late at night, after a long day of filming, I would have to download footage onto my hard drives and write my field notes. They also allowed me to hook up to the Wi-Fi so I could have access to my school and other sites that I needed. These private-use technological connections were privileges that very few villagers had. I worried that such privilege might cause a division amongst some of the villagers, but they were generally good with it, especially when I gave the village a couple of hundred dollars in donations and agreed to pay far more then the actual value of the services.

I had brought my sleeping bag with me, but there was no way I was lying down on that mattress. I have slept outside before. I have slept on camping trips and "back in those dark days" on a couple of rough all-nighters in areas not meant for sleeping – a patio and a lawn. I have seen people passed out in their own vomit on sidewalks, and watched homeless men tuck themselves into deep piles of cardboard next to dumpsters at night. I thought, however, that *that* mattress was the foulest sight I had seen. I went to a nearby Target department store and bought sheets, a tough mattress cover, pillows and pillowcases, air freshener, and a big roll of heavy clear plastic to seal off the insulation. I bought several brands of pet cleansers, but the smell of piss was there all summer, especially on those 30-degree Celsius days.

Once I'd got the place taped off and sealed, however, the dust and fibres were still invasive. I could taste them and feel them in my nose and throat. Within days, I had severe allergy symptoms and had to begin rinsing my sinuses with salt water at least three times a day. I did this behind my structure. Someone saw me doing it, and the rumor got out that I was doing cocaine. I began taking Tylenol Allergy and Aleve. (When I retuned to Montreal in August, my doctor informed me that my liver functions were all screwy from these medications.) Those first days were so intensely difficult, especially the damp days when the city workers turned the compost in the neighboring facility; I would lie in my bed with a pounding headache and I could hear various villagers screaming for their inhalers. I didn't care that my room was small. At those times, I wanted it to close in and consume me totally. I snapped a photo of myself struggling with the infection one afternoon. My head had swelled up to the point where my eyes had closed. This happened several times in the weeks I was there.

However, it wasn't all bad. My days were so exhausting that I fell asleep easily. Surprisingly so. But every night something would happen, some sound I didn't know, or a door would slam, or a person would run by in the pitch blackness and I would imagine all manner of things. The nighttime soundscape became so intense over the first couple of weeks that I started recording the sounds of the village at night on a digital recorder. It was quite amazing to listen without seeing, to hear what was going on. After a while, I was able to determine when someone was moving at night, and sometimes who it was, even from behind my closed door, because I recognized the swing of a door, the weight of a footstep, the tap on a glass window, or the stumble, the cry.

At times when disability cheques arrived, or food stamps, the nighttime activity quickened. My shack next to the commons area was in a good location to hear most everything, and there was a lot of whispering, and a lot of "visiting" on those nights when the cheques came in and so did a batch of meth. I never went out late at night unless it was necessary to use the outhouse or on those nights when I simply had to get out and go downtown. Other than those few nights, I did not want whoever was scurrying about to see me watching them. That kind of observing could only be interpreted as surveillance in the strictest sense.

The author in bed, infected. July 2011.
(Photo Eric Weissman)

Even though villagers underplayed the amount of drug use that went on in the village, much as the harm reduction proponents in other cities did, the fact was that villagers had identified methamphetamine as a major contributor to the grief in the village. I said earlier that I didn't film drug use, and I certainly didn't want the work to be about drugs. Not in Dignity Village. So writing about it, without showing it, seemed like a contradiction. But it was not. What was the difference? The difference lay in choosing to show how people

manage to live and grow, *despite* the presence of drug use. In some cases, people talked about drugs because drugs, like food and sex, were part of the lives of people, everywhere. So, rather than perpetuate the myth of a community defined by drug use, I chose to talk about the use of drugs in the specific context of the people's own stories.

In truth, however, most of the village was in denial about their drug use because they weren't too sure how outsiders would make sense of that information. The press loved to talk about the drugs. Their enemies, all of them opponents of "wild untamed" villages like this one, loved to talk about drugs. It was as if drug use only mattered amongst the homeless. While a handful of the villagers did and do heroin, and most smoked pot or drank, it was the meth and the "tweakers" (meth users) that got and get the most attention from within and outside the village. Tweakers have a lot of speedy energy to burn up. They talk super fast. They fidget. They steal stuff. They smoke too much. Their fingers are usually brown and so are their teeth. They scurry about at night. I recall sitting up listening to their footsteps some nights as they dashed about the village trying to find hits to ease the jonesing, that sensation of coming down off the high mixed with dreadful cravings. I remember being a cokehead about 20 years ago. Back then meth was non-existent in my circles. But I recall how crazy and fast we were. I have seen people do things on cocaine that I find hard to believe, myself included. However, cocaine was and is expensive. Meth is not.

Most of the homeless people I talked to in Oregon told me that meth was rapidly replacing cocaine as the number one drug amongst the very poor. In Toronto, I recently asked some of the people from Tent City what they knew about meth. They told me that they all knew what it was, but no one in their groups did it. They get together much like the Dignity Villagers do, the last week of each month for Mardi Gras – on those days when their welfare cheques arrive – and they'd pitch in on an eight-ball (3.5 grams) of crack.

Nevertheless, in Dignity Village, though you could probably have dug up all kinds of drugs, meth was spreading. Meth with its instant rush and low price tag provided instant gratification and a sense of elation. One of the residents told me that his use of meth was cross-addicted with sexual "issues." When he was paid from his part-time labor job each month or so, he purchased a whack of meth and stayed inside his structure for three or four days exploring that cross-addiction. We did not go into details. Once again, the question was not what substances were used, or by whom, but more importantly, how use itself had gotten in the way of clearly defined goals of certain individuals. It seemed pretty clear to me

that the tweakers and the junkies had little chance of improving their situation, economic, social or medical, while still hooked on substances.

In the few days that I had been there, even though I had got to know people, I did not hear much about goals, but I learned a lot about broken dreams. If the village was such a negative place, I wondered how it could keep going. This was not an attempt to be dramatic. My field notes were filled with negativity. Especially for the first two weeks. I find it hard to read them even now. I was angry and tired for the first two weeks. It seemed to me that the villagers were like animals or children, spoiled children, constantly complaining and being mean to each other. I was afraid to trust one informant over another. I saw how people were watching me when I talked to others, and I heard things about me – rumors that were going around. Samson was the only person who had not asked me for a ride or treated me suspiciously – his, the only voice that had given equal weight to my own. He was also the only one who stepped up and offered me a place to stay. That spoke to his good character. David Samson took on the role of gatekeeper for the rest of my stay.

THE BERM

Jon Boy Hawkes in his van. July 2011.

The berm was an adjacent grassy slope that ran parallel to the village. This was one of Dave's favorite places. It was officially city property and not the village's, so often villagers went out there to drink a beer or to meet with friends who were not allowed in the village. The beer drinking was subtle. No one wanted to lose the privilege of the place or bring undue heat down on the village. The fact that they went out there to socialize and lightly party was not to defy the rules as much as it was that they were largely immobile and couldn't get around much. The city bus stop was only a few metres away, but at three dollars a round trip, it was too pricey for most of the villagers. The berm was one of the few places outside of the village where they could go and at least have the experience of getting out. A few of the residents told me that it was nice to get out and have a beer, even if one of the rules of the village was no alcohol within a mile of the village. "We don't flaunt it, but fuck, man, sometimes it just feels good to get off the pavement and onto the grass." From the berm, it was hard to see the structures or the villagers on the other side. When the village site was still used as a compost facility, the berm helped to hide the piles of shit and gravel from traffic and passersby. Except for the whining of the generators, one can almost

feel that they are away from the village when seated in the shade of the trees and grass out on the berm.

From the sidewalk to the curb along the berm, it was strictly city property. Even though vehicles were not supposed to be parked there overnight, some villagers and their friends did so. This overnight parking was nearly impossible downtown near the shelters and hostels. The police knew that there were homeless people camping in their vehicles out by the berm. The cops did not hassle them much. On occasion, cops drove by and noted the license plates. The odd black Suburban would drive by every once in a while; there had been speculation that these were Homeland Security vehicles.

Every once in a while, the cops ordered someone to leave, or gave a ticket, or worse, impounded a vehicle without stickers and plates. The neighborhood south of the village, several square miles of factories and golf courses, was dotted with the odd vehicle here and there with people living inside. They moved around so as not to be ticketed, but with the village and the Oregon Foodbank within blocks of each other, this was an important site for some homeless vagabonds with wheels. For such homeless travelers, the village offered, at least in principle, a shower, a meal when there was food around, toilets, and access to donations. To this degree, the village continued to meet its original promise to help other struggling persons. Because it was a nexus of sorts for homeless folks, it also became a zone of surveillance.

The village had one of the highest concentrations of homeless people in Oregon; 60 homeless people on one acre of land, at full capacity, and 56 while I was there. Because many of them had criminal records and some were currently under suspicion, the village acted as Tent City did, as a zone of perpetual surveillance for enforcement agencies. The cops were permitted to enter the property. It had been part of the agreement with the city. However, they did not abuse that privilege. At least while I was there, they hadn't shown up. More often than not, uniformed professionals had entered the village in the form of paramedics and fire crews on 911 calls when someone had overdosed or had a seizure or another injury. Fire, medical and police knew how to get there. Since the village was literally adjacent to the Columbia River Correctional Institution, the authorities knew where it was, even if most city dwellers did not. Regardless of the proximity to the prison, however, and despite the police drive-bys, many villagers hung out in the open, smoked pot and drank beers in brown bags, and shot the shit. Other than the threat of surveillance, their use of substances was the same as I had seen all over downtown Portland.

In terms of the social dynamics of the village, the berm served as a sort of "time out" space where people could talk shit about other people without getting in their faces. Not that arguments didn't flow out into the berm, but the berm was kind of a no man's land where strict enforcement of the rules was difficult to impose. The discussions I heard on the berm were never heard in the village for two important reasons. First, they were often what might be called treasonous or seditious — one of the rules was to never talk badly about the village, as a way of disrupting things — and second, they often included people who were not allowed in the village, like Jon Boy.

I had been wondering about Jon Boy. I had heard rumors that he had come by and asked about me one day while I was out. But I hadn't seen him. Dave told me he wasn't looking good. "But you know Jon Boy. Jon Boy's Jon Boy!"

Dave and I went out one morning, as we did most mornings after the coffee was made, to see what was going on. A rusted, worn-out, navy-blue Astro van came by and slowed down. It was like a scene from a gang movie where the car slows down to suggest a threat.

"There he is now," Dave said.

A member of the council, who I will call Carlie, stomped onto the driveway and shouted at the driver, "You better not be thinking of getting in here, [then under her breath] ya motherfucker." The van honked and drove off. She turned to Dave and said sternly, "He better not think he's getting in here."

Another person I hadn't met before on the berm muttered something under his breath. I didn't hear it, but it was clear to me that there was tension associated with this van being here. The man got up and walked down the road toward the bend in the highway across from the Air National Guard. Dave stood waiting.

"Who was that guy?" I asked. I had to repeat it.

"Oh, that's Jay. I think you can see why Carlie frightens some people. So he's just going home."

I looked down the road and saw a modest house and a warehouse and then nothing. "Where does he live?" I asked.

"Down there. Under the highway, in a hole," Dave offered.

A young woman who lived a few doors from my structure walked out to the berm with a plate of scrambled eggs. She looked around nervously. I through she was looking for someone in particular. "Fuck!" she blurted. Then she turned around and stamped back into the

village. I looked at Dave. There was humor in this moment, I thought. He laughed, too. "Ah yes, the patients are loose early this morning," he said.

A few moments later, I heard the screech of tires and the van returned. I had my small HD cam in tow (always). Dave told me that I would finally get to talk to Jon Boy in person. And as the van pulled over about 50 yards from the driveway, Dave started walking, so I followed. The sun was bright that morning. I could see into the open back of the van through the windshield. The first things I saw were his American flags draped over the rear windows and a small flag rigged to his broken antenna.

Jon Boy threw open a rusty, squeaky driver's side door. It lurched on the hinge as if it wanted to fall off. Jon Boy swaggered out of the van and made his way towards me. By then, villagers – Dean, Rocky and a couple of others – had showed up at the berm to have their coffees and smokes and to greet Jon Boy. He looked pretty much the same. His hair was ragged and his front teeth broken. He sported his trademark leather vest and he looked like he hadn't been sleeping much. His skin was sallow and his eyes were dark-rimmed like most of the meth addicts I knew. His scabs and skin blemishes, though, were much more widely spread, and it was clear that he hadn't been doing well.

So, I asked him, "How are you?" as he reached for a hug. A hug. I have to tell you that as much as I liked the man, the soul that was Jon Boy, his body in its state of decay at that time worried me. I didn't want to touch him, but resisting the embrace of a friend would have been disastrous, not only to my working with him, but with the others. So, we hugged it out man-style. And he answered me. "Well, you know, I'm doing great, great! You know, I'm very sorry about the mix-up and all, but well. You know it ain't easy sometimes and I was wrong..." – he had the beginning of tears in his eyes, but he cleared his throat and continued – "...but I hope you are getting on okay. I heard you was coming soon."

I explained to Jon Boy that I was happy to see him, but I had no idea what he could see in my eyes. I spend so much time looking at others that I rarely know what *I* look like to them. But with Jon Boy, I had to be giving off that I was worried about how he looked and how he was living. He opened up the side door of his van and I was astonished at how filthy and cramped the interior of it was. I saw a sleeping bag, but I couldn't figure out how he could sleep in that mess, so I asked him where he was sleeping. "In my van." He motioned me to look inside and I gestured to my camera. He nodded. The interior of the van contained all his belongings, including a propane stove, bundles of old and dirty clothing and other sundries. Paper plates with food on them and all kinds of other confusion I chose not

to note, since it was hard to look at. Squalor. And on a small plate, I saw some burned tin-foil and a spoon, and I assumed he was smoking or shooting meth, but someone told me later that he was also doing heroin. Did it matter?

A little while later, I drove Jon Boy in my rental car, a Ford Fusion I had exchanged for the Subaru, so I could buy him some gas. We talked about the incident while I drove. The camera was mounted on my dash. He did hit the guy. He did think that TC was a deadbeat and a rat, and he would, if the situation presented itself again, do it over. "I miss the village, but I don't need it anymore," he said. "I have to make some moves, and it was time. It wasn't right me being a leader, the Chair, and all that, and hitting a person, but there was two of us and he wasn't any angel, and he should be out too! That's what's gonna kill this place, anyway, all those little drug gangs and stuff. There's no balance. There was a fight. How can one person only be accused, be responsible for a fight? Violence of any kind is not tolerated! Fact is they wanted me out, so they could get their own people in council and I fucking blew it. Fuck them. Fuck this. And it's too bad because this place, the village, is really important." As I slowed to turn into the gas station, he looked at me and said, "I just hope I didn't fuck up your faith in the place."

Why would he worry about *my* opinion? I had enjoyed meeting him the year before and interviewing him, but who was I? For the first time since I'd got there, I realized that the villagers had distinct expectations from me. I pulled up in the queue to the pump. "Well, you're here," he said, "and the first thing you find out is I ain't here no more. And no one told you until you get here. That chokes me up. That ain't right. And it is really my fault for fucking up in the first place, I guess." I tried to calm him. I told him it was all okay. "Everything happens for a reason" and other common phrases. "It all makes sense ten years later."

After a moment of silence, I told him what was really bothering me. "I just look at you and it worries me. You can't tell me you aren't doing meth." He said nothing for a moment. It was hot, sitting in the queue for the pump, and the smell of gasoline overtook us in the van as the guy on his motorcycle in front of the line overfilled his tank. Jon Boy took it in with a deep haul and laughed. I get that, I get that he liked the smell. (It is interesting how many of us addicts, in recovery or not, enjoy that biting, gaseous aroma. And skunk too.) "To tell ya the truth…" he said, "…I prefer smack, but I don't do much of anything these days." The motorcyclist pulled away and I pulled up to the pump. I put the car in park. He asked, "Can you spot me ten bucks for gas?" Jon Boy filled up the small gas tank he had brought and I also bought a couple of sodas and ice cream bars for us.

On the drive back, we didn't say much. He asked me how long I was staying and he suggested we get out and see Portland together. It was a real shame to see Jon Boy like that. Even though he had been using substances when he'd lived at the village and when we had first met, at least he had been maintaining his structure. He had some order in his life, and was getting involved. At least he had been until the beef broke out. But to look at him now, on video and in Nigel's photo, in the van that carries all his belongings in one unsanitary heap, I have to wonder where he is right now, a year later. Is he even alive? I heard rumors over the following months, and even very recently, that he wasn't doing too well. When had he done well, I wondered. If one can imagine a vehicle as broken-down as it can be without being immobile, well, that's how I felt about Jon Boy. He was running, and running, and running, and he was going to keep running until he burnt out.

We drove past a stretch of riverside mansions, and one of the most exclusive golf courses in Portland. The villagers used to collect stray golf balls and sell them, but the golf course management had put an end to that when villagers started lingering around the course too often. With the car windows open, I could hear racing car engines off in the distance. He told me that they were coming from a track where he and some of the other villagers worked once a week, doing security and other odd jobs for cash. He didn't seem jumpy or edgy, he was smiling, and I wanted to believe that this was the real image of Jon Boy, driving down the open road in the sun, with the wind blowing in the window, arm crooked on the door, enjoying a haul off his cigarette. Was it possible, I asked myself, to be content with this lifestyle? So I had to ask him, based on the video shot back in 2010. "Jon Boy. Last year you said, and these are pretty close to your words, you said, 'This is America and I can be anyone I want to be.'"

"Yeah, I remember that, in my structure. I 'd like to see that sometime."

I made the right turn onto Sunderland Ave, and I asked him if he didn't mind that I stop for a moment. We pulled over about 150 yards from the berm. A beat-up camper van we had not seen before was parked there. A young Afro-American man was cleaning stuff out of the back of the van.

"He'll learn pretty quick," Jon Boy said.

"What do you mean? Do you think the cops will roust him?" I asked.

Jon Boy looked at me like I was the greatest fool he had ever met. He propped his chin up and cocked his head back. "The cops? Not the cops. Eric. How many black guys have you seen in there?" he asked, pointing directly at the village.

"Well, I…" I stumbled. I hadn't seen any, but the village did have a few native folks and a couple of gay people so I … "What are you saying, the village is discriminating?" I asked.

"Naw, I ain't saying nothing. Nobody knows what to do in there…"

We watched the young man as he tried to unload a big box of old clothing. A cat leapt out of the van and he hustled after it, trapping it in the thick hedge next to the moving company yard. He picked up the cat and kissed it. Then scolded it. Returning to the van, he opened the side door and we could make out a couple of other cats.

Jon Boy smirked at the man. "Well, he might get in. He's perfect for that place. Ya never know. They're supposed to let anyone who needs it get in if there is room." Jon Boy kept his eyes on the man. I had to get out of the car. The aroma inside was beginning to sour from the gas, from his clothes. The sun was heating it up.

I asked, "Well, can you?"

He turned to me. "Can I what? I forget what we were talking about."

I tethered the conversation. "You still feel that way, you are free to do anything you—?"

He turned away from the man, who was, by then, fiddling with his headlight. He looked me deeply in the eyes. "This is America, Eric, and *anyone* can be anything they wanna be. I am doing what I want to do, for right now. I'm free."

SHANNON

Shannon at the greenhouse. July 2011.

There are people I meet in the field who seem to be outliers of sorts. An outlier in the sense of someone who orbits an ethnographic enterprise. They don't offer themselves up to it directly; neither do they reject it outright. They say 'hello' jokingly, turning their head away so that I know they don't want to be filmed. But they don't mind being heard. This can mean many things. One is that they are cautious. Another is, and this is almost always the case, a part of them wants to say something for the record, but hasn't figured out how or what to say and so is hesitant about being filmed. Shannon was one of these. For the first several days I lived in the village she went about her business and I went about mine, and she would walk by me as I interviewed people, always laughing as she passed, laughing just enough to be heard. She was an interesting study; petite, more stylish than I was used to in places like this, but too thin, skin to the bone. I never asked her age – it wasn't polite. But I surmised she was in her mid- or late 30s. One day she described herself as a trophy wife in her previous relationships. She seemed friendly with everyone and, though we rarely spoke, she always smiled as she passed, carrying meals on a tray on her way out to the berm. She did this every day.

After dropping Jon Boy off at his van, I went back into the village. There was a hummingbird darting and hovering. It was going from planter to planter. After all the rain, the opening flowers were sticky with food. The bird flew to the greenhouse. I went inside to find it, and there was Shannon, working. The hummingbird had flown in, and then out. Shannon looked up, startled by the bird and then by my quick entrance, but she smiled and blurted, "WHOA! Scared the crap out of me!" Oddly enough, this was an opening for us to start talking.

Her job at the village was to tend to the greenhouse and the flower gardens. Having been a horticulturalist tending to flowers and plants like the ones you see in malls and offices, she took naturally to her work in the greenhouse. The passive solar construction of this unique structure was completed a year earlier by community volunteers and the non-profit Da Vinci Greenhouse. When I left the village in July of 2010, almost a year to the day earlier, it had been a roughed-out frame. The enthusiasm surrounding the construction translated into vigorous planting and tending, and the greenhouse had functioned well for a time. In a few short months, however, like everything in the village that started off right, it had gone slightly awry. Several tables and plant racks were stacked with trays of food plants, but weeds were taking over, and several seedling beds were completely dry.

"Well," she said, "we have snow peas, and I have tomatoes. I planted all this from seed. I got here a year ago last May [2010], and this is what I got into. I did it here too, the gardening, two years ago when I was here too." Villagers had often departed for forays into mainstream life and then come back when it hadn't worked out. She was one of those. "I was actually working in a greenhouse. I did two years of horticulture training. Through vocational rehabilitation, they set me up with a horticultural therapist. It trains people with disabilities, troubled youth..." Shannon walked fully around me and then settled behind a large table of seedlings. The table was like a broad safety zone for her. She wiped her chin with the clean back of her hand. She got up and started pacing. "Yeah, it's like anxiety, like I have a... I can't work with the public. I have a panic anxiety disorder. Last time I went to a gas station I had a panic attack..."

There were a few minutes of silence, so I offered some words of my own. "You were diagnosed with panic anxiety..." The words hadn't left my mouth before her trigger pulled. She slapped her hands on her pant leg, struggled to find her words, breathed a bit hard, quickly, like I had stifled her words and had made her even more uptight. For some reason I was made nervous by the gap in her responses. She seemed perfectly willing to tell me

important stuff, and I was trying to let her know that I knew all about panic anxiety disorders just to fill empty space. I desperately wanted to restore the easy cadence. I saw some large tomato plants and mentioned my father's affinity for the plants, hoping it would recast the dialogue on more friendly terms.

"Up until the day he died, my father had a large tomato plant on his balcony." She stopped pacing. She stopped kneading the edge of the planter. She looked at me cautiously. "He was a gardener then?" I sat on the edge of a table and offered up a smile. We established eye contact. "Something like that, before he got sick, anyway, and when we were young, for a time, we worked in the gardens with him at our home." She became calmer and her body language changed, her shoulders dropped and she tossed her long blondish hair to one side.

"Yeah, that's it, and I get disability payments for it now." Shannon told me that she had a claim in with the government based on her disability, that she was waiting to get the cash, a large lump sum so that she and her husband could buy a car, get an apartment, and get out of the village. I asked her about her husband, and she said I had already met him, and then she quickly changed the topic, telling me the greenhouse was in disarray because she, like everyone else, saw working in it merely as a way to fulfill her sweat equity responsibility to the village. She pulled out a weed here, a strand of dead vine there. The job, she said, was too big for one person. It would take half a dozen full-time employees to run the greenhouse and the gardens. I understood her frustration. "And I can't get any goddamned help. Oh, excuse my language," she looked at me apologetically.

I told her she was doing a pretty good job, tending to so much greenery. "Don't want to do this forever though," she insisted. Looking relieved, she waved to Dave Samson who was headed our way. "Your highness is required on the berm," he said.

On the way out of the greenhouse, I had to ask her. "Hey, how come I always see you taking food and stuff out to the berm?" With all of her 80-pound frame, she leaned into me, demanding, "Is that on? Is your thingy on?" I nodded to her and pointed to the red light that indicates that "record" is on. "Good," she went on, "because those motherfuckers on the council 86'd my husband and I have to go out to the goddamn berm every day so he doesn't die of starvation!"

She smiled and walked towards her structure, one of the larger shacks a few doors from mine. I could hear her raspy laugh. And then, a 200-pound "Fuck!" from her tiny frame as she raised her hands and then wiped the mud off the seat of her pants.

JAY

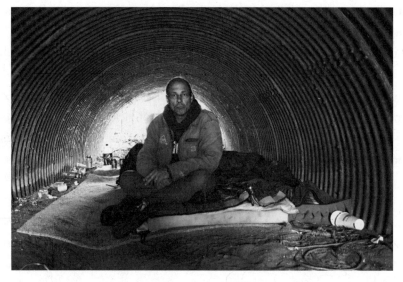

Jay in his culvert. July 2011.

Jay did not live in the village. Jay lived a few hundred yards away in a culvert under NE Sunderland road. Jay used to live in the village. He was and remains married to Shannon. Jay was 86'd for allegedly groping one of the other female residents. According to one witness, he was intoxicated at the time. He insisted that he was completely sober, and remembered only falling over out of exhaustion, and his hand having casually brushed the woman's breast. When he woke up in a haze, his pants soiled from urine, he was immediately kicked out of the village for violating one of the five rules, "No violence towards others" – five rules which are violated in some way by everyone who lives there, at some point in their residency. It was difficult to understand why some crimes, why some broken rules were punished and not others. He told me repeatedly during our interviews that such inconsistency was one of the most demoralizing features of the village. Together, Jon Boy and Jay's exiles drove various factions in the village apart. Perhaps he did touch her. Perhaps he did not. He was willing to believe that he might have grazed her accidentally as he fell, but having come to know him now, a little better than I did before, I shared his own disbelief. Jay hung out on the berm next to the village so he could be

close to Shannon. She could bring him hot cooked meals and he could associate with his friends.

That's where I met Jay – sitting on the berm, hanging with his close friends like Rocky, Samson, and a few others who ventured in and out of the village to show their support. A small group was lobbying to bring the matter up in a council meeting the following week, in order to change the by-laws so that a permanent 86 could be revoked and the violator reintroduced to the village. The idea of reintroducing people into the village who had broken a rule, especially about violence, seeded a new sense of despair among victims of such actions, in this case, the newcomer whom he had "violated" and a few others who had been emotionally molested, or verbally assaulted while living in the village. The law was never passed. But for a while, when I was there, it made many people uneasy to think it might have been.

Jay sat there on the berm, a beer hidden under his jacket, since displaying alcohol wouldn't garner any support for his potential re-entry and he told me in a bit of a drunken slur that he wanted to share his feelings about all this. "But not here. Out here. Too many eyes and big mouths," he said. A fighter jet from the Air National Guard took off and its engine vibration overhead was strong enough to rattle an empty soda can off the stone ledge. They generally take off about 500 yards from PDX International, and to avoid the commercial air traffic they sometimes fly over the village and then thrust about 80 degrees straight up. As drunk as he was, Jay caught the can. "Threes, they usually take off in threes," he said. Seconds later, two more took off, straight over the village. I found it hard not to look at them, to not feel energized by their furious power. "That's the worst part. Them fuckers going way up like that. You think that's loud, you should hear them fuckers from where I live. Even the spiders curl up and wanna die."

Back in the days of my filming in Toronto's Tent City, drug use, primarily crack cocaine, was so rampant that I made a promise to myself not to film, or at least not to use film of people that would jeopardize them or their community. But a handful of them insisted on showing how drugs and addictions played a role in their lives and so, in my earlier work, drugs and people on drugs were a major part of the visual exploration. At times it is important to "show" aspects of a culture that are hard to imagine. In *Righteous Dopefiend* (2009), Philippe

In a culvert near Dignity Village, exiled Jay talks about his life, the village and living under a road.
Scan the QR, or go to: www.tinyurl.com/JayInTunnel

Bourgois and Jeffrey Schonberg have written a deeply insightful and beautifully imaged photo ethnography about crack users and junkies in San Francisco, in which explicit images of drugs are an essential textual element out of which the personal stories of very poor street people emerge.[22] My own work has benefitted from Bourgois' and others' understanding of how biopower creates a demonization of the undeserving body by creating an easily identified characterlogically flawed homeless "user."[23] Much earlier, Nels Anderson's *The Hobo* (1923) was a milestone in participant observation and the first fieldwork-based monograph of the Chicago School of Sociology.[24] This detailed ethnography looked at hoboism as a culture and explored the role of family, language, social order and other elements of this historically important, extremely poor, casual army of labor, amongst whom heavy drinking was common. Anderson helped to place vagabonds and hobos within broader debates about casual labor, kinship and urban culture per se that superseded their apparent and obvious "flawed character." Both these and many other important studies of street poverty grant the reader a privileged view of people rarely understood so intimately. But, as a kind of warning against the misuse of this privilege, I remind myself of the bitterness that is still on the tongue of some of Tent City's ex-residents who felt they were misquoted and manipulated by writers and many journalists who took advantage of their "weaker" moments of intoxication.

That day, seated on the berm with a few inebriated villagers and Jay, I reminded myself that my entry into the village – their permission for my living there was, in part, based on a promise to not expose villagers in an unduly negative light. They understood that I wasn't producing a propaganda project for the village either. Still, I understood that telling the story did not require showing people when they were not in control of their thoughts and words, when their already damaged memories were jammed with meth, junk, booze, or meds. When Jay stood up to show me, at his insistence, to the culvert where he slept, and then

[22] P. Bourgois and J. Schonberg *Righteous Dopefiend* (Berkley: University of California Press, 2009) is a remarkable, incredibly detailed and long-term study of junkies that employs very graphic and gritty photography of addicts' bodies to connect readers to issues of poverty and addiction.

[23] Foucault first used the term in volume one of *History of Sexuality* (1976). He saw the modern state as regulating its subjects through an "explosion of techniques" he called biopower, that subjugate the bodies and populations they govern to the practices expressed in (for example) public health care, education and risk regulation. Foucault, M., *The History of Sexuality Vol. 1: The Will to Knowledge* (London: Penguin, [1976] 1998).

[24] There were two periods. In this case, the "Chicago School" refers to the emphasis on symbolic interaction, urban sociology and ethnographic methods employed in the 1920s and 1930s at several of Chicago's universities by important scholars like Nels Anderson, Robert Park, George Herbert Mead and Louis Wirth.

almost fell over, I understood what a rich opportunity this might be to see the world from his inner sanctum, and I knew that the effort would be wasted if we did the interview while he was so inebriated.

It was hard to find Jay when he wasn't drinking. Rhania, my filmmaker friend from Portland Community College, came by later that day. She had been working with Jay and Shannon for several months for a short film project. At that point she and I had only recently met, but we managed to have a conversation in which Jay expressed a serious desire to be interviewed by the two of us when he was sobered up. So, the next day Rhania, Jay and I made the 500-yard walk down the road with my cameras and tripod. As we walked, Jay was looking around nervously. Rhania and I made eye contact as if to ask what's wrong, and, as an unmarked black Suburban swung around near the Air National Guard, Jay looked to us and demanded that we, "Get down, low, low… Hope those fuckers don't see the cameras and all that shit, don't see us and kick me out. You know, I imagine there are worse places, but that's all I got… Cool now, don't act suspicious. " He paused, choked up, struggled through a tear and a cough. The camera wasn't on, and I wished it were because it was one of the most meaningful moments I had ever had in the field. He said through a deep sob, as he pointed to a trail through the high grass leading into a dark tunnel, "I mean, that's my home."

Jay walked us through a small stand of immature bamboo shootes. A worn path led to the culvert which was 100 yards from the main gate of the Air National Guard. Even though it rains very hard in Portland and was doing so almost everyday at some point, this culvert and the inflow were dusty and dry. Turned out it was an auxiliary culvert, about eight feet in diameter. And it never got wet inside except in the winter. Jay had only been there a little over a month. We stepped into the culvert, hunched over, and I became itchy. For me as an ethnographer, I found it interesting that other than immediately noting the relatively spacious quality of the culvert, my most salient reaction was to the spiders and how quickly this became a pervasive itch. Hard to control a camera when you were itchy. I saw, before anything else, the white puffballs and cobwebs that lined all the visible surfaces of the squat. Inside them, small white spiders about an inch in size had colonized the walls of the culvert. Jay didn't even notice them. I kept scratching my scalp.

"Do you ever get bit?" I asked.

Jay looked at me and laughed. "They don't bite. It's them brown recluses [spiders] ya gotta watch out for. Those suckers are nasty. They like it damp though. Downtown under

the bridges, ya get bit. Not here though." Jay slipped off his shoes and crawled onto a sleeping bag laid out on a foam bed. His beddings and belongings all seemed pretty clean. I set up the tripod and hooked up my big camera and decided not to do anything about the lighting. The sun was blasting in from the west and made the lighting on Jay hard to manage. There was a bright halo behind him and every time he moved, it influenced my lens and the lighting changed. But I couldn't escape how overpowering the rims of the culvert were, how the bolts and webs seemed almost intentionally placed to frame this shot.

Jay was a different person when he was sober. That day he was clearheaded and he spoke well. A debater. Logical. Angry. "I'm a mouth, I speak out," he said. "I hate them tweakers, and I put it in their face and they don't like it." With the village somewhat divided across three lines of addiction – tweaking (meth), junk (heroin) and soft stuff (liquor and pot) – Jay argued that various alliances seemed to be forming over the residents' dependence on not only certain substances but on the persons who smuggled the crap in and sold it. At the time of Jay's incident, several alleged tweakers were on the council and they were tired of his incessant speaking out. He took some pleasure in annoying them as often as he could by calling them "Tweaker, tweaker" in public and by making sarcastic remarks. Ultimately, he suggested, he pissed them off so much that they took his unfortunate fainting spell as an opportunity to rid them of his constant haranguing. Whatever the reason, he was here, in a culvert.

"Look, it's simple. I wasn't drunk. I even went to a doctor who told me that I might suffer from micturition syncope, a condition when a man can get up from sleeping and take a pee and faint and puke. And the way I read the write-up and the way they described it, that's exactly what happened to me. I wasn't drinking that night. I did take a sleeping aid from my wife that night, because of my past I have trouble sleeping at night and trust me this [he motioned to the culvert] is really hard for me sleeping in here... I just got no choice."

There are times in doing candid interviews, especially with traumatized persons, when the words an informant speaks are less instructive than the rhythms and tones in which they are spoken. Jay's voice was weaker, and the words rode tiny ripples of despair. It was as if his story were made of tissue and any second it was going to rip open, irreparably exposing a delicate soul. I felt that a moment of crisis was coming, as did Rhania. She placed her hand lightly on my shoulder and tapped. Once again, in my head, while he continued to discuss his personal life, I was split between feelings of guilty voyeurism and hopes of noble discovery.

Jay cleared his throat. "And I still face a lot of stuff I gotta face." Looking at all the webs that cloak his nightmares, he offered, "You know everyone says 'I'm afraid of spiders, I'm afraid of spiders.' Well, you know what, so am I! But I have nowhere else to go."

"And you have other more troubling issues too, though. You've been places that are more troubling than spiders?" I asked.

Jay took a moment to collect his thoughts. "Yeah, I have. So I can get past this," he said. "You know I checked myself into mental health after I got 86'd. I went to the doctor for my benefit." The tears were pouring out of his eyes, backlit by the bright sun as it radiated through the aperture of the culvert. It was quite amazing how, seeing my informants through the lens of my cameras for so many years, had shifted the way I looked at the world around me. Tears captured the diffuse light on their pearly skin and gleamed against Jay's silhouetted frame. He caught a tear and then another in his cupped fingers, catching them as if to save a part of himself, and then he brought them to rest on his cheek with others, as they poured uncontrollably. I heard him talking through this but it did not register until I looked at the video, hours later. Were it not for the camera recording both sound and video, I might have remained lost in this tragically compelling imagery, and never heard the words that finally betrayed his hidden pain.

"I smoke weed, uh, I been trying to quit because the mental health classes that I go to require it. And I been using marijuana to help me sleep at night. It's worked for me for 30 years." He was looking into the camera, directly. He seemed to be pleading with the lens or me, or an unseen authority. His voice was broken. I cannot describe how moving it was to hear; a metaphor would be rude, I think. I have goose bumps now, watching the video clips from which this transcription was derived – I had them then. Quivering, like a child, who struggles to understand, "Why?"

"And I'm really having a hard time quitting." Jay covered his mouth, suppressing a sob. Catching his breath, he choked it out, "And I could go back to jail for that."

A long pause.

And then came the confession. Finally, someone to listen and to tell his story. "Well, when I was 12, I was kidnapped, ah, for 11 months. And every heinous crime that could possibly happen to a small child happened." He became calm and the tears dried up momentarily. He spoke matter of factly, effortlessly. "I was kept in a closet, and slid plates of food, maybe three or four times a week under the door. I was taken out and abused." Jay's eyes were scanning every inch of the ribbed rounded walls of the culvert. Fighting

back a new volley of tears. And now his eyes glossed over again. "I am very claustropho-
bic."

A long pause. I heard him swallow.

"Uh, stuff I am learning to deal with." He wasn't with us, he was back in the closet, and later, in his prison cell, and then, perhaps, back in the village in his home with his wife. He was nowhere near, but only a meter away. "They didn't just hurt me by kicking me out of the village and keeping me away from my wife. They hurt me because they put me back here."

BRIAN

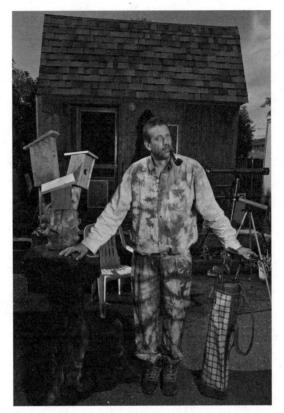

Brian in front of his structure with the tree stump,
a birdcage he built with Walt, and his pipe, of course. July 2011.

They called Brian the "Kramer" of the village, since he was roughly the same height and build as the Seinfeld character. And just about as quirky. "Ah yeah, yeah, I imagine that people might say that, but nah, this is just me, heh eh…" He often finished sentences with that laugh. He smoked a pipe, proudly parading around the village in tie-dyed clothes, a visual medley for which I was in part responsible. I'd felt that doing tie-dyed garments for the village was a good way for the village to make some products it could sell. I had owned a painted shirt business back in the '80s and it wasn't a bad business. And it wasn't too expensive to get into either. So I'd located a craft store in Portland and bought some dyes

and some fabric paints. Mitch, who'd been living in the dorm near Brian's structure, knew how to do tie-dyeing. We agreed that with so much tie-dyed clothing in Portland, this could be a sellable product online and at the village store. At the very least, it would be a production that many folks could enjoy. Soon, Brian, Michelle and almost everyone ended up hanging around the workbench as Mitch and I started pumping out "Dignity Village" tie-dyed shirts. I don't think one was ever sold, but I do know that most of the folks in the village had gone scrounging donations for blank shirts and other clothing that they could tie-dye, and soon the village looked like the Grateful Dead had foolishly parked their tour bus at the gates and left it unattended.

Nevertheless, Brian was very real, very present when he talked with me. He commanded a certain respect, and he gave it. He spoke like a polished politician, very careful not to speak incessantly of rumors or to openly criticize. His social and political gift was diplomacy. He was vice-chair of the village and he wore the role well. At meetings, he was authoritative when he had to be, but for the most he demonstrated a very patient style, and steered discussions well. One of his hands was deformed at birth, but this didn't stop him from smashing tennis balls into the athletic field across the road every evening, using the old set of golf clubs his 'Grammy' gave him. Like most of the people I had met at the village, other than being a bit dirty and casually dressed, neither his appearance nor manner of talking and socializing betrayed the significant hidden psychological trauma that underscored his journey into homelessness.

One day, Brian came over to the workstation in front of my shack, where Mitch and I were making shirts. He was dragging a 150-pound tree stump he had found floating in the Columbia River. The Columbia is almost a half-mile away. It has banks about 15 feet high. Brian had dragged it from the Columbia, up the highway, past the front gates of the Air National Guard, right through Homeland Security's perimeter safety patrols that dart about the vicinity of the village. I imagine that passersby, including enforcement forces, must have seen him dragging it up NE Sunderland. He told me, however, that no one had hassled him. Probably, the only thing stranger than seeing a homeless man dragging a stump that distance past a military installation was seeing this same man approach in his tie-dye shirt and pants to ask, "Where's the stain? I 'm gonna make some art!"

For three days, during an unusual stretch of heat and sun, Brian shellacked and stained the crap out of that stump and, even though it took a full gallon of stain to permeate and saturate the dense wood, the result was pretty miraculous and stable. When it had dried, he

asked me, "How big is that car you rented anyway?" He laughed, "Hayah ah ha ha." He had a laugh one would imagine hearing on the Oregon Trail late at night over the campfire. Not thick like molasses, but crisp and clear like a good belt of bourbon. His speech was heavy with country drawl, resonating with what I can only describe as a deep sense of purpose and wisdom. Everything he talked about, whether it was the nastiness in the membership meetings, or the latest issues with the city, or his Grammy, ended with this kind of laughter. Brian was a determined humorist. He laughed again. "He he aha ha… I want to figure out how to get this to my Grammy. I think it might look good in her place." I suggested he could sell it to an art gallery. There were many galleries in the area, and natural themes seemed very popular. He studied the piece of wood, and tried out various angles and positions, checking to see how best to rest the large stump. With one arm, he shoved it around as if it was much lighter.

There was no way that this stump was going into my car and he knew that. I think he was quietly imagining how funny it would have looked to see us driving around with that thing sinking my rear axels, sparks grinding out from under my bumper, the sleeve of his tie-dyed shirt ruffling in the wind on his arm outstretched through the window. "You should meet her," he said. "My grandma. Well, she is my 'mom,' too, I mean she raised me, so she is kind of both, I guess. If you really want to know my story, you need to meet Grandma."

"Your Grammy?" I asked him, toying with the expression of "g-r-a-m-m-y."

"Yeah. My mom," he replied, as if the connection between the words was obvious.

It was a bit confusing to me. He urged me on. "She wants to meet you. I told her there was a filmmaker staying here. She thinks you must be nuts. Ah ahahah hahahah heh heh. Doesn't mind being interviewed, though."

Grandma lived in a suburb of Portland, called Milwaukie, about 45 minutes from the village. She and Brian spoke often by telephone or when he visited her in person. One of the interesting truths about places like the village was that unlike the streets, or hostels, or a prison, villagers have their own homes, even if it is just a half a dorm like mine. Once housed, it seems to me, that villagers begin reclaiming a sense of groundedness. It became realistic, once this center was established, to think of other goals, such as talking to family, or finding work. Once a serious problem like housing was resolved, villagers started establishing goals that went beyond finding a place to sleep safely each night.

For every one of the villagers I interviewed, reestablishing relationships, sometimes with friends, employers, family, or with lovers, followed very soon after finding housing. Not all

romantic relationships were permanent or long term in or out of the village. Brian was having an affair off and on with one of the women he had known in the village for some time. She was a bit of a floater. She had been involved with several of the men there. But when Brian was with her, he was respectful of her and, while others bad-mouthed her, he never did. In fact, in the time that I knew him, and we talked often, I don't recall him ever bad-mouthing anyone.

Brian often disappeared into the comfort of his ranch-style, plank-sided house. He had tool kits and artist supplies, sports equipment, and various other materials he had gathered in donations, in junk piles around town, and on odd clean-up jobs. The house was tucked away at the rear of the village, near Shakedown Street. I often found him outside chatting with his neighbors, and working on some piece of carved wooden art. He liked making wooden axe handles. He had been a computer technician, and had done various other jobs. But around the village, in addition to his role as vice-chair, he was often running around helping out his neighbors with handy work. He didn't speak very much about his current or past relationships. Some of the villagers, usually folks who did not consent to interviews, remained loners, in an intimate sense, and what relationships they did have seemed to be found only in the village or at places of part-time work. But others, like Brian, had layered and emotional ties with people within and beyond the gates. I surmised, wherever possible and desired, villagers started or even refined relationships with important family members once they had established their residency in the village community.

Every villager I talked to thought that membership in Dignity Village was like belonging to a family, and a community. Even if this fictitious family arrangement was temporary, or contentious as many families are, participating with others on intimate and personal levels stoked the fires of longing, longing to connect with estranged children, spouses, family, and friends. In the informative study, *Skid Row: An Introduction to Disaffiliation* (1973), Howard Bahr wrote about the disaffiliation of skid row men and the homeless in general. People on the streets, and people who have been chronically homeless for any period of time, in this light, are nearly always seen as defined by a lack of conventional connections that render them unviable in the "normal" sense of finding jobs or having meaningful lives. I have always thought this was a more interesting way of understanding chronic street poverty; looking at the street poor in terms of social and relational disadvantages that extreme poverty creates, rather than by the ambiguous use of the word "homeless." But, it is only partially more advantageous.

Even the "skids" and "bums" of skid row have affiliations and social networks, and more recent research, such as Wagner's (1993) *Checkerboard Square*, Capponi's (1997) *Dispatches from the Poverty Line* and my films (2003-9), to name just a few, substantiate the importance of social ties for the chronically homeless. In fact, the street is very often defined by a social economy that is fundamentally predicated on ties, obligations, reciprocity and social expectations. While the quantities and diversity of material resources exchanged on the streets is limited, the importance of protecting others, sharing resources and "pitching in to help out a brother" cannot be ignored. Affiliations on the street do not appear to us in the mainstream as viable in the "normalized" sense, and so we ignore or deny their existence. I suggest that we have to look at how these ties and this social economy satisfy basic universal social needs like friendship and support, and then we must ask if it really matters if such needs are satisfied by qualitatively different material, political and spiritual practices than those we consider common.

Some days into my stay, I wrote in my notes about Dignity Village as a social structure and political community that represented an intermediary urban space that allowed for the psychological and social mediation between the unstructured "disaffiliation" of the streets, and the restructuring of a mainstream citizen. Brian's story helped me frame this understanding. In fact, all the stories have pointed to the likelihood that, despite setbacks and false starts, each of the residents I met had learned something from living in the village that asked them to consider what their rights as citizens were, and how they might have achieved these. Since I had abandoned the pedantry of focusing on characterological deficits like addiction, or criminal behavior, and started looking for the connectedness of the villager to others through positive choice making, I had begun to learn a great deal more about how conventional and unconventional linkages help people to get off the streets than I had before. But more than this, I had also learned about how these people maintain a sense of dignity and self-worth from their lives outside the comfortable world of so-called stable housing.

Villagers were "connected." They had relationships with legal and health professionals, supporters and visitors, other homeless people and many others. Their most important relationships in terms of the emotional and material value they experienced were with friends and family, within and outside of the village. Informants generally described their families as "normal," representing a wide spectrum of standard configurations: housed, employed and including other siblings. Some were described as useless and dysfunctional. I have heard the descriptions about "normal" families. It seemed that whether the family or friends

of villagers were "homeless" or not had little bearing on villagers' homeless experience. Everyone there knew close friends or family who were housed and those who were homeless. Other factors, like the mental health of parents and siblings, were more often cited as being influential on the poor choices villagers had made. All of the villagers I talked with said that the village provided a location from which to build relationships. One resident, in particular, frequently spent time with her children in and out of the village. She had a daughter and son-in-law with a good trade and they visited frequently with her grandchild. Sometimes she would leave the village, stay at their house, and baby-sit for some days. The village has allowed residents with long terms of street engagement and addictions, sometimes, strong ones, to practice the skills needed to live with others and reconcile conflict in "civilized" ways that streets and hostels just don't provide. Living in a "stable" community has also made them realize the importance of home and having meaningful relationships with others *outside* of the village gates. For those who came to Dignity after shorter lapses in housing, the village has been a place to re-collect their bearings, and plan re-entry strategies.

Within the village, participation in the democratic council of the community offered individuals a chance to voice their opinions. At least intentionally, this was the case. The factions and fear that many of the stories referred to put a damper on "free" action amongst some of the villagers. This political entropy concerned Brian. As village vice-chair, he was finding his voice, and he felt it would be a damn shame if others did not. Brian often spoke of the empowering benefits of participation in council and membership meetings.

For Brian, the village was part of his three-year plan to become organized, and to find a job and get situated in an apartment. "None of this," he said, "is possible without her support." So we got into my car one fine sunny day and we drove 50 kilometers, past the strip malls with many vacant storefronts, along a worn and bumpy main highway, past diners and fast food joints. One of the hamburger joints near the turnoff to Grammy's place sported a large sign that boasted that George Bush had stopped there for one of their famous burgers – "Visited by G. BUSH" – on a large billboard. Brian insisted that we stop in for a hot dog or burger on the way back. Since my arrival in Portland, I had been amazed at how much of this kind of food existed. In the downtown core, there were parking lots jammed with decoratively painted food trucks. I thought they were tent camps at first, but no, these were legit mobile food malls. It was like entire communities dined on burritos, Thai noodles, hamburgers, fries and Coney Island hot dogs. Several of the small restaurants were "world-renowned" for their ten-layer burgers or 14-inch-long dogs and Coney fries. I had been eat-

ing too much of it. In six weeks, I went up 15 pounds. I agreed to buy us lunch, but I had to remind him, "Okay, dude, but don't let me eat any more fucking fries." He thought that was funny. "He he aha hah ha ha…" he laughed, "…you'll be doing meth soon."

Grammy lived in a pleasant townhouse complex. It was clean, suburban and modest. Lots of red-white-and-blue bumper stickers, flags, and minutemen lawn ornaments. Trimmed hedges and the sound of lawn mowers. One might call it working, or lower middle class. There was no graffiti, no garbage blowing around. It was the opposite of the downtown streets of St. Henri where I lived in Montreal, and it was the kind of neighborhood where many of the residents in Dignity Village had come from over the years. It had become interesting to me just how many of the villagers came from what we generally consider middle- or lower middle-class backgrounds. Unlike the residents of Tent City – most of whom had come by their lot because of long histories of incarceration and mental health issues, or from families stuck in the culture of abject poverty of their ancestors [25] – in Dignity, the population seemed to be more diverse, a mixture of people who had come from mainstream working-class homes, the middle class and the streets. And while many of them had come from across the country to get there, many others knew each other well from growing up around Portland. In fact, Brian and a few of his village neighbors used to hang out and party together some 20 years earlier.

As we drove to Grammy's, Brian was quick to point out all the alleys, homes and schoolyards where he used to get into trouble when he was a kid. We pulled into the parking lot and a neighbor came by to greet Brian. She was all smiles and happy to see him. Brian and her son used to hang together. She walked over to him with outstretched arms. A big smile. She took a visual note of my fumbling with the camera and my shoulder mount. "Well, well, look at you," she said to him. "You're, well, you're pink! Leave it to you." She gave him a good hard stare without saying much. She smiled, encouragingly, and then said, "Well, well. Just look at you. So nice to see you!" She waved to me and proceeded to her doorway.

I gathered my gear and set up my camera and that was the first time I really noticed what Brian was wearing. How could I not have noted it down? I was so used to seeing him in unusual clothing in the village, where such eccentric behavior was normal, that here in Middle America he stood out like a hallucination. As we approached the front door, I had

[25] I am alluding to Oscar Lewis' ideas about a culture of poverty that creates a self-perpetuating value system amongst the worst-off poor. Lewis, O., "The Culture of Poverty" in G. Gmelch and W. Zenner, eds., *Urban Life* (Longrove, Ill.: Waveland Press, 1996 (1966)).

to ask myself how his unusual and decorative approach to dressing must have looked to others, for there was Brian, his pipe dangling from his mouth, wearing pink floral pajama bottoms, a pink t-shirt and a pink hat on his six-foot-two-inch frame. And a pink ball cap. I mean, he was 3-D pink in the middle of a neighborhood where every other house had an American flag, most of the cars had NRA or some political bumper stickers and, after all, George Bush liked the food there. Brian led me to the door: watching him through the camera, I followed. Funny how once again, through the lens, I saw things I wouldn't have noticed. It was as if the lens transformed my persona from that of friend to that of observer. As he turned to show me in, I saw it was a T-shirt from the U.S. National Guard. It was a "breast cancer awareness" thing and on the front, it said: U.S. National Guard – AMERICAN HEROES. On the back: LOYALTY – DUTY – RESPECT – SERVICE – HONOR – INTEGRITY. Forget the brown and pink floral pants. They were probably just comfortable, and they matched his shirt and hat.

Brian knocked lightly on the door, and then pushed it open. We entered the spacious but modest two-bedroom flat. I kept the camera on as he entered the door, but turned it off before we met his Grammy. To me it's inappropriate to enter guns blazing. Grammy was seated at the small kitchen dinette table. Grammy looked younger than she should. I didn't ask her age. Seemed inappropriate at that point. Brian had told me she was in her 60s. I forgot that at a young age she had had her daughter. But Brian had told me that his mom was young when she had had him, and that's in part why Grammy raised him. It's why he sometimes called Grammy 'Mom.' Many of the families I have met through my interviews with residents of the village had their kids younger than national averages. In the U.S., birth rates had been dropping for over two decades. Partially due to an up and down economy, and partially due to the transformation of gendered roles for women, those same women had been waiting longer or choosing not to have children. In 1971, the average age of a mother was 21, but that age had increased to 25. For the residents of the village, and for many of the homeless I have met, their mothers were likely to have had their first child as young as 16, commonly around 18; Brian's birth mom was 15.[26]

Grammy was at ease in front of the camera, possibly because we were in her kitchen, her space. "My name is Arline King, and it's okay to use this as long as you don't show it to the police," she laughed. She was a little heavy and she told me she worried about her blood

[26] The U.S. government supplies this info in great detail at www.tinyurl.com/US-Vital-Stats
See also Centres for Disease Control www.cdc.gov/nchs/births.htm

sugar sometimes. And she was tall. "So what do you think of this guy?" I asked. Arline sat back in her chair, sighed, then leaned into the table with her arms bent at the elbow and her hands bracing her chin. She looked up at Brian. He looked back at her directly. She sat back again. "I had almost given up on him, actually," she said. She looked at me with a smile, almost as if it was an absurd question. "Well, has he told you about himself?" I nodded and smiled. And she went on to share her tale.

"Well, he was a drug addict, and he was a law breaker, and he was just about anything [bad] you could put in there and probably a lot of things I didn't know. And I didn't think he was ever going to get straightened out." She smiled and her eyes opened wide. She engaged the lens directly. "But he's actually, wow, I dunno. He's interested in his community, he has a different outlook on things, he found a part-time job, something he hasn't done in a long time, and he actually gets up in the morning and gets there."

"How did it make you feel when he was all fucked up?" Oops. I apologized for using the f-word. She laughed. "You been over *there* too long…" Arline was frank. She looked at me, not the lens, in the "eyes," and said, "Well, this is going to sound horrible, but it got to the point where with all of his drug abuse, that he got to the point where I said, if he was going to go and kill himself I wish he would just hurry up and do it, because it's just agony going through this."

She continued: "There's a commercial, I think it was for Alcoholics Anonymous, and there's this family and they get on a roller coaster. And they get in the car and you can hear the gears starting up and the ride starts and goes through all this terrifying up and down and it's up and down and up. And you can see the looks on their faces and when they get to the end of it, and it stops and you can hear this big sigh, and they all sigh, and then you can hear the gears cranking up again." She looked up at me as if that was the essential symptom of Brian's story. Once in place, a pattern of reliance on substances and associated activities impelled the addicted person into the downward spiral that impeded any ability to maintain a job, or to pursue goals or merely to show up on time. Small things that, over time, added up to the lack of "mainstream ties" that produced Brian's state of disaffiliation. Grammy knew this too. She had a live-in example of it in her own life.

For Grammy, it was this cycle of hell that she feared. Living in the village, in a shack without real heat or plumbing, in her opinion, was a huge step up from where he had been about to end up. I had to press the question: I was confused by the double role she played in his life. I mean, we had skipped from saying hello to discussing what it was like living with

a meth head. I asked her straight up, "So he calls you Mom and Grandma. That must be an odd place to be?" She sat back in her chair again and having gauged his response with a sideward glance, she offered, "Well, his mother got pregnant at 15, and the boy who was the father was also 15, and he wasn't going to marry her so I agreed to take care of Brian, but only if I could legally adopt him."

So, the girl was her daughter. I wasn't sure why, but I remember noting that something in me had prevented me from making that assumption. I looked at them for confirmation in clearly stated language, but to have asked for that would have been clinical, so I didn't.

"Ah, so you stepped up," I applauded her.

Both nodded, and smiled.

I learned that as a youngster, Brian had never known who his mom was but had known he'd been adopted, and this had caused him a great deal of identity anxiety. When he was accelerated in school so that he could ply his prowess on the basketball court with older kids, he'd found it hard to compete and socialize with older boys and the fun had gone out of the one thing he loved, basketball. You could understand how a child in his early teens with a gimpy hand, questioning his roots and origins, struggling to find acceptance, might well be traumatized by the loss of the one thing that gave him a sense of respect. In the chronically underemployed town of Walla Walla, Oregon, where they had lived, self-respect had been hard to come by. But drugs weren't. Brian had become increasingly interested in who he was and from whence he'd come. When he was ten years old, he learned who his parents were. It wasn't the shock that his adopted mother's daughter was his real mom that got to him. What really got him was his adopted father's psychiatric disorder.

"My father [Arline's husband – the granddad] was diagnosed with multiple personalities. Some were personalities that would not accept me as a son because they had never had sex with a woman." Brian was composed, spoke factually. Looked me straight in the eyes. "He had other personalities. The one that upset me the most was watching my dad act like a five-year-old child. His name was Jeffrey."

Arline had been staring down into her hands, head hung in resignation. "Oh yeah," she whispered, shaking her head.

Brian looked at Arline as their eyes met in a moment of empathy. "And that one, socially, personally... He heh ahe hah aha..."

"Yeah, that one freaked him out," Arline added.

Turning back to the camera, he told me, "That one I just couldn't handle."

As for Arline, other than his having frequent headaches, she hadn't seemed to have any idea that he had this disorder. He would go to bed with headaches and wake up hours or days later, and eventually he was diagnosed with the multiple personality disorder. Arline only found out about this after he'd been diagnosed with pneumonia in the hospital, and something strange had happened.

Upon his release, "He came home and told me that Glen died, and Glen is his first name. I looked at my husband, thinking he was talking in the third person, or euphemistically. And I thought he meant his heart stopped and they had resuscitated him, but no. I asked him again, 'Well, what do you mean?' And he says, 'Well, I was lying in the bed in the hospital and looked over the side of the bed, and I seen all these bodies lying at the side of the bed and I was digging through the pile trying to find my body, and I couldn't find it.' And I said, 'Well, if you're not Glen, who are you?' And he gave me some name, I can't remember what it is, and so I started to notice things as time went on that were strange, so I asked him, 'Are you telling me you have multiple personalities?' And he said, 'Well, I don't know but there are a lot of people inside of me.'"

So, they'd gone to Clackamas County Hospital and a psychiatrist had diagnosed him. Arline added, "And that just kind of released them all. Once it was spoken verbally, like that, and somebody with authority said, 'Okay you have multiples,' it just opened the floodgates." Brian agreed with this observation. "Yeah, father had 15 of them."

There was a long pause. Both Arline and Brian looked like they were caught in bad memories. Sensing the need for some levity I pointed to his pink and brown pants (I found out later that Arline had made them for him. She made all kinds of things from her sewing studio. She was a very good craftswoman and tailor). "He's a pretty brave dude. Don't you think he is brave walking around Dignity Village all pink and…?"

"Well, he's faced a lot."

"What do you think the toughest thing he had to face was?"

"His father, because of his age. He wasn't old enough at ten years old to deal with it, but now he could probably cope with it and laugh," she said, looking to him for agreement.

At age ten and then 12, his anger had become too much. He'd seen a counselor but it hadn't helped. At 16, he "shot-up" for the first time. Brian seemed to feel no pain sharing these details with the camera with Grammy seated across from him. There were few lies or secrets between them. She was tough.

I looked to Brian. "What were you banging, heroin or meth?"

Quickly, decisively, he stated, "No, meth." His eyes rolled and he craned his head back. A smile formed on his face and he looked to be happy. He went on. "It was that old peanut butter ether-based batch and I just immediately fell in love with it, greatest love of my life, greatest mistake I ever made in my life." Brian looked at me and just smiled. Softly, he added, "Heh heh ah hahahah."

Together they said "meth." Matter of factly. Resigned. Deep sighs. Were they hopeful or fearful? I could see in their eyes, through my lens, that they shared a resignation to the addiction. As he shuffled, I focused on the tattoo on his left arm. It had 18 barbs. Each barb was a month he had done in jail or prison. He had to add another 13 barbs.

Grammy told me how proud she was of her son. How he had become a real person again after being at the village. She was proud too, as the vice-chair of the village, of how he handled his job responsibly and honestly. As she said these things about him, I could see him watching her. Gauging her response. Not a ten-year-old looking for answers, but a man in a period of reinvention. And then, after an hour of cordial moments and chitchat, we departed.

I took Brian to the "Cardiac Arrest Diner," as I called it. I often took my informants out to restaurants for lunch or dinner. This was not manipulative. I had to eat. They had to eat. When we were together and hungry, we ate. Even back in Montreal, when a panhandler asks me for money, I offer food, if I can. If they say "yes," I provide it. If they say "no," and they do, I never give money. I explained that to the residents early on during my stay. Other than a couple of cash donations to the village for propane and food, some art supplies and materials, the only other material resource I supplied was the dining out, when I could afford it.

Brian laughed under his breath as he approached the take-out counter. "Well, well. Well, if it ain't you, stranger!" exclaimed the older of two women behind the counter. A young guy walked up and shook Brian's hand. No one paid attention to Brian's clothes, not even an up-and-down quickie to take in his pinkness. After a few introductions, in which I was presented as a filmmaker from Canada, the discussion turned to his Grammy. They knew her well and wished her well. We ordered, burgers, fries, and a shake for Brian, diet coke for me. I heard the patties as they sizzled on the grill, and the grease boiling as it violated the fries. My arteries were pleading with me, "No more!" The young guy insisted I have some of the "best chili in Oregon on my fries, and a shake, instead of soda." They had the best shakes, apparently. The fact is, among these people (and so many cultures),

hospitality around food sharing is a custom; it has to be respected no matter where you are when you are engaged in fieldwork. Brian looked at me expectantly, as if he was counting on me to agree.

I paid for the dinner, and they told me I could film them if I wanted. But I explained that my cameras were in the trunk and not set up, so maybe another time. We grabbed the food and ate it on a picnic table outside. That was the best chili. We made a toast with the shakes.

"Thanks," Brian said.

I nodded, agreeably. "Well, can't let you starve."

He laughed, "He aheh aha ha ha... No really, thanks."

BRAD G. AND KAREN

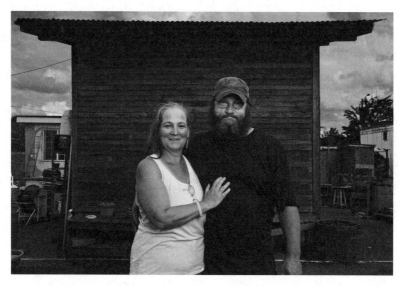

Karen and Brad G. in front of their place. July 2011.

One of the loveliest structures in the village was directly across from mine. It had no murals. It was box-like, with horizontal cedar-strip walls, corrugated aluminum roof, and large glass windows on three sides. (Seemed like a bit of Frank Lloyd Wright had fallen into the village.) That was Brad G. (henceforth Brad) and Karen's place. The camp is one of the rare emergency housing spaces where a man and a woman can stay together in shelter. Shelters are for the most part gender segregated, regardless of marital or relationship status. In the village, several couples had come together in search of housing in which they could cohabitate. Brad and Karen had been together for five years. Dignity was the only place they knew of when they became homeless that allowed them to be together, the only place other than the streets, squats and tent camps.

Karen tended the flowerpots around the house. She swept the compost dust and other debris that invaded her space. The broad wall of their structure faced the compost facility and as the west wind blew, as it often did, the compost hung there. Possibly that was one of the reasons that their planters did so well. But I preferred to think it was because of her preening. I smelled pot coming out of their place from time to time. But they were never

loud, and they seemed to never fight. Of all the people I met in the village, they were out-wardly very calm and peaceful with one another. But Karen laughed when I told her that.

"You mean you don't hear us? Come on? Sometimes I have to tell him to keep his damn mouth shut!" she laughed. And then, as if some switch inside her just turned off, she told me, "I don't like doing interviews, but maybe another time, maybe another time when I don't have so much to do here." She giggled and pulled some weeds from a planter. I stepped back and returned to my shack. I sat on my porch and just watched her. It wasn't unusual for us to sit on our porches, or on chairs and simply watch the comings and goings. As people scattered back and forth from one area to another, Karen slowly and method-ically tended her simple and sparse garden. She spent a great deal of time tending to only a few plants. It was the tending, not the plants that mattered. Each plant was cared for with tender fingers and a smile, as if they were small children.

I found Brad seated on his porch a few days later. It was hot, hot. The asphalt tarmac was as a baking dish and it was easily 20 Fahrenheit degrees warmer on there than outside the gates of the village. He was used to it, he said. "It's either too wet, or too cold. I think there were five days all told that were just right." Still, he had a half-gallon container of hot coffee perched on the rail. "Round 103 or so I figure." He smiled with one of his big front teeth missing. He had a great smile and a woolly beard that imposed an air of folk hero on him. His accent couldn't have been local. It sounded like he was a country singer. He was, however, the computer whiz in the village. And he spent a lot of time outside the village going to courses on community development and activism. Many of the villagers were able to get sweat equity credits for the time they spent doing outreach, or going to classes outside of the village. But since few villagers understood what "all this activism stuff was," they were reluctant to accord Brad, or any others, credit for being activists. There was an edge to him that I didn't understand until we interviewed.

Brad was a very interesting study on camera, full of "tells." Shuffling uneasily on his plastic lawn chair, he seemed to be taking the interview very seriously. I reminded him that it was unnatural to have a video camera in one's face and it was okay to feel odd, and also that he shouldn't worry. "After all, we are just trying to get to know each other." He didn't seem to buy it. "Brad, you're doing fine and I am not going to use anything that doesn't work. It's not a test." Mimicking my voice, he laughed it out, "THIS IS NOT A TEST. Well, *it's* not the problem [the camera]. I have always had that problem." He looked apologetic, feeling inadequate about something.

I tried to reassure him. "But it's not a *problem*, I don't want you to think of it as a problem. It's completely normal to be a little shy when someone shoves a camera in your face." He looked off into the distance, leaned one arm onto the arm of the chair and seemed to relax. He smiled and looked directly at me. "Well, ya see, I have a problem speaking in the first place." He gestured in circular motions with his hands in front of his face. "I have to hunt…" and then, pointing to himself, "I know what I'm talking about. But to convey 'em to you… well… the words… don't come out. My mind tells me in images."

He kneaded his fingers and looked at me, waiting for a response, as if this had always been a point of detachment between him and others, this difficulty to share ideas. Maybe that's why I always heard him talking to himself as he walked away from people. I suppose if he'd come from more auspicious family background and had had a savvy doctor, he might have been fortunate enough to be diagnosed as aphasic or A.D.D. If he had been labeled such, he might well have received meds or treatment years ago, but he didn't, and so this difficulty in communicating with others was planted in his mind as a label of sorts, as a self-limiting label, because – based on my experience with him – he had always been plain and clear spoken. "Very rarely have I been misled by you and I always get what you mean, so maybe, I hear the way you talk [in images]," I said. Brad rolled his eyes. And he chuckled.

He looked like a furry little Lotto ball in a Lotto machine. Settled into his armchair, he relaxed. As he started to introduce himself, a plane overhead from the PDX smothered his voice. He laughed again. And when he laughed, his whole body bounced out of the seat. A nervous laugh, as if to say, *Yeah right, just when I am ready to talk, a fucking plane!* "Plane, Plane!" he exclaimed, just like we used to yell "Car! Car!" when we played road hockey. And then his neighbor's dog started barking. He looked crossly at the dog. It stopped. As the sound of the plane went away, I told him that I preferred to use the shotgun mike on my camera to catch any and all ambient sounds. He agreed with me that one of the social skills one learned from living with 60 other people on one acre of land was how to shut out noise and stay out of other people's shit. The dog started barking again.

"Well, we shouldn't have to, though."

"What do you mean?" I asked.

He took a big swig from his coffee mug and assumed a pensive pose: elbow planted on the rail, chin braced in a cupped hand. With his other hand, he pointed his index finger in a declarative gesture, "In a city, they have by-laws about noise, dogs barking. You know, if your dog barks, you get a ticket." He looked at his neighbor's house again, then

around the corner. No one was there. He lowered his voice, "That's how it is supposed to be here, too."

For about a year, the neighbor's dog had been barking so much that Brad had had to bring it up at council meetings. But the village hadn't made a decision about what to do with the dog. Seemed like a moot point, but these little matters of procedure in the village were the ones that had people questioning the village governance and were also what some cliques had used to their advantage in the delicate democracy of the village. The laws about noise and invading other people's privacy became subsumed under frail alliances and social dependencies that played out in council meetings and behind the scenes. Brad didn't expect that to change much.

"I like it here, it's just the Peyton Place that goes on here, you know?" he chuckled. "Everybody here, you know? You made a decision in your life that went bad, you know? You are a product of every decision you ever made." Brad ran through a list of jobs he'd had back in Las Vegas: he'd been a heavy machinery operator for three years, he'd run his own computer shop in an appliance repair shop but it had closed. He'd been a guitarist, his greatest mistake being getting drunk after a gig, and watching thieves steal his equipment, thousands of dollars worth, from his car. He and Karen had been together at that time in Vegas, an area that, under the economic crisis of the 2000s, had been hit hard. With his computer business gone, construction almost nil, and his only other source of income, his musical tools, stolen, he'd become fed up. They'd made a hasty decision to get out of Vegas.

After "beg, borrowing and stealing" as much cash as they could, they'd bought air tickets to Portland, "because it was the cheapest airfare they could grab." They just wanted out from a "no place, no good memory experience." After arriving in Portland, Brad and Karen bartered their labor, sweeping floors at a storage facility where they stored their belongings. They camped out around town for a few nights, and then the owner of the facility told them about Dignity Village. They had never heard of it. Even while traipsing around downtown with other homeless folks, no one had suggested it to them.

But then again, there was a rumor I heard on the street that many of the homeless folks in Portland looked down on Dignity Village because the village had become elitist. And we need to remember that, by definition, this was a transitional emergency housing campground, where any homeless people in dire need of shelter were supposed to be welcomed. In downtown Portland, I met many street folks who laughed when the name Dignity Village was mentioned. One guy referred to it as a "gated" community, and told me, clearly, that in

his and most of his gang's opinion, the villagers had become snobs. There were stories of persons looking for a night's respite from the hell of sleeping on the streets, who had been turned away because the commons room had, in recent years, become more of a lounge for residents, and the village more of a privileged community than an emergency campground.

When they arrived, Brad and Karen stayed in the unfinished commons area, as most new arrivals did, and waited for a dorm and then a structure to become available. It was not easy to get into a structure. The demand far outweighed the supply, and because there was no firmly executed rule about how long transitional housing was meant to be in the village, many villagers lived there without even considering transition out of the village. Villagers had been staying in their structures for longer periods than the original plans of the village anticipated for several reasons. One was that there were few opportunities beyond the village for housing, especially for couples, and another was that it was difficult to impose a time limit on tenancy because there was no clear definition of what transitional had meant. No one who had experienced homelessness wanted to expel someone else or be expelled into it. As a result, villagers who'd got structures stayed in them unless they were kicked out for violations. Vacancies did appear therefore, when someone died, or was 86'd, or, more happily, if they'd found a job somewhere and moved out. So, after a while, the couple did manage a structure, and then finally ended up in their own piece of America, as Brad once called it.

Brad respected Dignity Village, despite the drama and the unenforceable rules. He expressed the wish to see more communities like it in order to help other homeless people. He had been experimenting with being a housing activist. Brad had increasingly been involved with other motivated village residents, like Ptery Lieght who lived a few doors over, next to the barking dog, and who'd been a very vocal and active housing advocate. Ptery had been taking Brad to various social justice group meetings in and around Portland. Brad had learned from Ptery that *activist* meant getting involved. The night before our interview Brad was at an Out of the Doorways leadership meeting. The night before that, at a meeting of Right to Survive,[27] a housing activist group that fights to decriminalize poverty and to help create housing. At the meeting, the discussion was about an impending action to occupy a piece of vacant urban land at the gates to Portland's popular Chinatown. The occupation was to be called R2D2 – Right 2 Dream Too. Brad had been really turned on by these meet-

[27] As a central housing activist organization, Right to Survive is an excellent source of information and momentum for housing activism in the area. www.right2survive.wordpress.com

ings, and afterwards he'd been hopeful and optimistic about the village. But it didn't take long, after we had returned from meetings together, for him to recognize that Dignity Village had suffered a serious decline in its collective will to carry the message. "This place has become about housing, not housing activism," he once told me. "You have to be willing to give up what you have, not to them – not them rich bastards who run everything – but to someone who needs it, if you want to keep it."

In the autumn of 2011, Brad and a few other members of Dignity aided the R2D2 group in a successful occupation of a choice piece of downtown acreage. At the gates of Portland's popular Chinatown, they set up a tent camp for 50 people by signing a one-year lease with the landowner. As Ibrahim Mubarak, the key figure in the group and ex-cofounder of Dignity Village, told me, "This is how it is done. You can't sit in your subsidized house or your apartment and change things. Carry the message, my brother, carry it by showing it." Brad, with Karen's blessings, had become inspired by the housing action. The logistic details are fairly well guarded by the group, but Brad and I discussed how they might use donated goods and materials to fabricate the platforms and the high wall that would surround the lot. I asked how much the rent was, but the amount they paid was unclear. I was told by one of the settlers that the fee was nominal, perhaps only a dollar for the year, and suited the landlord's desire to irk city officials who had challenged him on other zoning-related issues. They were able to occupy the land because it suited the landowner's desire for revenge. But in the meantime, their presence in a highly visited part of the city was carrying the message. Regardless of how successful the occupation is now measured, the landlord's desire to shake things up presented a loophole that the group was, back then, able to exploit, much as Dignity had pounced on a loophole in state law back in 2001. Without clearly defined laws that guarantee the rights of the poor to housing, housing activists have had to be aware of any legal ambiguities they could exploit to push for the rights of the poor.

Back in 2001, Dignity Village had been envisioned as an exemplar of community social justice, a site of and for housing activism. Inasmuch as it was not fulfilling this goal through aggressive community outreach when I stayed there, Brad and Ptery had had no choice but to get involved outside of the village. I asked Brad about his frequent involvement with housing rights groups in

Villager Ptery Lieght films the inaugural meetings, procedures, and establishment of Right 2 Dream Too. Scan the QR, or go to: www.tinyurl.com/R2D2procedures

the area. He had made plans to attend a major march in San Francisco on August 6, 2011, as part of a general gathering to protest homeless and poverty legislation across the U.S. "I am going just because there is a cause here, you know."

But what about the cause that Dignity Village represents? Was it a lost cause? Couldn't villagers turn it around if they participated more in the governing of the village? I asked him if he might think about being on the village council and he replied, "I alrcady was vice-chairman. 'Round about when I first became a member." Clearly, from the curtness of his reply, it was not a good deal for him. After a moment, he added, "Look, we have a membership-run organization. It's a 503-c, based on membership. Membership runs everything and membership can change everything. And so, a lot of this runs into a popularity contest. Well, I don't try and run any popularity contest. I just do my job and do it well."

As the top computer tech for the village, he dealt constantly with the technical ineptitude of others in hooking up to the three communal computers or, in special cases like mine, with connectivity issues and Wi-Fi. He filled out forms and grant proposals to help new residents learn computer skills or to get access to public programs for obtaining used computers. He had a lot of tradable skills and I surmised that he could, if the work was there, find it and move on. As well as one of the quieter persons I met there, he was one of the most active in progressive areas of the village affairs, without participating directly on the council. While he refused to be on council, he spoke of politics. "Well, there's a lot of lacking, a lot of…" He looked around to make sure no one was listening. I could hardly hear him as another plane flew overhead, but I guess, out of practice, he just wanted to make sure that his honesty wasn't overheard by some unhappy villager and converted into gossip.

"People just aren't getting a lot of things done. When this place started… when, I mean, this was supposed to be an activist organization. And help other people out of the doorways," he whispered. "And nobody… I mean once in a while you see one or two people go out [of the village]." Then, stone-faced: "There's 60 people here… it needs to get involved in its roots. Ya gotta get a spark, you know. Ya gotta understand why this place was here."

"Lot of people aren't getting that," I replied.

Brad was adamant, "A *lot* of people are not getting that. They're here for the 20-dollar stay over fee, you know. Twenty bucks is the insurance, you know, it's pretty cheap to live, and they're not bringing it [the message] back to the other organizations, they're not bringing it back to people who are still in the doorways."

I asked him about Dignity Village being a transitional place. He was absolutely clear, slapping the rail so hard that his, by then, empty coffee container fell off. "Well, it could be."

"How so?"

"Well, if people would get out and activate, they would get into networking that would lead them into different situations! See? That's where it was all supposed to be. Working with other organizations. Now, transportation is a big part of it. A monthly pass… Where's anybody from here going to get 82 bucks a month for the bus?"

I thought this was important. It was one of the reasons that the downtown occupation zone was something to watch for. The location of the R2D2 tent site, this site of protest, was central and conspicuous. It housed worst-off poor people in tents within minutes of access to central missions, churches, welfare offices and other supports that the village's location rendered distant. R2D2 was also highly visible to the mainstream. It confronted various urban symbolic imaginaries, those categories of expectation that we develop living in the city.[28] Bums in doorways yes, but a tent camp in downtown? I am assuming that for the state – be it the city or broader governance – the isolation of the poor to the margins, or to the illegally occupied lanes and sidewalks, renders them vulnerable to power brokers and ideologues that want, above all else, to control the way things are done, especially regarding public policies and housing. Within hours of opening its "doors," R2D2 had received visits from city representatives, police officials and concerned citizens. Within days, city inspectors had begun the process of surveillance and statutory regulation and inspections that would have had to precede any official response from city governance. Brad wasn't worried, nor Ibrahim, and as attention turned to the coterminous evolution of Occupy Portland – part of the global Occupy movement – R2D2 quickly became a topic of conversation back at the village amongst those who wanted to shake things up.

At the same time, however, Dignity Villagers were still getting sick on an inhospitable piece of land, and while R2D2 was setting up tents on a gravel lot next to Chinatown, the City of Portland announced the opening of a 47-million-dollar housing facility called the Bud Clark Commons. For 47 million dollars plus operating fees, the facility was to house 130 homeless individuals in studio apartments. It had an array of community services that catered to the area's needy. A similar project, but much smaller in nature, had opened in

[28] For a discussion of how urban space, values and expectations confront the claims of the marginalized see Wright, T., *Out Of Place. Homeless Mobilizations, Subcities, and Contested Landscapes* (Albany: State University of New York Press, 1992).

Toronto a year earlier. It was called First Step to Home and it appears elsewhere in my research. Their own observations are just now being studied and will be released soon. Whether these places might meet the long-term housing goals of Brad and other activists for transitioning homeless people remains to be seen. In the case of Bud Clark Commons, most of the activists I spoke with thought that such housing was a great idea, but so limited in its reach, that for 47 million dollars the state could probably fund 100 intentional communities with supports, and that would pretty much get everyone off the streets and into a reasonable shelter. Portland's mayor at the time, Sam Adams, said some time ago that he had no intention of evicting R2D2, and there was some talk amongst activists I had met that the institutional model – Bud Clark Commons and grassroots sites such as R2D2 and Dignity – might each fit into the city's ten year plan to end homelessness. Dignity Village, whether it wanted to be included in the discourse on poverty or not, had come to be once again situated firmly in this debate between homelessness as a growth industry, and the basic right to shelter. As Brad pointed out, it was always intended to be in this debate, "not isolated out here on the fringes."

PTERY LIEGHT

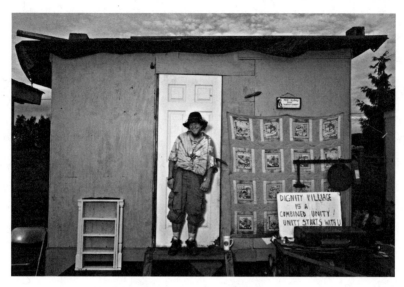

Ptery and his structure. July 2011.

Ptery often walked around with a notepad, or a book or some other instrument of knowledge, usually leaving the village to go to a political meeting at one of the many housing and poverty activist associations in Portland. Ptery, with a "P" and one "R," was dubious of the power embedded in proper names. Ptery changed his name to one that inhered neither masculine nor feminine qualities, Ptery, for pterodactyl, the winged dinosaur. He wouldn't even recognize his previous name. And he preferred me to not use traditional pronouns like "him" or "his" since they imposed the legacy of patriarchy and hegemony on his story. I simply find it hard to write without doing so.

Ptery came to Dignity by choice. For Ptery, Dignity Village was the discursive site of debates that go beyond mere housing or social structure: it was the site of discourses that embody a complete restructuring of the way we as humans conducted ourselves *with* this planet. Ptery had come to visit Dignity Village in August of 2010, a few weeks after my first visit. Ptery had been living in Seattle's well-known Tent City #4 (TC4). Life in Seattle was hard. Tent City 4 is still a temporary campground for about 100 homeless folks. They slept in tents and temporary huts formed from materials they scrounged up in the nearby city

waste, or received as donations from "sponsors." Run by an organization called Share/ Wheel, Tent City #4 was highly organized and, according to Ptery, had been managed well, better than Tent Cities 1 and 2, which no longer functioned. "But 3 still does. How I got here? To the village? I just heard of these new movements going on in Oregon, and for me it was not about finding housing, but carrying the message. So I came down to investigate things in Portland, and on the way back I needed a place to crash, so I stayed at the village one night – fell in love with it here. The fact that Dignity is a stable village—"

"Stable?" I asked. Had it ever been stable, I wondered.

"Well, Share/Wheel does a good job, but TC4 and the other 14 camps which they have on church lots, by law, get moved all the time. Nickelsville is another good example, you know, the one we have been reading about in the news? It was a TC too, and it was moved 14 times. A few months here, a few months there, and every time 100 people have to pack up and it's just to be moved to another spot. To keep the city and the state happy. So good rich folks don't get jumpy about things."

"So *this* village is relatively stable then, I guess?" I was astonished.

"Yeah, believe me, compared to other places, this is really stable," he reassured me.

Nevertheless, Share/Wheel had a policy the village could benefit from. Even though residents of Dignity Village could become members, if they chose to, they didn't have to in order to live there. Share/Wheel required its residents to become members, and required them to participate in decision-making and other community activities as part of their membership. In other words, all members were expected to take part in the self-management of the community. In Dignity, since membership had become a choice rather than mandatory, the self-regulating value of broad membership had declined in the village.

It had been argued by Ptery, and other activists he introduced to me, that this creative citizenship was an empowering feature of such communities. To be a member meant to be part of the decision-making process. In Dignity Village, this was part of the original design, but this practice had been and continues to be ignored. Many members chose not to vote for personal reasons. This is an unfortunate loss for the villagers. It seemed to me, and to Ptery, that what the required participation really did was give disenfranchised and lost people an opportunity to practice conversational and social skills in a highly normalized and competitive arena. In this sense their political actions and opinions could be seen as legitimate. They would have found voice and the freedom to pursue their rights as most citizens could.

Ptery wanted the world to enter a conversation about how we lived as part of the fabric of the planet. Not as a festering blight upon it. The first day Ptery was in Dignity Village was the official ten-year celebration, and Ptery had met one of the founding members, Ibrahim Mubarak. Ibrahim, a tall, deep voiced and well-spoken man, was serious about housing. And for Ptery, in the midst of a journey to find a place to carry the message, meeting Ibrahim, and seeing the relative stability of Dignity Village were in keeping with Ptery's conversational approach to life.

"So the universe was speaking to you," I suggested.

"It's speaking to all of us, Eric."

And the village had really spoken to him, so much so, that Ptery put his name in on the list to become a resident at the village. By February of 2011, after couch surfing from time to time at Tryon Farms, a commune-like place in Oregon, Ptery was offered guest status and made the move to Dignity. His girlfriend back in Seattle had said, when he announced his departure, that she did not mind because she understood Ptery was on a mission. And Dignity Village made sense to his mission. But they kept in touch. She and a friend of hers came and stayed with him in the village in his uniquely "Ptery-hut." Ptery didn't let us shoot inside his hut, and I felt it imprudent to write about the interiors of people's structures unless they explicitly said to do so. But I can tell you this much, because he shared it with me: it was organized, and filled with pamphlets, books, paper and writing materials. It had native-made curios and natural herbal teas here and there. For all intents and purposes, it reminded me of a poorly constructed, cluttered college dorm. The exterior was painted pink and a large quilt was tacked up to the wall.

For me, Ptery was a contradiction. Ptery was a loyal and devout feminist, the ultimate post-modern, among "anarchists." Ptery liked structure, though. It was precisely structure that Ptery thought was the key to the village's ability to turn itself around.

"You know, it's fitting that we are next to a giant compost heap. The village is kind of a compost heap. Homelessness is kind of a compost heap. The greatest things, the nicest flowers, come out of compost. People come here, and they are not here because of the great choices they made or because life has been good to them. Not very often. A few of us come to carry the message. But look around, Eric. Do you think these people want to, or can carry a message? Now? They are here because they can't break down anymore. The crap that society makes people do to live right just isn't working for everyone, and they fail. Well, at least society calls it that. But they just can't break down anymore. So they come here to rise up."

Ptery was rarely around the village. He confounded people there with his "activism." It was far more overt than Brad's. If anything, Ptery was seen by his opponents as an agitator, and Brad's participation as a "conversion." A growing factionalism between Christian bible readers, and Ptery's spiritual New Agers had begun to bud within the village. Many of the villagers, who were really struggling to get straight or to manage having a house for the first time, didn't understand Ptery's New Age language and wisdom. "A conversation with the earth? Fuck me," one guy said. And Ptery had other "predilections." He was learning about being a Wiccan and attended meetings with other Wiccans. He made medicine bags for people and spoke the Aboriginal sentiments of creation and the "grandfather." He had gone to New Age festivals up in the forest of Washington. "I hear they all dance naked and fuck in the jungle up there," the same guy said. Ptery dressed unconventionally, sometimes in his casual hemp shirt and loose pants, and, at times, suited up in a three-piece he keeps for official meetings with the city and such. Other villagers misunderstood most of his activities. Many of the members were reluctant to give him sweat equity credits for his activism. Beyond these hours, he worked at a Wellness center in Portland, one of only three in the area to have a communal Hot Soak tub. He was New Age, a post-modern man, and his passion for change probably intimidated villagers who were still shell-shocked from being homeless.

Rarely, however, had I seen so much energy emanate out of such a diminutive fellow. He didn't use hard drugs. He was just passionate about the "cause." Even when he'd been suffering through head colds and sinus infections, he'd found the energy and drive to get out of the village and made his calls to various activist meetings. Ptery embodied the spirit and the action of the activist community that Brad had spoken to, the spirit around which the village had been originally framed. At one point, however, some villagers suggested writing him up for non-compliance of hours. They did not understand what value his activities had for the village. What could a housing activist do for a village that houses homeless people? The reaction of the villagers to Ptery's outside interests concerned me. How far had the village veered off course if even its own members were questioning the outreach of one of its own?

There were many anxious days for Ptery, when the village met to discuss membership issues. At some point, I finally spoke privately on his behalf to different villagers about this controversy. I reiterated what seemed to me to be the important values expressed in the village articles of incorporation, namely that it was an activist community. That meant that

any outreach by members of the village to the greater community was extending this value in the spirit of the village charter. Many villagers had no interest in what I had to say. But a few did. Villagers started talking more openly about what the village meant, what its intentions had really been. These values became increasingly more salient after a visit from the city in mid-July.

One day, I went to interview two members of the Portland Housing Bureau, whose names I cannot reveal. We discussed things about the city's contract with the village that have since become common knowledge. But, really, we did not discuss much at all. They asked me why I was there in the first place, and I explained that I was doing my dissertation. I was looking at how differently constructed communities for the homeless meet their needs for dignified living. They were both very supportive of the work. They also were big supporters of the village, they said.

Going into the meeting, the villagers had asked me to do two things for them. First, based on the city's 2010[29] assessment of the village, the villagers wanted to know what they could do to expedite several of the recommendations issued in the assessment. Among these, they most urgently wanted to know what could be done to get the village relocated to a safer, permanent location. Second, they wanted to know what could be done to get a long-term contract signed with the city. For some time the city had promised a longer-term contract, and it had not been forthcoming. This had produced a real morale buster, as rumors of eviction had started to fly. These rumors, coupled with the malaise started by the impeachment of two key members, were beating down hard on the village. It was a real struggle for people to find faith in anything.

Other observations and suggestions from the assessment made a great deal of sense to those who had read it. Many villagers were really interested in offers of outside advocacy by therapists, community development leaders, builders and educators that the assessment suggested would have value for villagers. Most importantly, Lisa Larson and Scott, her husband, who were the villagers most in touch with the city, wanted to know when the city was finally going to come and visit to discuss the assessment.

There I was, in the office of the PHB, with a couple of deadpan city officers, who, seeing my recording device, clammed up. They had very different views on what was going on at the village. They assured me that they were going to extend the village's contract but were clarifying language and still looking into the permanent location issue. "Why

[29] www.tinyurl.com/Into-The-Meeting

issue a contract, if they were going to be moved?" They also said that they were in frequent contact with the village, but had never heard back. I could honor that because I knew how hard it had been to get information to or from people there. Lastly, they'd said that they had had no time to visit the village because of the staff cuts they had experienced a few months earlier, but they fully intended to, as soon as they could. Other than that, I couldn't get them to discuss any strategies or to enter into any debates about housing versus intentional communities. I thanked them for their time. Before I left, I suggested to them that I found it odd that I felt like I could come down there and talk to them, but villagers themselves felt that that was inappropriate or fruitless. I wasn't accusing anyone. I was just saying.

I met with Ptery who was waiting for me at a coffee shop nearby. We walked to the offices of Street Roots, a magazine like *L'Intinéraire* in Montreal that is written about and, in some cases, by people experiencing homelessness. In Portland, Israel Bayer ran the magazine. He was a strong booster for the village, and for the homeless in Portland. He was very vocal, very active and very informed. Few housing activist events took place in Portland that didn't involve Street Roots, Sisters of the Road, a communitarian restaurant, and Right to Survive. But Israel also was worried that Dignity Village had lost its footing in the world of housing activism. As we walked in the front door of Street Roots, the phone rang. It was the PHB. They asked Israel to join them the following Friday, a couple days away, for a site meeting at Dignity Village.

"Magic, I guess," I said. Israel laughed about it when I told him the story because, as he pointed out, one of the problems with the villagers being locked into their isolated existence, and not reaching out, was this lack of action. "All people have to do is reach out and show some interest in things and the rest of us will respond. How do they expect others to act with urgency if they don't act at all?"

It was surprising to me that the village was so adrift. From the perspective of organizations like Street Roots or R2D2, the village was really stagnant. It functioned to house, but not to express anything. In the village concept itself, however, had been implanted ideals about love and caring for others that kept many homeless folks coming back to it. For Israel, for Ptery and Brad, this spirit of camaraderie and community was a great taproot from which great activism could spread.

ROCKY

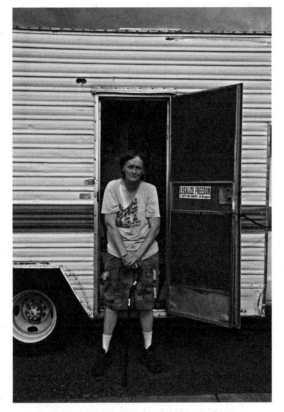

Rocky and her camper, by the berm. July 2011.

In ten years of working with the homeless and telling their stories, this gay, 52-year-old veteran and ex-truck driver was the first to take my camera away with her and record a message for me. Rocky came by the village frequently. She did not live there, but had been a resident a few years earlier. She was living in Vancouver, Washington, in a small apartment. But the village was where she felt at home. This was where her friends were, and she would show up with her dog, a 105-pound black, loveable wolfhound-giant schnauzer cross, and her 1987 Bronco, almost everyday. We met out on the berm, even though, as a lifetime member of the village, Rocky could go and come as she pleased. Where newcomers and non-members can only move freely in the common areas of the village, Rocky had friends

in all points of the tarmac, and she always added a spark to things. I came to expect to see her daily.

Rocky told me many things about herself, about being raised in foster homes and juvenile halls and learning that 12-year-olds could beat up eight-year-olds, or that coming out just made it harder to be a truck driver. "I came out at 19, but I still got married later in life, 'cause that's what was expected of me. I married a man who beat me. I left… They used to watch, you know, at the diners. At the truck stops. They'd watch me back my rig in. 'Cause I was a woman, and, you know, 'cause I wasn't straight. You bet your ass I made damn sure I backed my rig in clean." Rocky had left home at 14 because she was abused and then had spent time in Peoria, in '74, in one of the last "hobo" camps, where the hobo men had protected her and taught her what honor meant. Her recollection of life there reminded me of many of the themes Anderson had written about in *The Hobo* in 1923, and in his autobiographical, *The American Hobo* (1975). "When I got to the camp it was all these true old-timers. And there was a rule when I came into the camp – anybody came into the camp was welcome, but if you bothered with me, they would never find your body. The old timers took to me. I was an honest kid. I mean, I wasn't no thief and I never talked back." Her face lit up and her smile, enlarged by the absence of teeth, backlit her radiance. "They showed me how to ride the trains. Scary at first, but I didn't know fear then."

"You didn't know fear?"

"No. Un huh. My dad had beat me so bad – there was only one man I was afraid of, and I was gone [from there]."

Years later, after her stint in the army and, after leaving her deadbeat husband and coming out, she became seriously involved with another woman. They had a life and a home together. Being a truck driver, Rocky was doing lots of long hauls. Rocky was on the other side of the country when she found out her romantic partner had left her for a man, and had left her without a home.

That was largely how she'd found the streets and entered adult homelessness. She'd made her way to Dignity in due course. She had a unique quality about her. When she looked back, she looked at her life with gratitude, as something that she owned and not something that had been thrust upon her by the actions of others: she had been able to salvage important friendships, all her friendships were vital.

I found it odd, but she frequently made visits to that woman's, her ex-lover's, family. She went a few times while I was at the village. She played with her ex's kids. She was always

happy when she returned, sporting a bright smile, and she would say how wonderfully they were growing up. I got the sense that she had a hard time admitting her pain. Clearly, her past had built up on her like layers of shellac. Unlike the others in the village, I heard very little gossip about Rocky. And when she talked about these visits, the guys on the berm just clammed up and smoked their pot or drank their beer.

Rocky had joint problems. Then in her mid-50s, she suffered from osteoporosis and back pain. She got headaches. Her arthritis kicked in every time the weather changed. Some of the villagers had extra-strength Ibuprofen to give her, but smoking a joint seemed to work best. I never saw her do any hard stuff. I never saw her drunk. She seemed to be embarrassed whenever I saw her stoned. I had to chill her out on that. The last thing I wanted her to think was that I was judging her. So, in due course, I told her all about my addiction, my years of recovery. The fact that I lit up in '79 and got clean in '96. We talked about AA meetings. She knew the language. She knew first-hand and through others what that life was all about. I suppose my sharing with her, my speaking of my past, helped her to trust me. Our conversations soon turned to more intimate discussions about love, life and the spiritual.

When no one was around, there was a certain tranquility about the berm. One day, Rocky told me about her desire to travel across the country again. It seemed like a sudden revelation, but she had decided to sell her small truck, get rid of her apartment, and buy a camper van. "Nothing fancy or nuthin'. I ain't made of dough! Just something for a few grand that'll get me around. I miss it." In less than a couple of weeks, she pulled up to the berm in a camper van. The van became a hub of activity over the next few weeks as friends of hers in the village helped her fix the alternator, the electrical, the brakes... Several of the villagers had automotive and mechanical skills, and, despite personality clashes, they managed to get the truck working. A couple of times, I had to drive Rocky to the automotive shop, and once to the VA hospital in Vancouver, Washington. We had become close, I thought, but she never explained, beyond having a desire to see the country again, why the upheaval or why the need to get away and out of housing.

Before I left Dignity, Rocky recorded the following for me on video: "I just think it is time for you to go wherever you go and take time for Eric. I saw you really tired that day and remember that book that I know I've read and sounds like you've read too – tired can be a problem too. So be careful, and yes, you bounce back, and I'm nobody to you… but remember, I know if you get too tired you can really have a problem. And I'm really gonna miss you."

STEVE AND CAROL

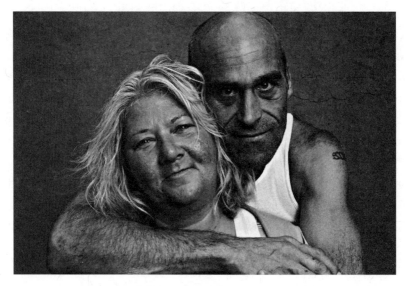

Steve and Carol. July 2011.

One morning, early in my stay at the village, I noticed Steve lurking around the portalets. It seemed odd. He just stood there. Shifting, looking around, his back to the portalets so he could see anyone approaching, as if he was protecting something. A few minutes later, Carol appeared from the outhouse. She handed Steve their household roll of toilet paper, and they walked away towards their shack, a quaint structure about double the size of mine. Steve had met Carol some 12 years earlier and had been clean at the time. It had been love at first sight. He'd started using again, and when we interviewed they had been together ever since, happily in love and, to my knowledge and within my experience, more or less peaceful and devoted to one another. On the streets, in hostels and squats, "A man watches over his woman, man. Ya got to. Do you know how many freaks and assholes there are out there?" Steve laughed. Not a nervous, neurotic laugh, but because he had always been a laugher.

My understanding of him was that he had a mechanism that had helped him find some humor in everything, however dark it might have seemed to others. "Man, she's my lady. I know nothing's gonna happen to her here. But I look after her. It's what we do." Steve and

I spent time together. "I ain't gonna lie about anything" he'd said in one interview. "I only speak about me, and no one else," he'd told me, "so I ain't got no problem saying nuthin'." Steve was tired of all the misrepresentations of people who live on the streets, of all the reporters "dissing" the village and homeless people. He once told me, "It's like they condemn us for using drugs, but they never talk about how we try to get off it. Because if they do, they gotta talk about how they can't help us. I want to get off drugs, Eric, I don't like using heroin, but it's a fucking bitch, man." He laughed again. "Anyway, we got a script [from a street health organization], and we're gonna get on the methadone... next week I think... as soon as we can get to the pharmacy. At least we got housing now, so at least here... in the village we can try to get clean... The village is a low-cost place to live and good chance to pull your head out of your ass and get your shit together, get a job and get your life back going on again."

"So that's why I ask you what is your game plan – to get off the crap, to get off the heroin and get stabilized? So, that's like three, four months, right?"

"We'll see... Well, I'm gonna be doing a Diversion program here in a few weeks."

"A what kind of program?"

"A Diversion program for a DUI I got. I crashed a motorhome. It's an alcohol treatment. They teach ya to recognize alcohol patterns and what to do to prevent it. And the outcomes and the responsibilities of being an adult drinker. Of adult drinking and not endangering people's lives."

"And when does that start?" I asked.

He rolled his eyes. "August first or something."

"And do you have to leave here... or—?"

"No," he smiled. "It's an outpatient. AA meetings and stuff like that."

He rocked his head and rolled his eyes. I wondered if he knew the program could work. The desperate part of him that frequently complained about the stupid things he did when he was high was overwhelmed by the cynical part of him that wanted to believe in his helplessness. This was a key point in debates over structural violence and the exercise of biopolitics.[30] The debate over treatment and cure was not a battle of words but was waged in the living breathing person, Steve, in this case. On the one hand, his addiction, symptomatic of his traumas and bad choices made on the streets, kept him tied to that lifestyle, and his desire

[30] Once again from Foucault: a style of government that regulates populations through biopower. Foucault, M., *The Birth of Biopolitcs, Lectures at the College de France, 1978-9* (New York: Palgrave, 2008).

to overcome it kept him chained to a system that failed to actually help him. The ideas that complete abstinence, like normalized housing, were valid goals for everyone might not have been true. Overcoming Steve's addictions might not have been possible.

The current debate between treatment and harm reduction places people like Steve on a teeter-totter of policies and expensive programs that often find their place in many addicts' lives only because of court decisions, as means of avoiding jail, and rarely out of the actual choice of the addict. "Even when an addict or alcoholic does make it to treatment," my counselor at rehab told me 16 years ago, "only about two percent of us stay clean and sober, and learn to live useful lives without dope." Steve kept going back and forth between a few days of jonesing to get off the drugs, a few minutes of hope that a diversion program might work, and then the realization set in once again that, after a lifetime of such attempts, there probably was no point. He didn't know what the answers were. We talked about whether the responsibility was his or not. But he'd come to rest on the probability that addictions and alcoholism were produced in his world, the street, to fuel an industry that catered to treating these problems, hopelessly and endlessly.

"Well, you know, I haven't had a drink in 16 years?"

"Yeah, yeah, and you must have a wicked case of cotton mouth," he laughed. "I've been to the meetings. I've done the steps, the 13th step—"

"The 13th step?" I asked.

"Yeah…"

"Well, the one step we're not supposed to do. That's the mythical one – where you pick up women at a meeting. Not supposed to do that," I suggested.

"Why not? Why not? Women are people too. They got rights to be at my meeting."

"Yeah, but you're not supposed to pick them up there."

"Why not?" His head was cocked and he looked at me like a prosecutor might, just before accusing the witness of lying or something.

"Because people aren't, women aren't—"

"Stable? At meetings…" He twisted my thoughts. "How do you know? They are people too, they got rights to meet other people. How do you know where another person's state of mind is? How do you know?" he demanded.

"At a meeting? I guess because they are at a meeting?" I offered.

"Well, how do you know how long they have been in treatment, how long? Maybe they are ready to take the next step, and progress with life. Isn't that what recovery's all about?

It's progressing and getting better… moving forward… You're moving backwards if you ain't moving forwards…"

"Yeah, but there are rules… I mean you can get laid and have sex, but…"

"Yeah, yeah. First you get a plant and then you get a fish and then you get a puppy… and then you get an 'old lady.' Why?"

"Well, you know what the state of denial is then?"

"Yeah, it's somewhere over in Egypt."

Steve was smiling the whole time. He had thrown almost every cliché I have heard about recovery at me. Clearly he had been around enough to know that recovery, packaged as it was in "programs," didn't work for him. He did not want to offend, and instead of going to an angry place out of his frustration with the way things were, he'd chosen to joke and play around.

"I am not here to convert anyone," I told him. "I mean, I don't talk about this with everyone here. But I guess, it is good to understand, from those of you who are struggling, what this means."

"No, no, I'm good. I'm good. You're just asking me questions and I am just being straight honest with ya. It's just my opinion."

"Everyone's got one."

"Yeah, like assholes, and some of them stink," he laughed.

"Dude, I just want you to be happy, is all."

"And I am happy. I could be a lot more happy and comfortable and secure in my own skin, but it is what it is right now, and it can only go forward from here."

"And how does it go forward from here? I want to know."

"Well, just by pulling my head out of my ass and doing what I need to be doing, you know, fighting back. You know, get that monkey off my back, kick him to the road and get rid of him."

"What has Dignity Village done for you?"

"It's given me a sense of security in that I got a place to live and stuff and have an address… and be able to take showers and be clean, and do the work in, in moving forward. Anyway, I have to get on the methadone… it's part of the diversion program. I have to take a UA [urine analysis]. Mandatory UA. If I test positive I could do a year in county jail. And I don't want to do that."

"Well, the pot stays in your urine a long time. Do they test for that?" I asked.

"They're gonna have to get used to it," he smirked.

When I did this interview, Steve and Carol preferred to remain outside of the contentious politicking that members ended up involved in, so they did not ask to be members. Both Steve and Carol were hesitant to get involved in the politicking and backstabbing that framed many of the members' alliances with one another. But he had opinions. "Somebody needs to do something, because it's out of control. There's cliques and they have all the control. And it's well, they're all on council and crap, there's nothing anyone can do or say about what they do."

I suggested to him that it was because they had been here so long that the cliques had become pretty entrenched in the structure of the village. And also that people just felt that if they tried to get on council, it would cost them socially or materialistically. He agreed.

"Yeah, and so they pretty much run the camp anyway they wanna," he insisted.

I asked, "What would you do if you were on council?"

"I would take the gray area out of the bookwork."

"What's the gray area?"

"Well, the rules are black and white and then there's the gray area. Where it depends on how good a friend you are and how bad we are going to punish you, you know? It's black or it's white. It's right or it's wrong. I have a lot of friends here, you know, and Dave and Laura, a bunch of others. Bubbles, I have trouble with Bubbles. He's just too negative. Negative all the time. I don't need that. It may not seem like it, but I have enough trouble staying in a good mood."

MICHELLE

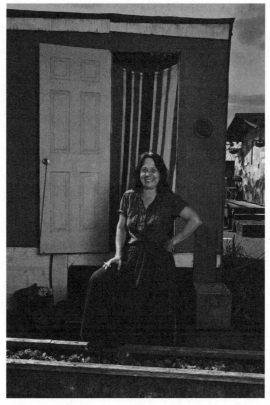

Michelle and her dorm. July 2011.

One day, before I went to New Seasons Market to buy my daily salad, I filmed a few of the villagers who were trying to figure out what to have for dinner based on the meager canned goods they had stashed. It was a few days until the food stamps were issued, and the usual Sunday leftovers from the bar down the road hadn't arrived. Normally, the restaurant brought its entire Sunday brunch buffet leftovers; bacon, sausage, pancakes, bread, eggs, fruits and rich desserts. Villagers pounced on the food. I refrained from eating it because, in all honesty, watching them claw into the stuff with their hands made it unappetizing. But it hadn't come that Sunday, so as we ended filming I offered to pick up some food for Michelle and a couple of friends. I didn't know her too well but I knew her well enough to appreciate

how hard it must be for a single woman to be living in a 6 x 8 foot shack without a support network. Left to fend for herself on the streets, she would, if the stats were correct, have to hook up with a man or a group of street people, to ensure her safety and that things like food and shelter were found. In the village, she was one of only a handful of single women. I knew she was angry most of the time. I knew she could rocket into incredible rants. I also knew she had a good heart. This place was her last hope. I knew, even if she didn't say so.

Michelle was reticent to accept my offer. The two others asked what I was getting, ready to share it. Not Michelle. She just shook her head. I had met struggling people who declined my help, but usually because my offer of food or clothes wasn't what they were after. They wanted cash. Michelle had never asked for a thing. So I couldn't put a finger on why she in particular denied my offer.

I walked away. She chased after me and said, "I'm embarrassed... I'm not working... I'm living off Washington State food stamps." It was embarrassing to her because she had real skills, but nowhere to use them. She was a journeyman carpenter, and was a card-carrying union member. But Michelle, like many other single moms with threads of mental health issues and personal trauma, could no longer transform her skills into long-term stable employment, even though she had a pretty impressive resumé of carpentry, framing and other construction gigs from Seattle to Portland. In a declining economy on the west coast, where "even paint shops are reducing their employees from 200 to 20. It just isn't possible. I'm 50 years old, and I have no home. And, half the time you can't find a place to even squat because the cops are all working for the banks and the banks are all working for the capitalists."

Her tone became loud when she talked about the liturgy of her life, as she always engaged in the classic Marxian ideas about the alienation of the laborer and then shifted to her disgust of the police and the mental health system, wherein less than a year ago, she had been diagnosed as manic depressive and committed to a mental health facility for a few weeks. Her switches were many and they turned on and off in unpredictable linkages. Her circuits overloaded, her body, her face, her gestures transformed instantly, blurting things so quickly and so nonsensically that she welled up and her cheeks flushed. "I'm sorry, I'm sorry," she said. "I know I am not supposed to get angry. I know you don't like that on camera." "No," I told her, "that's not it. I just well, I don't know how to help you."

A long pause. We just smiled at each other. A transformation in her. From anger to apparent tranquility.

"But anyway," she went on, "I feel great here, man. Portland rocks! And the sisters, the 'sparky sisters.' The electrician sisters, are really reaching out to me and helping me to feel included, people are really helping me to feel a sense of inclusion, even though I am embarrassed that I am homeless."

While I was there, from Seattle to northern California came tales of how the unions helped to support the unemployed. The support of local unions had been vital to her sense of self-worth. Her face lit up, she put her fists in the air. "We're working people," she exclaimed and looked to me with a furrowed brow, fishing for agreement.

Michelle was not new to hardship. We sat together a couple of days later out on the berm and had a conversation about that. She and her single mom had come to Seattle when Michelle was just ten years old. Mom had got married a couple of years into it. And, "She had real mental health issues, I can tell you. To this day I believe she was a perv. And I ran away when I was 13." I wanted to know more about this. Michelle obliged. The circuit was turned on. Michelle had grown up in local state group homes and she insisted, "Back in the '70s they really cared for runaways and juveniles. Places like Echo Glen were like summer camps. It was a beautiful place, about 40 miles from Seattle, up in the woods and not like now – it's just juvenile lockdown…"

Her eyes were red with anger. She swung her arm up and down like an axe. "Fucking lockdown, man! They don't put a safety net under runaways anymore. They just toss them on the streets."

She had been in that system from 13 until she'd become pregnant at 17. Her first child was born a week after her 18th birthday. She had seven children from four fathers. "I had a little confusion there. Growing up by myself like that, especially without a father figure. You get a little confused about those things."

I asked, "So you had no father figure to look after you?"

She was waving her hands like a referee waving off a goal in an NHL game. Waving… shaking her head. "Yeah, no, my stepfather. But no, not really. And to this day, and you know it has taken me years to figure this out, but I really believe, to this day, I feel that I was part of the marriage proposal. I feel like my mother had a diabolical plan for me. But my stepfather had restraint and never took her up on the offer."

"Which was what?"

"To have me sexually, to molest me."

"Really?"

"Yeah, and she used to degrade me sexually." Michelle directed a fit of anger in a controlled fashion. Her hands cut the air, like blades. She caught her thigh with one hand and the slap stung her leg. She recoiled and shook her hand to release the pain. "She used to call me 'whore' and, I mean, I was only eight or ten years old and she would be yelling at me, 'You filthy whore, he is my husband you're a slut' – CRAZY woman, but I feel like I have finally come to a point where I can talk about this and really let go. She lives in P____. My sister won't talk to her either. And, you know, that's the thing. Through Facebook and… the net, my sister and aunts and uncles I hold no grudge against, are there, and I just don't feel too good about contacting family, I guess. I see other folks here doing it all the time, but I'm nervous about being involved with family."

Except her kids. She was proud of her sons, her daughter. She clung to the ties she had with them. "You know, one of them has a problem with drugs, but all in all… it's pretty good. One of them just got back from Afghanistan…"

"In the army?"

"Yeah, and he didn't do too badly." Clapping her hand around her forehead, she teared up. "I was just so against it when he went, but he didn't do too bad. He turned out really well, he's sending me some money." She smiled radiantly.

Seated on the berm for that hour with Michelle, I had almost forgotten that we had started out that day trying to figure out how to get her some food because she'd run out of food stamps. She wasn't worried though. When she'd got her stamps, she'd always bought good food, good quality, organic and wholesome, so when she'd gotten low on food, what she had left to nibble on was good food. She'd been scrounging like this since she'd left the carpenters' union after ten years, about five years earlier. In the '90s she had been living with the father of her last three kids, in a ten-year-long relationship, in a nice quiet rental home. Back then he'd had trouble working and, "We had stable housing, and all these kids and I was on welfare. Clinton was saying he was going to kick people off welfare, and I was wondering what I could do. And, mysteriously someone left a Tony Robbins pamphlet in a wastebasket on Thanksgiving '96 and I just went, 'Whoa! I don't need to be on welfare anymore!'"

She'd got into a new trade apprenticeship program for women, a program designed to teach women the skills necessary to compete in a man's world, as she put it. Math skills, social skills, organization and "all the stuff I needed to go and get into the apprenticeship program for carpenters. And I just kinda dove right into it."

Her breath became labored, and she frantically brushed the hair off her face, then she told me through a rush of tears, "And I saw the possibility of home ownership, of putting a roof over my kids' heads and I realize now that was my whole problem, buying into that Carleton Sheets thing – investments, mortgages, equity. It's just wrong. I don't have a head for investing. But I saw the possibility of owning my home for the first time, and I tried, I did so try. And, you know, property prices were going up, and the work was getting harder and harder to find and on me, my back. I knew women don't last that long in the union, in the trade, but, I was like… [she mimicked holding a machine gun] I'm gonna go out here and make myself a home, rrrrrrr… and one of my kids is autistic, and… and I'm doing this in 2001, 2002 and 2003 and housing prices are just increasing. And then the house we rented in got sold, and we had really loved it. We had cheap rent and we loved the neighborhood. And housing prices just got so high and I felt like I was just struggling to keep a roof over my family's heads after that. And after they weren't dependent on me anymore. That's when I walked away from the carpenters' union 'cause there was really nothing, um, and I walked away – from the possibilities – of owning my home."

I paused for a moment, tilting the camera downwards and she smiled at me apologetically.

"But that's all in the past." She wiped away the tears, took a deep breath.

Michelle had been raised religiously. She still had faith. Throughout her journey, over the years, she has moved from church to church and congregation to congregation, and it was only recently that she had been fed up enough to internalize her faith. Back then, she stepped away from her family and the union and she turned to her faith to help her make sense of the turmoil. "And I was really into my church. I saw this preacher who told me that I really had to concentrate and focus on my kids. He told me I had to stop getting involved with men, and that really affected me."

The experience had played on her conscience, creating a deep sense of guilt. She'd taken the preacher's words so deeply to her heart that she had tried denying herself intimacy or a lover.

"So I didn't date anyone since 2004, until this summer. And that only lasted a month. But I knew it was just temporary." She looked into the sky. "You know, I'm lucky I found this place when I did, because I don't know what I would've done."

"How did you find Dignity, the village?"

"Well, gee, that's a long story."

"Short version, maybe?"

"Well, I was living in an apartment that one of my kids had. Across from the Seattle City Center. Beautiful. Cheap, too. And he kicked me out. And I know why he did it. He did it for a woman he was seeing. He said he needed to rent it out for the money, but I think he did it for sexual favors. Bottom line is I had nowhere to go, and this, after everything I had done and the sacrifices I had made. Out on the street, like that. Shameful."

After couch surfing, using shelters and sleeping behind a church, she'd become involved with one of the several temporary camps strewn across Seattle. What is today known as Nickelsville – a city-recognized, but not legalized, tent encampment that is now in its fourth year – became her home. She had unfortunate memories of that place. At first she'd felt it had great potential. The community was really fighting for land claims by the homeless. But, organized under the auspices of an activist NGO – Share/Wheel[31] – Michelle insists the community's fiscal arrangements and outreach were soon being overseen by a management team, rather than by the actual members. "They try to make us think we have some say, but it's way worse than here at the village. If they think they have factions and all that crap here, they should see up there. And one guy was getting two bucks a head for everyone who stayed there. Two bucks a head a night."

"So over a thousand a week?" I asked. "To watch the village?"

"To be a manager," she said sarcastically, fingers gesturing quotation marks. "The tent master. Anyway, I helped build the place. I worked on the structures and I had good friends there. I never did dope or caused any trouble. And I left one time to try my business, my vintage clothing thing. And it worked for a while. But it was hard, Eric. Really hard. So there I was again. I was living at the Harborview, but it was no good. So I followed some people I knew, from the U-district parking lot.[32] We took the bus down to Nickelsville. And I had busted my butt for that place. I had been separated from my kid. I was met there at the gates by some people who tried to get the tent master up. And the tent master decided to reject me 'cause I didn't have any ID. This was just last month after being away for six or seven months and they wouldn't get anyone out of bed to ID me. I'd never got barred from that place, never been disciplined, and they turned me away at midnight without even a blanket onto the streets of Seattle, and that was my repayment from Nickelsville. That's how they

[31] www.sharewheel.org

[32] The university district near the University of Washington in Seattle – the "U-district" – contains many common areas, shelters and social services, and has been the site of squats and other uses by the homeless.

repaid my hard work and dedication – by turning me away when I did need help because I didn't have ID."

"But they knew who you were?"

She nodded, "But they didn't care. And *they* probably got kicked out in a couple of weeks, because that's how things go there. People making major decisions for that whole community just don't care. They get elected in because no one else wants to get involved. It's almost sheer punishment to want to get involved with that place."

When she'd heard about Dignity Village and had come to it, it was like the angels were singing and heaven had opened to her, finally. The fact that the village had controversies and was struggling to deal with its identity did not bother her. She also didn't care that Ptery had thought Nickelsville was a great model and had been run well. "But at least, here, it's us doing it. We don't have a tent master, although I can see how it might look that way. But we can speak up here and have a voice. And I love this place. Just the place itself, and the real, uh, community, man. And, you know, now I really want to be about activism. I need a purpose in my life and I just want to spread a message of unity and I just been through all that like spirituality and I just think that we all gotta get it – you know sometimes I'm the worst you know for going 'oh that person's got money, oh, oh, oh'... and I don't want to be that way. I just want us all to unify and take our lives back, and I want people to move back into their houses. And that's what got me down here in the first place. Just seeing all the foreclosures and the tragedy in the place I lived for 44 years."

"Seattle?"

"Yeah, yeah sorry... sorry."

"Don't be sorry, don't be. This is hard stuff to talk about."

She smiled. "It really is."

"But maybe it's good to talk about it?"

"I totally think so."

"There are people who need to hear your story."

"Thank you." She wiped her eyes.

MITCH

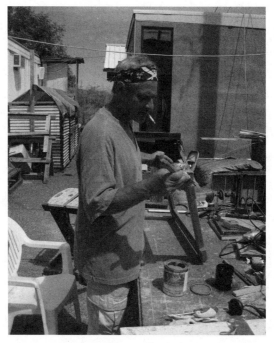

Mitch builds a frame for sale at the market. June 2011.
(Photo Eric Weissman)

Mitch was my alarm clock in the village. His favorite place, the workbench, was directly in front of my door. Every morning around six or seven, Mitch fired up his own personal stash of gourmet coffee, steeped in a Bodum. I think it was the coffee that got me up, but it could have been the sanding, shaving, scraping and sorting that went on. He wasn't allowed to use tools or power devices before nine a.m. And some people were on his case about using them at all since power tools used up a lot of electricity that the community paid for as a group. I think his activities, however, offered a positive opening to other villagers who often joined in, and he kept the workshop more or less organized so other people could pursue projects. But there were times when he was angry, and I knew it because he would drop boards or rattle tools too loudly or shift the heavy table around, at seven or eight a.m., and I knew he did this just to get even with people.

Mitch and I became good friends. He frequently reminded me how wonderful he thought it was that a Canadian Jewish person could be a friend of a Serb. I am still not sure I get what he meant. My people have been on this continent spanning three centuries and so have his. Other than his mentioning it, there was nothing that betrayed his ancestry. Still, it was common for me to greet him in the morning while the coffee was brewing. He would usually start with, "No wonder you're a poor Jew, ah, Jewish person. You don't get up early enough." To which I would sometimes respond with, "How are you, handsome Serbian? Planning any cleansings today?"

One of the most peculiar things about the village was that it was very "white." There were a couple of folks who were Native Americans and two others had ancestors from Asia, but out of the 56 people who were there during my fieldwork, any traits of ancestral heritage – cultural things like ethnic styles of cooking or dressing – were generally gone. Chronic homelessness tends to do that. It tends to modify traits that speak to one's cultural uniqueness by separating people from the unique material cultures that correspond to customary dress and food, and then it imposes the universal culture of depression and poverty on those areas of human cultural expression that are left void.

One Native American village member preferred to keep his name confidential so I call him 'Ben.' Ben was a Yakima man in his 60s from Washington State, and often traveled out of the village to visit his nephews who lived near various salmon rivers, tributaries of the mighty Columbia. He made dysphemistic jokes about Natives and cowboys, and he complained about how his people had been displaced. But he thought it completely unremarkable that a dominant culture like the "U.S. would look down on us homeless. They didn't do too good by my people." His structure had been painted with replicas of cave paintings, but this was not his doing. Ben was just lucky to live in a structure that reflected what he considered to be a "native aesthetic." He thought the paintings were "pretty cool." He wore a couple of trinkets that were of West Coast indigenous cultures, but not just from his own. He showed me some arrowheads he had found. He was proud of them even though they were not from his band. And the only material artifacts of his own ethnicity that he was able to share were the samples of pickled salmon he would get from his nephews. He enjoyed fishing, as did I. So we used fishing stories as bridges to conversation. He kept it light, however, and he resisted being photographed. He kept his feelings about his culture and America under wraps, wishing to avoid any controversies with the "losers" in the village. "I am an American, man," he had said, "not these fakers. We were here 100,000 years ago, not these

jokers." We became close enough friends that near the end of my stay, when Ben had been taken to hospital by ambulance for hypertension, he had asked me to accompany him. But he didn't want his picture published.

Regardless of their ancestry, all but two of the informants at Dignity were identified as Americans first, then, for example, as Oregonians or Californians. While matters of kinship, that is, who their parents and siblings were, for example, were important, cultural heritage seemed almost of no concern. Except for Ben, and Mitch. Mitch was American, but for reasons he never explained he referred to his being Serbian often. Mitch knew I was Canadian. He equated multiculturalism and long, complicated last names with being Canadian. "Don't you have a hyphen in your name? What kind of Canadian are you?" he asked me.

"Sorry, just the plain Canadian kind."

Mitch had been married until 2005. They'd lived in southern California, and he'd worked in carpentry and framing. It was a good business for a while, but it soon started drying up. One of the biggest problems was finding work that paid the bills because "it was hard to compete against all the Mexican guys." Not that he was a racist. Not Mitch. He used to work with and hire the same crews of lower-paid Mexican labor that he dug up in Home Depot parking lots. "It's just the way it is down here. I don't know what it's like up there in Cannuckda," – he laughs – "but down here, it was getting hard to make it in Cali. Besides, I had a dream of heading out and up the coast, building a cabin in the mountains, and she would never do that. She could never be that far from Nordstrom's [a high-end department store]. So we divorced. It was simple. No problems, no arguments. It was friendly. But that isn't what put me into homelessness. I put me into homelessness."

Mitch was a straight shooter. He had lots of opinions. In addition, he was very motivated to get the village's silent economic engine running. The village could benefit from producing crafts and other goods to sell, he felt, if only they would take advantage of the lumber and other raw materials that had been donated. And he observed, as almost everyone did, that the village was loaded with talent – artists, craftsmen, tradesmen and so on. It was quite possible to find ideas, hands, and eyes, but in the time I was there, and to this day, the craft micro-industry he envisioned hasn't happened. He used to tell me, "When I run the, ah, if I ever get to be CEO, I would really try and get crafts going here." Mitch often suggested that all the components for a booming cottage industry were in place, but everything had to come together just right. While I was there, his mood oscillated between high

expectations of that happening to utter despair and resignation. Still, he was really grateful to be there.

After he'd left his wife in 2005, he'd headed up the coast to Sacramento. There, his father had died. He'd spent a year living in his dad's house. He'd renovated it. Then he and his two siblings sold it. None of the siblings had much to do with each other. There were no hard feelings. Just not much reason to connect. Mitch took his inheritance and headed up to a small hillside Shangri-La near Hayfork, California. He built a small cabin and started a marijuana grow operation. "Dude, you can print that if you want. Everyone does that there. Even that was hard to make a living at. I mean the growers have it hard. It takes a ton of work and money to invest, but the price per pound went from 3,500 to 1,000 pretty quick and a lot of us were having hard times. I missed a few payments. Lots of us did, and the foreclosure talks had already started. Then, the county started asking for engineering reports and structural changes to my cabin. My truck went, that was a kicker. Me and my dogs, Baja and Juno, were like stranded and up there in the winter, you can't get in and out without a truck. My Bronco was essential – vital, man, it's vital to have a truck like that up there. Anyway, this major winter storm was heading in and my truck was just barely working, so I grabbed the dogs, a few of my tools and whatever I could get into my truck, and I got out of there."

After a few months hanging at his mom and stepdad's, Mitch took off north. In his mind, southern California was heading into an irreversible drought and he just wanted out of there. He didn't know where he was going, but he knew it was north. Therefore, with his truck fixed, and a few dollars in hand, he headed up to Oregon because as far as he could tell, "Oregon, even with global warming, would have normal water levels."

He worked in Astoria, Oregon. You can't go much more north in Oregon than that. He was using his carpentry skills, installing windows. It was labor, not craft to him, and he hated it. But it paid. Then in November, like all outdoor work in Oregon, it stopped. He was laid off. Social services and housing services in Astoria told him to head to Portland. Astoria was not the kind of place you wanted to be when sleeping in your truck in the winter, and Portland had services. This advice is common in states where seasonal labor is increasingly difficult to get. "That's what they tell all of us, man. Go to Portland, or to Seattle. Go to city 'X.' There you will find services."

Mitch made it to Portland in late 2010. From January to March, he slept in his truck with his dogs, next to a levee that diverted the Columbia slough back to the river proper.

Without the levee and the pump houses that distribute the water through them, parts of Portland would likely flood. Mitch parked his truck and made this concealed location his home. I have since learned that many of the homeless make it to this tract of land because it is secluded and close to the Oregon Food Bank. One day Mitch went to the food bank, and because he was being hassled by cops all the time about his truck, he'd asked if he could use their parking lot for a while. They'd told him to go check out Dignity Village, a few hundred yards down the road. It was right there, across the levee where he had been squatting. He had walked his dogs there all the time, but he had never noticed it. Never. Many times I had heard the same story from people who'd camped out on the levee across from the village. They'd never heard of it or seen it, even though it was in clear view when they'd walked the ridge.

"I think it's funny that I didn't see it. 'Cause you're looking as you walk the dogs, you know, next to the Multnomah County Drainage Facility, and you see the moving company, the prison, the maintenance yard and the compost facility, but you don't see the sliver of land with the village on it, because it is the last place you expect to see a civilization. Well, you can call it civilization, I guess. Then after I went there and checked in, in March, I guess. Well, whenever it was, I went back to the levee and there it was, right there, like it had been all the time. Freaked me out man – sticks out like a sore fucking thumb."

Mitch had become a resident of the village in May 2010, even though he had been going there daily to get water and use the facilities for months. Sometimes he got food there, but he found many of the villagers kind of tight with their donations and were restrictive about who they'd let in. They'd given him a hard time. Sometimes, he would drive to a pizza place in town and get the extra pizzas at the end of the night and then he would return after ten p.m. to share them with people at the village, and sometimes the villagers on duty would not let him in. They would say, "Well you can leave the pizza but you can't come in." This pissed him off. This is something else he promised to change if he ever was elected to council. "This is an emergency camp. We are an outreach center for the homeless. This place would start reaching again under my watch."

I suggested to him that he often mentioned being in office. "So, as much as you complain about this place and the people, sounds like you have faith in the place." He looked up at me with a sly smile.

"You are very clever, my Jewish friend."

SCOTT AND LISA

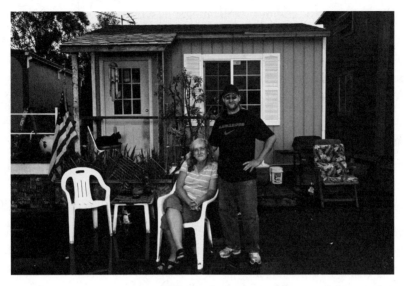

Lisa, Scott and Sabbath. July 2011.

One of my favorite photos is of Scott and Lisa posing in front of their structure, next to Brian's place. Many of my students have commented on how unusual it was to see people that we might have thought of as homeless, in front of structures they called home, and looking, for all intents and purposes, like "home owners." I asked Scott and Lisa to comment on their photo, which I sent as a Jpeg file. "HOME... It may not be much, but it is all we need. We are Scott, Lisa and Sabbath [lying on the porch]. When we arrived at Dignity Village two years ago, after living on the streets for two years, we found a place to call home with people we call friends."

I was puzzled by the brevity of this note. And for several months I just thought about it and worked on the outline for this book. Lisa and Scott were very active in outreach and other areas of the village social and political life when I was there. They had little difficulty sharing their views and ideas with just about anyone. We made several hours of interviews, and they had never been at a loss for words. So I was surprised they didn't have more to say regarding the photo. I was surprised, in fact, that a few key informants expressed satisfaction with the shots, but had little to say directly to them.

Scott had been exceptionally energetic. He had been taking meds to help him with a psychiatric condition that had made him a little hyper, and sometimes he'd heard voices. He'd been told that it was "auditory hallucinogenic syndrome," then schizophrenia, then both. Whatever it was, it may have been related to the methamphetamine addiction he'd had for much of his life. Scott and Lisa admittedly had shared that craving, for the rush, the elative feelings that meth had given. But for the most part, they hadn't partied much since finding the village. The village had proven to be a safe place where they were slowly rebuilding their self-confidence and working on healing some old, deep wounds. I decided to call them in April of 2012, to do some follow-up work. Lisa took the phone first, so I asked her very simply to start once again from the beginning. "Why exactly did you end up with Scott on the street?"

She answered as if the tapes of our last interview were still on pause and she had had this response ready all along. "Well, I was in an abusive relationship with my husband. We had two daughters, and 16 years into the marriage he starts hitting me. But it wasn't just hitting. It was abusing me so bad that I thought I might die. But I couldn't get away." Lisa took a moment to think. The pause lasted a bit too long. I thought that perhaps I was losing her interest.

"Just like that, he was, just hitting you?" I asked.

"Well I, we, were drinking too much and we were doing a lot of meth. The girls knew about the drinking, but they didn't know about the meth until the day I walked out. Don't laugh, okay, but I went right to a friend's place. I thought he was a good friend. He used to say that he wanted to take my husband out for a good 'whoopin', and crazy as it sounds now, I trusted him. He was also my dealer. That's how I met him. So I moved right in with him. I had nowhere else to go. And, you know, two weeks. Two weeks into that relationship, he started beating me too."

Abusive spouses had become a common story element I heard from women on the streets. Women who end up in dire homelessness often, suddenly, must take up with men for support and protection. Very often these relationships are brutal, if not fatal for the women involved. The women, running from abuse, run into still more abuse. As much as I liked Lisa, as I listened to her explain this, I heard all the same stories I had heard before. "You know his mom had told me he had been declared mentally incompetent at the age of nine, but he had so many assets that I ignored the obvious. He was smart and knew math really well. And we were friends first. I thought we were friends.

When I left my husband, he was my best friend. He beat me worse than my husband ever did."

"So, Lisa, I have to ask, you know of all the things we have talked about, you never talked about this in such detail—"

She cut me off, anxious to express her newfound freedom. "It's part of my healing process. Here at the village I have really had a lot of time to work on myself. Even since you were here. And I have been working with Michelle, the therapist who visits here, talking about all this. It really helps to speak to other women here. Women who know me, know where I have been. They have been there. Time is healing my wounds, and I feel more open about it now."

I heard Scott in the background shouting ideas to her. "Tell him how many times you tried to get free of that fucker."

"Yeah," she laughed loudly, "so I left the boyfriend twice a year for five years, and he would always track me down, and be charming, and promise he would stop, and I would go and..."

"Did you ever think you might have battered wife syndrome?" I asked.

"Well, now. Now, I can think that way. I didn't know it when I was in it. I believe that's what it was. I had it fixed in my head that I couldn't find anyone to really love me. Five years ago, before I met Scott, I was just lost."

Scott and Lisa had been working temp jobs together while she was with her psycho boyfriend and Scott was fresh out of his own divorce. They'd been working the St. Paul Rodeo, on security, and one night in the back of the van as they were driven back to town, they'd played games on each other's cellphones. They'd become friends. "Just really good friends," she insisted. They'd known each other for two and a half years before they got together. "He was living with a buddy at that time, and we were just friends. But when my boyfriend beat me the last time, I just had to go. I had been to Scott's before. As friends." Scott and Lisa had partied together. They had talked on a daily basis. "Just friends, like I said, but he really was my best friend. So on December 24, 2007, I told my boyfriend I was going to meet my daughters for Christmas dinner, and I moved into Scott's."

I asked her what makes someone a true friend, after the disasters she had had in the past. "Well, Scott never told me to shut up or criticized me for saying what I say, or being who I want to be. He never hit me or threatened me. He never used my own words to hurt me."

Scott's lady friend, who he'd been living with, hadn't been too keen on Lisa hanging at their house, so Scott and a friend had broken into an empty house so Lisa would have a place to sleep. The house had been on the market but hadn't got a lot of visits, so it was safer than anywhere else she could have gone. And it had heat. "I slept there for close to a month. I was kicked out three times by the realtors. The house was in Milwaukie, near Brian's Grammy's place, probably a block from his Grammy. Scott and I each knew Brian longer than we knew each other. Funny that we are all here. Now. Eventually, Scott and I stayed there together, in various houses on the market, dodging realtors and, you know..."

They had been busted a couple of times for "criminal trespass." The first time, the judge had let them off. The second time, they'd got 48 hours in jail and two weeks' community service. They never did the community service, so they ended up doing two weeks in Clackamus County Jail, picked up on a bench warrant. This jail was apparently one of the worst places in Oregon, but most villagers with records had said that about every jail.

Out of jail and homeless, they'd found a small stand of trees next to the railway tracks between a couple of warehouses. It was relatively secluded, and in the area a few other couples were camped out discreetly. Scott and Lisa camped in tents for a couple of months. The cops would come by to make sure they were okay. Cops are generally hard on street men. They are a bit more cautious with street couples. With the numbers of couples and families on the street increasing, enforcement has had to develop a sliding scale of policies towards the worst off. In Scott and Lisa's case, the cops had been lenient, until persons unknown had vandalized local businesses. Scott and Lisa had been kicked out of their tent camp and onto friends' couches for a while. They'd signed up on the wait list at Dignity Village. Eventually they were accepted as a couple into the village and were allowed to sleep in the commons area together. In about a month they'd got a dorm, and then a structure. That was about two years before our last conversation.

When I stayed at the village, they had been living in a quaint little structure at the end of the tarmac, next to the prison fence. The grounds surrounding their place were well kept, the interior of their home was comfortable, clean and cottage-like. It was a cute spot with a cute porch and a Stars and Stripes flag hung proudly next to their front door. They spent a lot of time in there during the day and, at first, I thought it was because they were doping it up. But the truth was that Scott worked really difficult hours. On Thursday nights, they both worked at the local auto-racing track. The track hired a lot of homeless folks from

around the area for minimum wage or less, and it paid cash. They got to see their buddy, Jon Boy, when they worked there, too.

For many employers in the area, the homeless provided cheap and dispensable labor. For many of the villagers, day labor at regular low-paying jobs like factory work, doing odd jobs for supporters, and under-the-table wage labor, were ways to earn a meager supplemental income. Villagers had worked as sign carriers, you know the guys we see on street corners flagging cars or dressed up like mascots; casual shipping and factory labor – usually the midnight shifts – and a variety of security positions at fairs, malls, local events. Steve-O, who died just recently from liver failure, drove big rigs for the astonishingly low wage of eight dollars an hour.

On Saturdays, Scott and a few of the other guys traveled with a local merchant to the Saturday market in downtown Portland. The vendor steadily employed Scott and Brian, but often other villagers would help out, if they could be squeezed in. It was hard work. I spent two days with them, setting up and tearing down the 400-square-foot tent with 50 racks of clothing. They would set it up early on Saturday, then go back to the village and sleep and then go back again Saturday night to tear it down. Then, Scott stayed up all night doing security for the market. And he was really happy to have both jobs. You see, these guys, even with their drug use and their poverty, were not afraid of hard work. But high-paying hard work, the kind that would get them out of poverty and into regular housing, hadn't seemed forthcoming.

Sunday mornings, the guys showed up and set up the tent again for the Sunday version of the market. The market was set along the waterfront and between several town squares, and it was jammed with clientele when I saw it. There were many interesting vendors, crafts mostly, and an array of ethnic foods. One vendor-craftsman made interesting belts and bracelets from old bike tires. And then every Sunday afternoon, the guys tore down the booth. They slept most of Monday. So, from Sunday night to Monday night I rarely saw Brian, Scott and Lisa. They were just too tuckered out.

Lisa handed Scott the phone. He had a few things to add. He wanted me to know that, since I left, they had really been working hard on putting a stake together. "We have goals. We are saving money, but it's not a lot. We would hope to get on the list for subsidized housing, but with what we make, we wouldn't get into good housing. But for now, we are happy to be at Dignity Village. I mean it's done so much for me, for us."

"What are the most important things it's done for you?"

"Well, I know I dug myself into the cesspool I got into. When my wife left me and we got divorced, I did what any single divorced guy does. I was at bars and I got back into meth. I did that. And when my mom came and lived with me in my house for the next couple of years, it drove me crazy. She wanted to treat me like a 12-year-old kid. And I forced her to leave. I did that. I know I did that. But I never had time or a place, you know, a place where I could take the time to worry about that. You know the village helps me because it gives me a place where I can be who I am and I am accepted for that. I found my voice at the village. I have learned to speak out about the wrongs that are around me. I have a sense of home again for the first time since my divorce."

During our conversation, he told me that his mom wasn't doing too well. She was living in The Dalles in Washington with family. His dad lived in Arizona. Dad had money. He lived in a fancy neighborhood. Scott and his father hadn't seen each other in many years. Scott didn't see his brother or sister either. None of them were too agreeable with Scott's life choices. "And it's probably best that way. If I spoke to my father, all he'd do is tell me what a failure I am. But my Mom, she's old and I hear she isn't doing too well. We speak a couple of times a year, but I really need to get a hold of her this Mother's Day and try to make my amends. My life went the way it did, and I haven't been able to dig myself out yet, but I'll get there."

Lisa shared his optimism. Most of all for Lisa, the village had provided a space where she could be who she wanted. She knew that there were social and political conflicts in the village, that there always were in groups of people living together, but folks in the village were pretty tolerant of one another, despite the vocal and, sometimes, loud arguments. She used that word, *tolerant*. Most of all, the place inspired her to use her voice. Villagers were encouraged, at least in principle, to speak out and to feel safe doing so. That's why they had rules and protocols about not using violent or demeaning language towards one another. In principle, this rule was supposed to encourage people to feel free, to enjoy the right to self-expression without fear of reprisal. But the rule also required that people be courteous to other villagers. This sense of civility is interpreted differently on the streets where, very often, getting along means moving along. But in a sedentary place like the village, people were encouraged to work out their problems in ways "normal" people do.

And since Lisa had lost her fear to speak out, through her relationship with Scott, the village seemed to be the perfect place for her to develop her social and leadership skills. "I used to cringe when I said anything heavy – with a husband who beat me and with a

boyfriend who beat the shit out of me. I was afraid to speak. But being in the village with Scott, Scott's so special for me... First of all, I learned I didn't have to cringe if I said something he didn't want to hear, or do something he didn't want me to do, and he gives me the opportunity of being who I am, saying what I want to say. There are no retributions. From him, or from the people around me, for the most part. I mean, we have arguments and fights, here in the village, but don't you?"

Scott and Lisa, as an unusual example of the successful street couple, show that relationships do not have to disintegrate, as most do because of life on the streets. In some cases, the exigencies for homelessness and street life are a proving ground for intimate relationships. As much as they bicker or mimic each other, Scott and Lisa had remained a tightly knit unit.

After the December elections, Lisa had become a council member and the head of security for the village. Scott teamed up with Ptery on the outreach committee. While Ptery is out around town being actively involved in housing actions, Scott stays back at the village where he feels most comfortable, taking students, tourists and interested academics like me on tours, where he tells them right off the bat, " You are probably going to see some things you won't agree with or understand, but miracles are often like that."

Before ending the call, Scott spoke enthusiastically about the chance the village has to overcome its hardships. Despite some of the "whacky" rules and changes that have been occurring since the annual election in December 2011, he was sure the village had a solid future. But he also insisted that I ask the people involved what they thought about that. "So much has changed since the elections, and so little. I can't explain it really, and there I go, I've been running off again."

"No, not at all. It's good to hear all this," I told him.

"Well, it's making me nervous, a little hyper, I don't know why, but it is. But, I guess it's just that we are at a crossroads here, and it's sink or swim time."

CHAPTER FOUR ~ DEPARTING

NO EXIT

I gave my entrance into the community a great deal of thought but I have never really been able to make an exit. Officially, I left on July 23, 2011. I had cut my visit a couple of weeks shorter than planned. My stay there had been marked with so many observations of the same mundane events, the constant bickering and the general malaise that many of the stories spoke to, that I was beginning to feel not only physically exhausted but also psychologically spent. There comes a point when psychiatric problems, toxic air and drug culture become repetitive and of little value to the work. My decision to leave the village ahead of schedule happened over a period of a few days towards the third week of July. My field notes are filled with examples of the frustration I was beginning to feel in the village. The greatest frustration was in watching day in and day out a state of complete non-involvement by the majority of the villagers with the world around them. They stayed in the commons room and watched TV all day. Or, they stayed in their dorms or on the berm and wallowed in self-pity. Those few who did venture out were making plans for the future, but the majority seemed anchored in childish disputes and a black hole of drug-induced despair that, as witness, I found suffocating.

Villagers grudgingly put in their hours in the store, or sweeping the grounds, but there was so little enthusiasm it was hard to watch. I came to dread filming the partisan playing out of the political meetings, when only weeks earlier I had thought them the key to the democratic process of the village. I still believed that the process was important, but I was angered by the lack of willingness of most of the villagers to get involved and participate. Such participation would have reduced the impact of factions on the decision-making process. I had a lot of talks with Mitch and Ptery, and with Dave Samson. I took them out often and we talked about how the village could survive, and at that time it just seemed that the collective will to change had vanished. I remember having burritos with Mitch one night and telling him, "I can't stay here any longer. It's pointless. Nothing is going on." If it hadn't been for Nigel's visit between July 16th and 20th, I might have left even sooner. His coming brought a bit of life to the village, and the photo shoots, as I mentioned, inspired some new conversations. But the village and the people in it seemed continuously bogged

down by apathy and indifference. Nigel noticed it immediately. "It's tragic, really," he said. "I mean, they are people after all. I can't imagine living like this." On July 20th, the day he flew back to Toronto, my notes begin with: "Nigel flew home. Fighting exhaustion, boredom, allergies. Q. Have I stayed here way too long?"

That night I went out with Dennis Karras, who had for some time been a strong supporter of the village. Every Friday, Dennis had brought donated organic foods from a nearby New Seasons Market. I had interviewed one of the managers of the market. He had expressed a very common sentiment amongst entrepreneurs and restaurateurs whom I had met; there was no such thing as waste, just a lack of desire of people to redistribute. So New Seasons and several other markets and shops had established a practice of handing over their near-term products to several people like Dennis, who, out of kindness and a "sense of responsible sustainability," redistributed the products to the needy, and to community organizations that had had use of them. When I think of the vast amounts of foods that are dumped into the garbage in our cities, it is difficult for me not to ask why it is we don't do more daily redistribution and on a wider scale, and also, why are there so many by-laws that stand in the way of that.

Dennis was part of the Columbia Ecovillage,[33] a mainstream cooperative residential community about five miles from the village. He and I had been friendly, and I spent some time with him, filming the hard work he went through to organize the delivery of donated goods to the village, a school and another homeless program. He knew that some of the villagers were frustrated by the inactivity of the others, but he seemed more optimistic than me that the village could pull its head out of the sand. We sat outside at a pizzeria on the charming Alberta Street. He looked at me and said, "You know, I can see how it has worn on you." I replied, "It's just the allergies." He smiled and laughed, and then a couple with two youngsters strolled by. The kids were attracted to Dennis's laughter. He had a rich, vibrant laugh. The kids were wearing bright and weird plastic toy eyeglasses, and they looked every bit the part of Ptery's subaltern Wiccan festivals. Dennis, himself dressed in a funky T-shirt, with several wristbands and beads and his trademark cap, immediately started a conversation with them, and the children were remarkably light, bright and animated. I choked up. Was this world of life and color, of pedestrian civility and spontaneous laughter, only possible outside the village? Were not these the kinds of subtle decent things that make someone's life

[33] www.columbiaecovillage.org

135

dignified? Was I bummed out by the sense of loss of innocence that the village was giving off, or for something more profound? Was I discouraged that the village had so dismally failed to live up to the great expectations built up about it by the "left" press and through its own self-marketing?

One of the kids shook Dennis's hand and then trotted away with his family. When Dennis returned his gaze to my own, I must have shown my sadness – I believe it was that – sadness, bordering on sorrow. "You can only do what you can do, Eric," he said. I recall sending off an email about that time to Darlene Dubiel, who was the senior administrative assistant in my department at Concordia. The email was a venting of sorts, but she told me some months later that she had felt disconcerted by the tone of my rant.

I took a moment to enjoy the last bit of pizza crust. I waited until I had Dennis's attention and said, "Rocky told me it was time for me to go away. Time to get some rest." He said nothing, just smiled and turned to the family as they walked away. I watched them as they went westward on Alberta, into the sunset, and as they did, a homeless man was shuffling from waste can to waste can, plucking a bottle here, a can there, and then he paused and eyed the two empty bottles from our dinner. Then he was gone.

"Great pizza," Dennis said. We parted ways.

That night, when I returned to the village, Samson was fighting with Larry, the chairman of VIC, over issues related to village intake policies. Bubbles, an overbearing, tall, intelligent and belligerent man, was arguing with everyone as a council meeting ended. I went into my dorm. I was quiet. I worked on my notes and pondered if leaving ahead of schedule was deserting my post. I suppose people figured I wasn't in there. I heard some voices next to my window. They were in the midst of making a heroin deal. When it was done, one of the guys said, "Sweet!" That was the most enthusiasm I had heard for some time. A moment later, Fred emerged from the commons and *charrrouggghhh*, he coughed for several minutes but it felt like hours. Far from being used to the sound of this, I was caught up in the convulsions and the agony. At some point I took two sleeping pills because I wanted to sleep, hard.

I was about to nod off when Bobby Jo stomped into his dorm. My dorm shook and rattled, and some videotapes fell off my desk. He slammed his door. I could hear other villagers knocking on it, pleading with him not to do anything stupid. He was so angry at the bickering during the meeting. "Damn, *damnnnnnnn*," he said in that drawl of his, and he broke something. It was loud. Someone, a woman, but I couldn't tell who, said, "That's an IR.

Somebody write him up!" He went completely silent. He stayed silent all night long, so silent that I tried to imagine how anyone his size, with hypertension and anger issues, could remain so still. I felt badly for him because he had tolerated me despite his doubts. I thought maybe he had left, somehow undetected. I was, as evidenced by my field note entry, "at the end."

I could not live there much longer. I wondered for a moment if this was part of how the psychic shift occurred that allows someone entering homelessness to learn how to put up with this stress and anxiety. Was it simply a matter of getting used to it? Every village thing, every argument, every disagreement, every mutual decision, any act of tenuous cooperation was so labor intensive, when filtered through the lens of damaged identities and post-traumatic stress that they all demonstrated in some way. Nothing was easily done. There had to be a discussion, a debate and then some kind of power alignment in which favors were called up, if anyone was to get something done there. I think that is what forced my decision – the recognition that I had to either get used to the place, or get out of there. If participant observation meant getting used to *this* place, I didn't want it. I even gave Samson shit a few nights earlier, called him "useless." We got over that, but that wasn't right. I had gained 15 pounds from eating fast food, and I was in my fifth week of a sinus infection. Just before I passed out that night I wrote – scribbled, more accurately: "We are all stressed out – EVERYONE here is stressed out. Who will save this place?"

On July 23, 2011, I left the village, two weeks earlier than I had planned.

Before leaving, I discussed my decision with a few of the council members and the villagers I had come to know best – Samson, Rocky, Ptery, Brad, Mitch and the others you have read about. I gave away most of what I brought with me except my computers and other video technology, my basic clothes, and some fishing equipment I needed for a stopover on the way home. None of that stuff mattered to me; the fan, the lights, the coffee maker, the bedding, the books, raincoats, pants, jackets, sweater, even a pair of expensive hiking boots, meant nothing to me. But I was really bothered that I was leaving behind people who had become part of me, friends. There was no attempt on their part to make me stay. I think they knew that I had seen just about as much negativity as any one "outsider" could handle. But, still, part of me felt that I was deserting them. And then there was Rhania. We had become very close, intimate. That morning as I packed my car and she had come to say goodbye was very hard on her, I think. I had been so out of touch and so caught up in my work there that I had failed to see that our intimacy was unbalanced. I remember reading Malinowski's *A Diary in the Strict Sense of the Term*, published posthumously in 1967. It revealed

his anger and contempt for his native informants, his frustration with doing his fieldwork in the heat and the backwardness of the place and other, perhaps *darker* details about where "his head was at." It caused quite a stir amongst anthropologists. The question of whether fieldwork could be honorable or noble if even the "founder" of modern fieldwork could have been so corrupted was debated well into the 1980s.

Like some of his critics, I had read the diary and had felt he was one cracked personality. That morning, however, after I drove away, I actually stopped a few blocks down the road and in something of a panic, asked myself if the extra two weeks I had lopped off my stay would really have mattered. I sat there for close to half an hour with the engine running, writhing in my seat, twisted by feelings of guilt for hurting Rhania, guilt about leaving the village. I wanted to call someone for their advice, but in the back of my head I had what one mentor in the department had told me, and that was, "It is not noble to make yourself sick over your work." Then, as if I just couldn't worry about anything, as if every last ounce of energy I had had that I could expend on stressful things had vanished from my body, a calm overtook me. I laughed quietly at first, and then I drove down the road gesticulating quite hysterically, and I have no idea if anybody saw me or not, but it must have looked bizarre.

I was going to spend a few days talking to some housing activists I knew in a small northern town in British Columbia. I was going to fish and sit by the Skeena River and listen to the water. I called my sister to tell her I was officially out of the village. She was happy. I went to Shary's Diner, a franchise eatery near the airport. I ordered bacon and eggs. I felt out of place. A church group rolled through the diner. An obese woman and man sat at a table next to my booth. They ordered four full orders of breakfast entrees and gobbled them down before I could even finish my normal serving of eggs and bacon. They made me angry. I wrote in my notes that: "I couldn't figure out how they sat in those tiny chairs. I don't want to stare. For five weeks I have been staring and observing, interviewing, the villagers, everyone, but out here when I see sick people I turn my head away out of politeness or shame… I am glad to get out of there. I am glad to be leaving Portland."

Except, I now know that I have never really left.

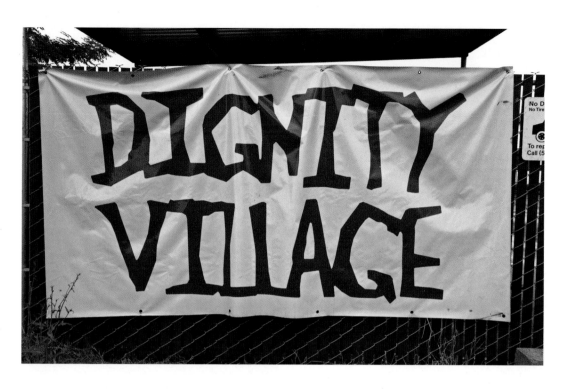

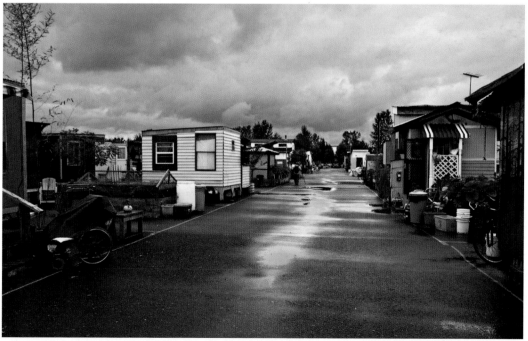

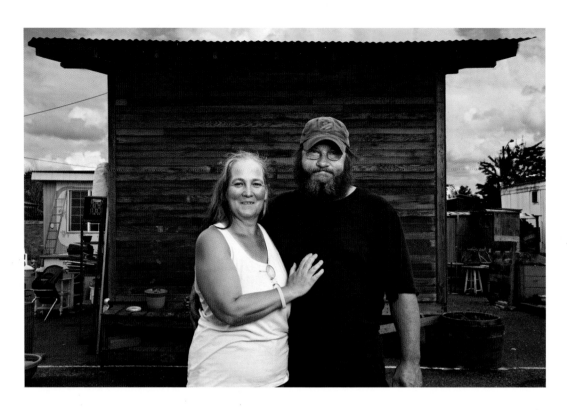

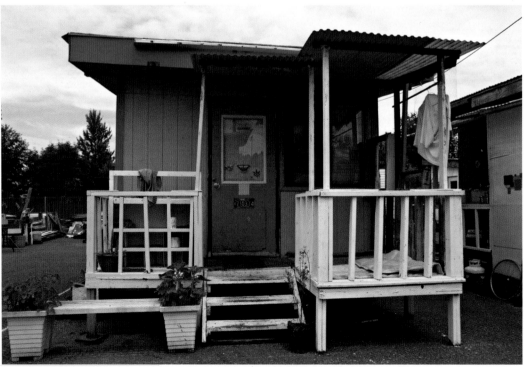

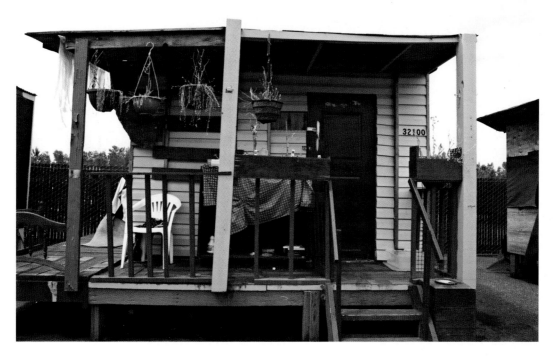

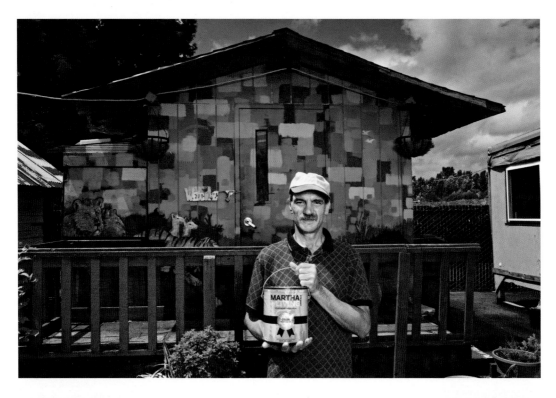

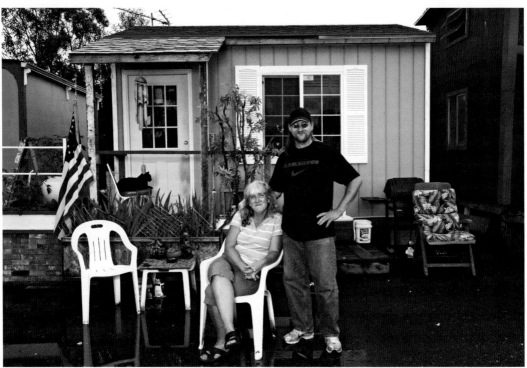

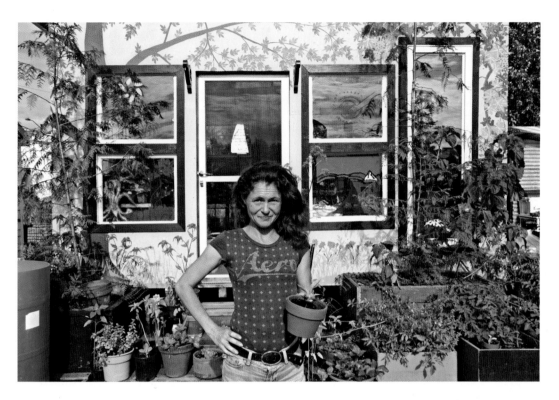

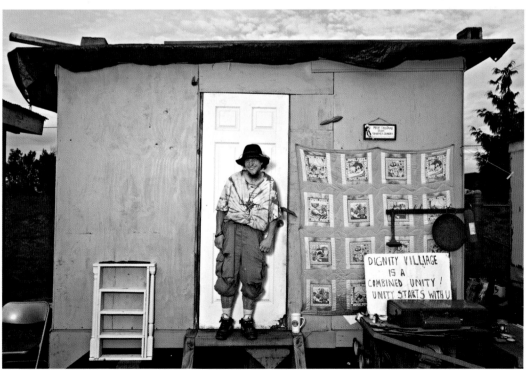

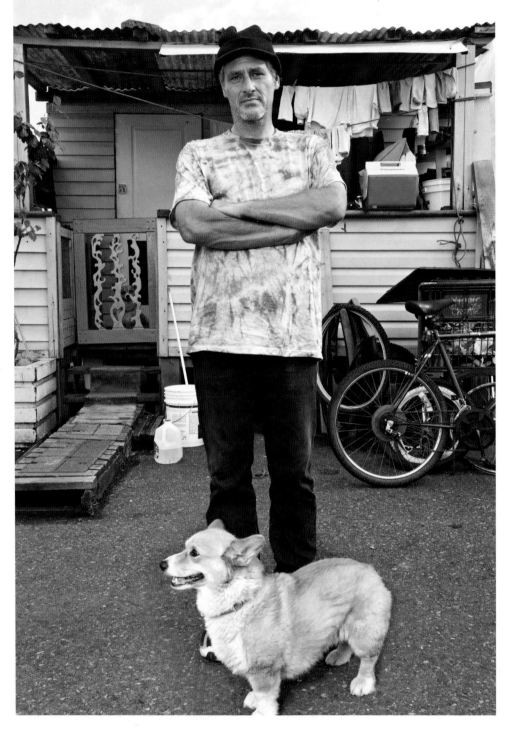

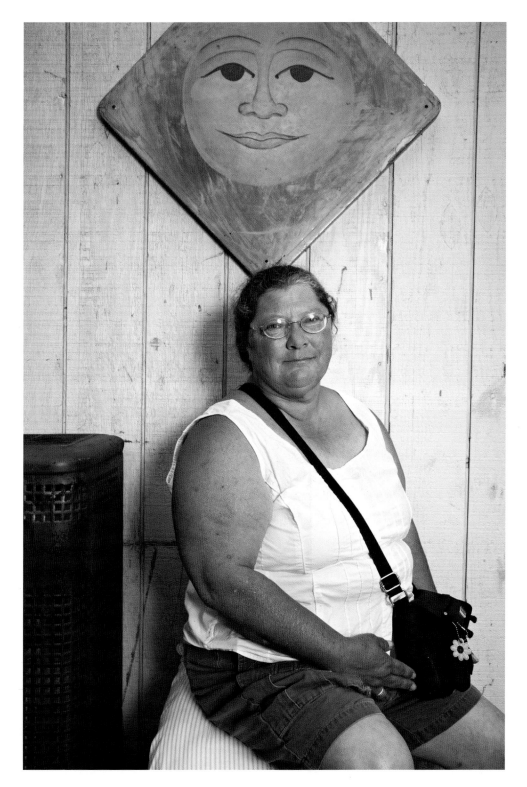

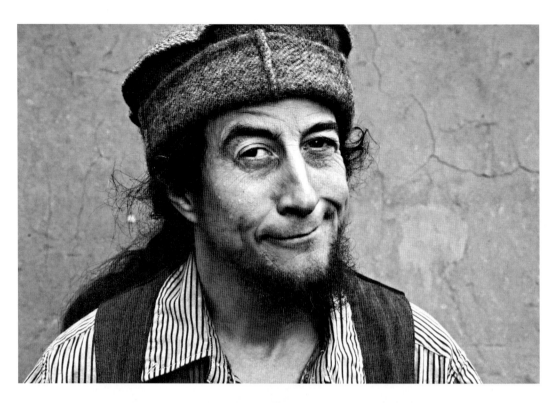

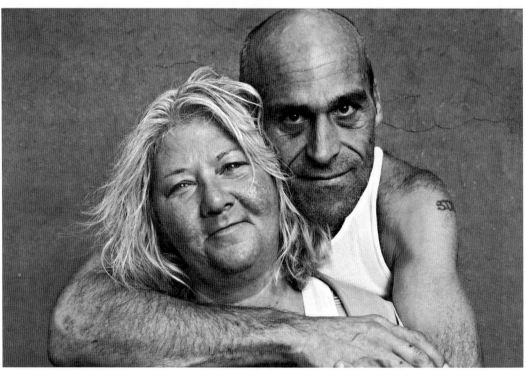

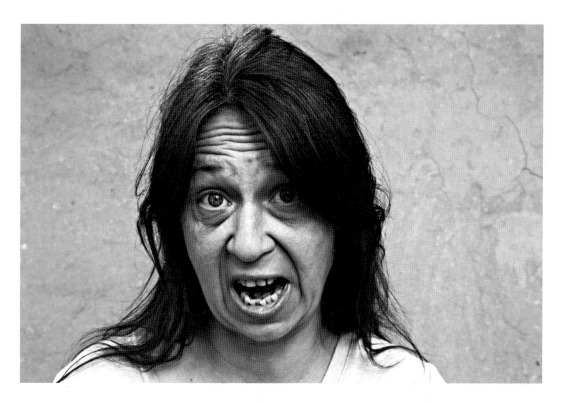

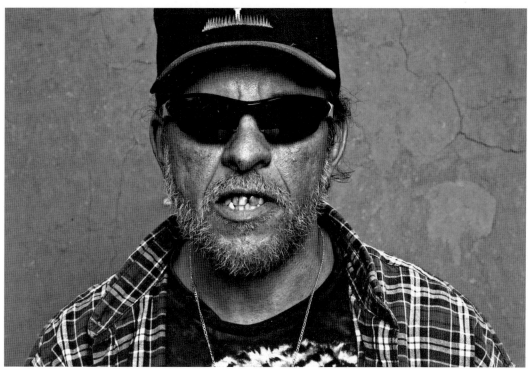

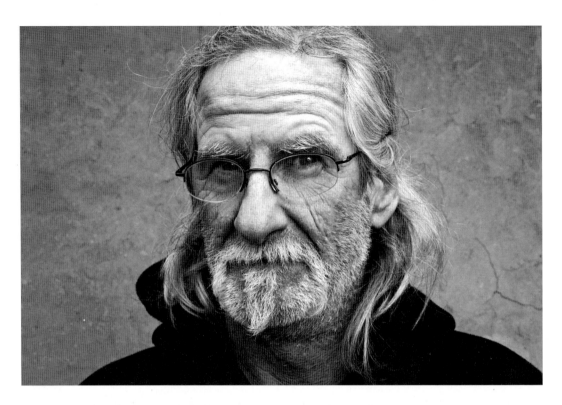

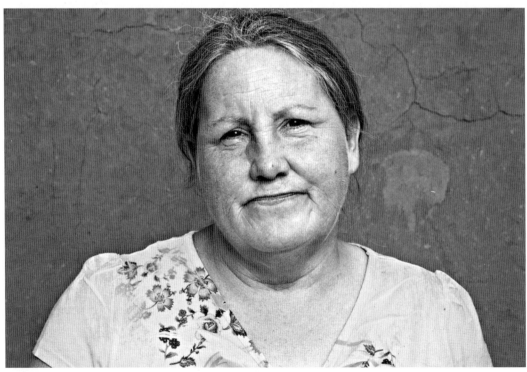

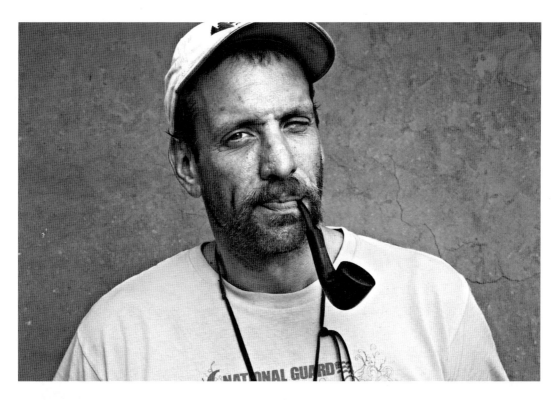

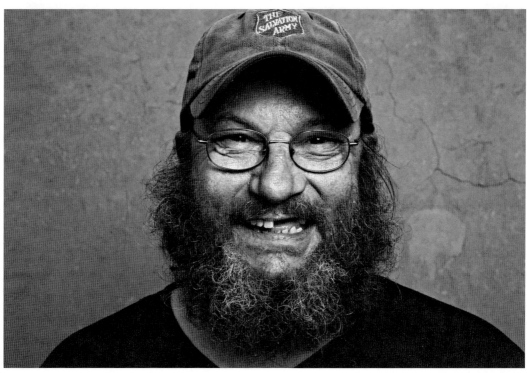

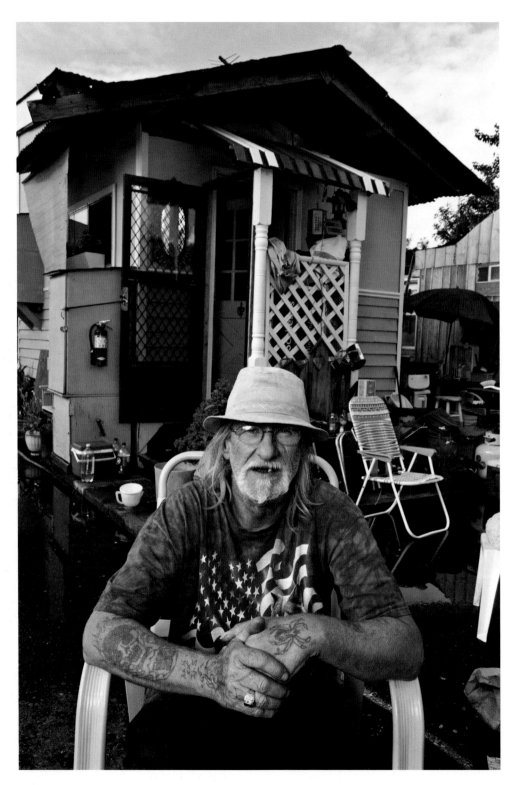

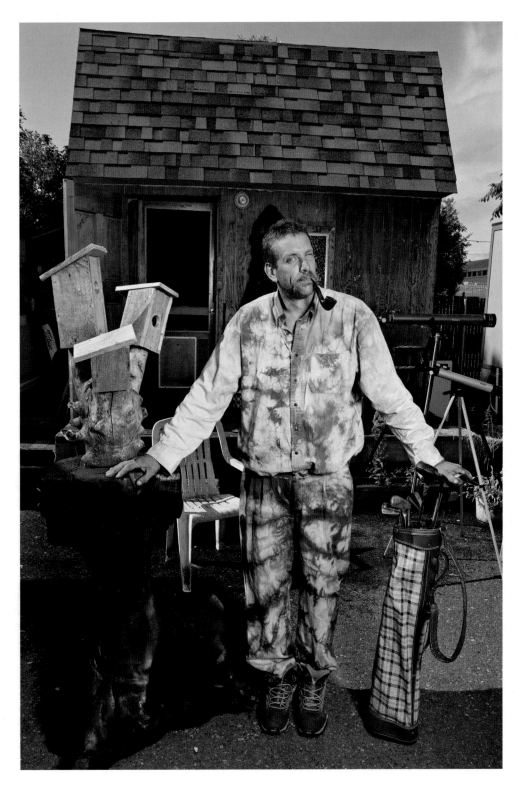

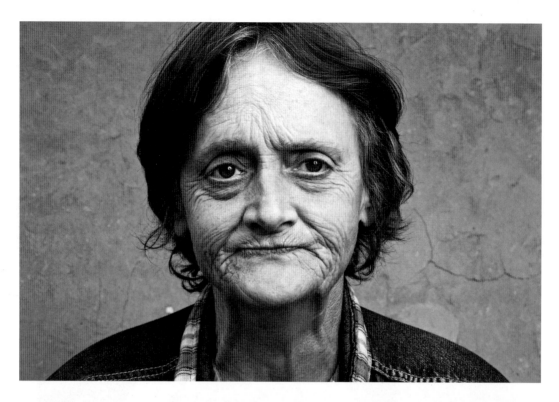

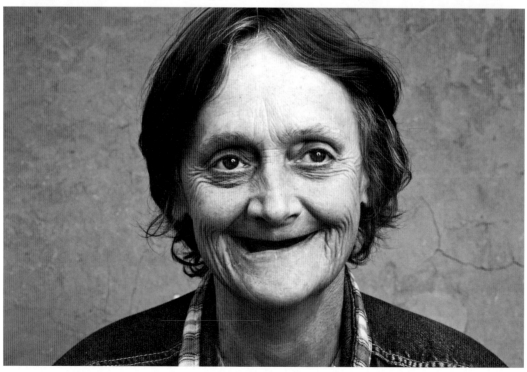

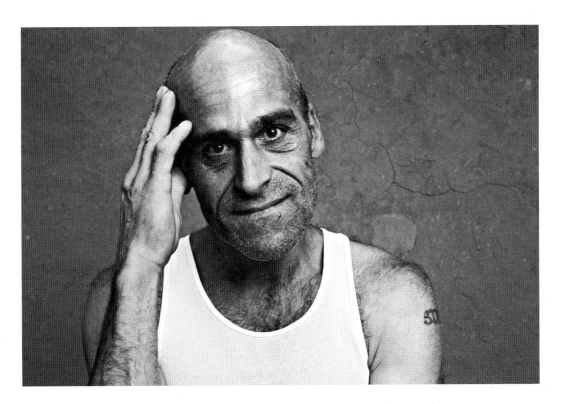

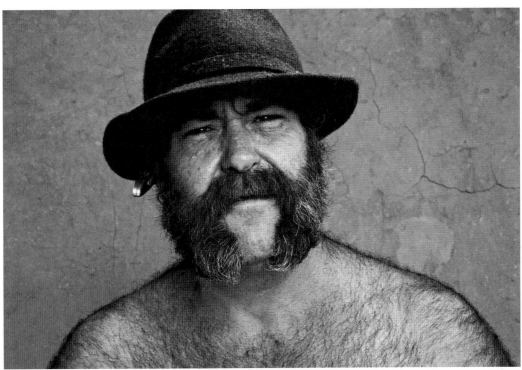

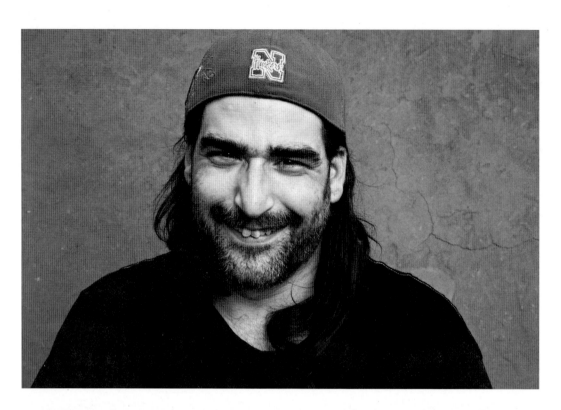

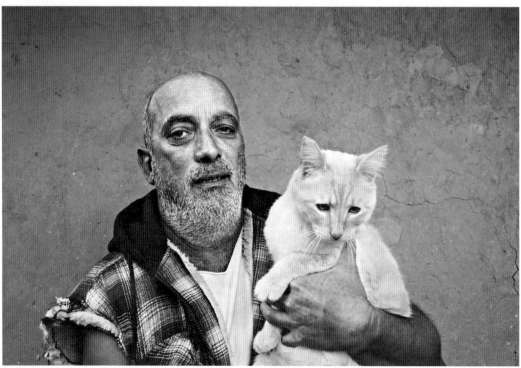

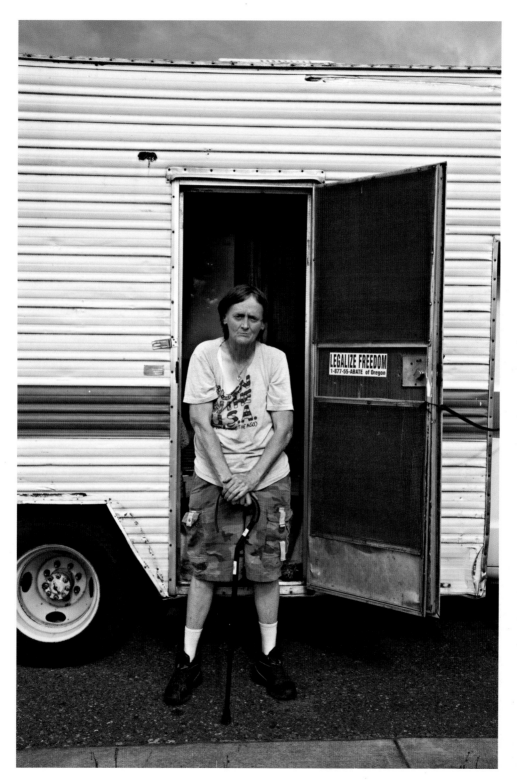

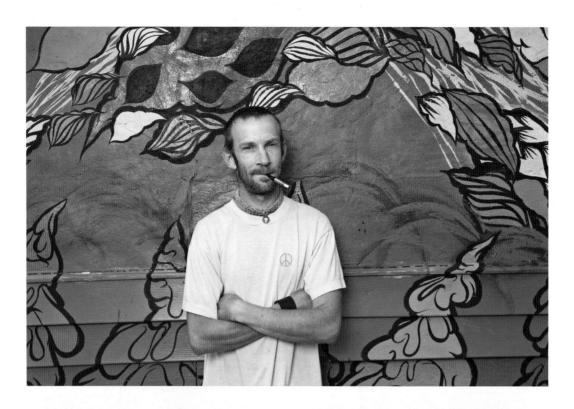

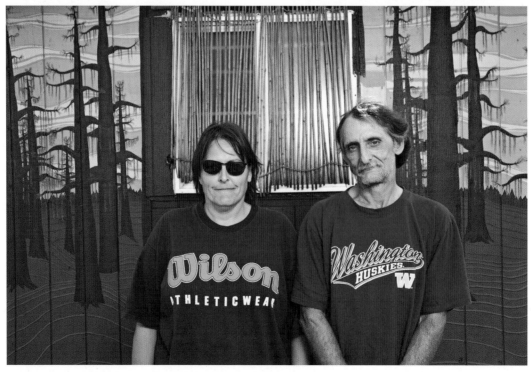

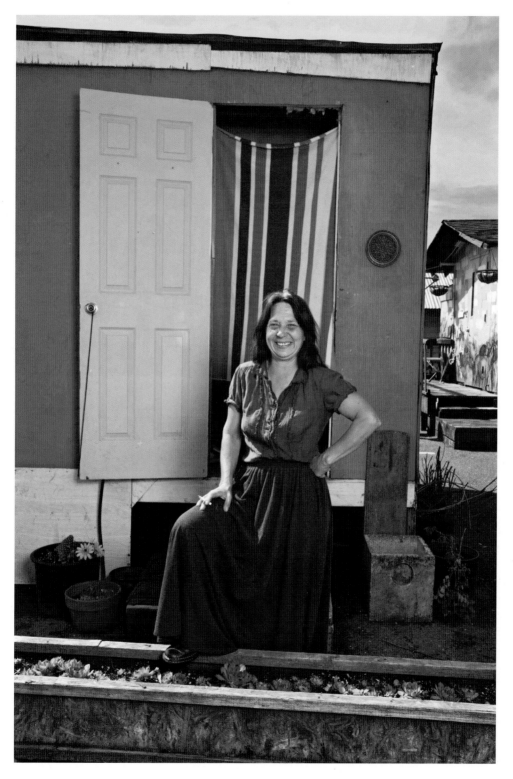

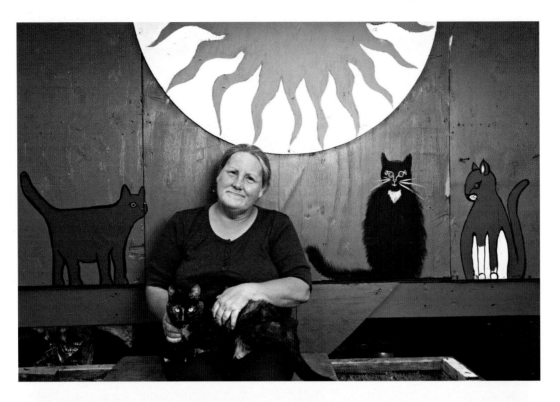

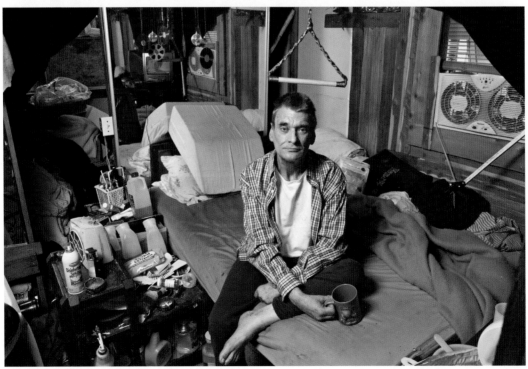

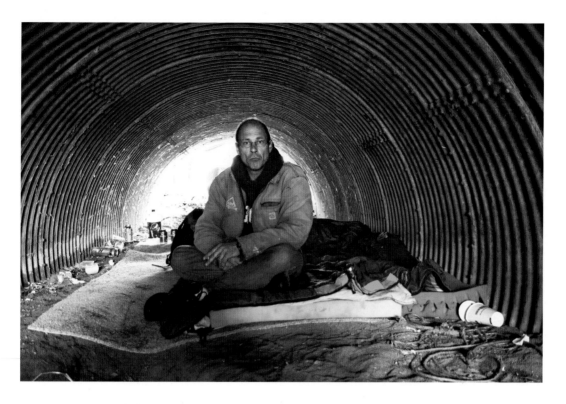

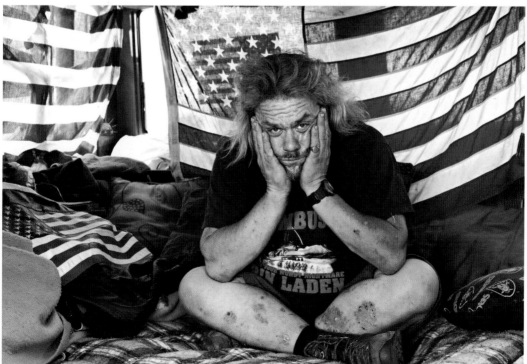

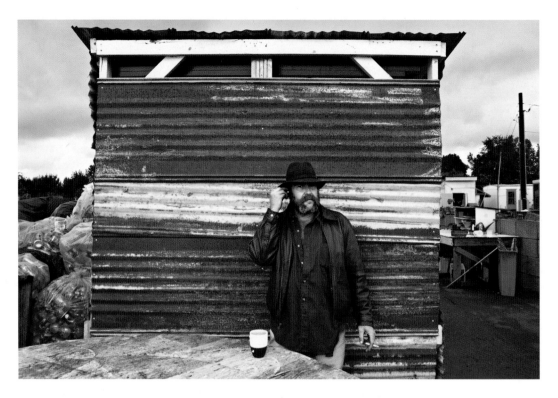

Dignity Village Photographs

by Nigel Dickson, July 16–19, 2011

145 Laura, seated by her structure, has been there long enough to be grateful for her home.

146 Ptery Lieght.

Carol and Steve.

147 Michelle.

JD.

148 Dave Sullivan.

Mary.

149 Brian King.

Brad G.

150 Dave Sullivan in front of his structure.

151 Brian King in the clothes Mitch dyed, with his clubs, painted stump and a birdhouse he built.

152 Rocky.

Rocky, again.

153 Steve.

Samson.

154 Ken

Bobby Jo and Nugget.

155 Rocky outside her camper: "Freedom begins at home."

156 Dave Allen against painted cobb wall, a few weeks before his "86."

Melissa and TC in front of the forest mural that covers their walls.

157 Michelle outside her dorm: "Portland rocks, man!"

158 Mary and one of her cats against the backdrop of her structure.

Brad Powell anticipating a full recovery from his leg injuries.

159 Jay in his culvert: "They put me here…"

Jon Boy Hawkes in his van: "This is America, man…"

160 David Avery Samson (Samson) tweaks his cheap hearing aid in front of the cook shed.

162 The quilt on Ptery's wall.

A retrospective montage inspired by a quiet early morning walk through the village on my last day.
Scan the QR, or go to: www.tinyurl.com/QuietMorningWalk

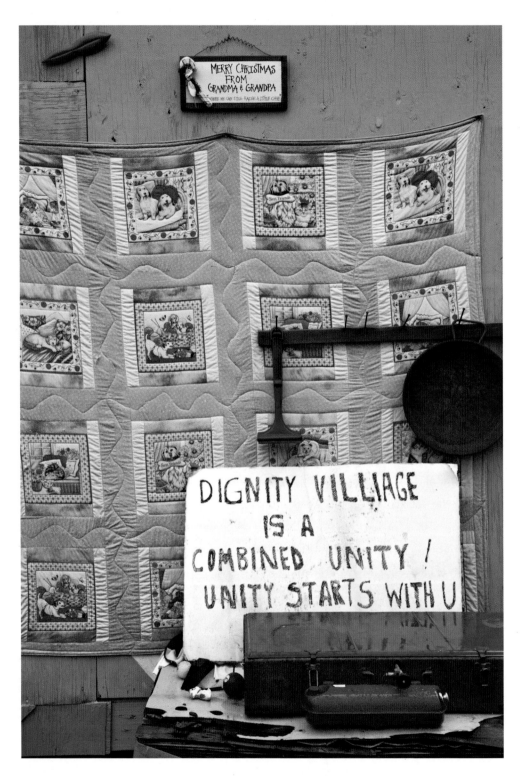

FOLLOWING UP

How does one stop a storytelling that began with my own tumble into addictions and homelessness over 20 years ago, a storytelling that continues in conversations with and the presence of villagers in my life today? This is an ongoing process. It will likely never end. Eleven years after encountering Brian Dodge, the first man I met in Tent City, we still chat and do filmed interviews about his life in housing. The same with Terry Potts and a few others. Dignity Villagers and I continue to talk over Skype and by phone. I think that one of the things that living there did was unite me in some kind of solidarity with a few of the people who lived there. Not everyone there liked me or participated in my work, but those who did connect, remain connected. Modern technology has made it possible to record and share our current experiences and to communicate, and so we do. The performance of ethnography with informants like those you've met here produces important stories and lessons about the culture of the shantytown. But it also produces friendships between them and me. So how do I exit? The easy answer is, I don't. I am not sure where the rule is written that this communication must end. In fact, it has been written that the current state of ethnography is such that it requires our becoming friends with informants.[34] And further, that this friendship imposes a virtually perpetual time frame on the work.

Since I returned to Montreal, Ptery, Mitch, Brad G., Dave Samson, others and I have talked regularly on Skype and sometimes on Facebook. I frequently receive short texts and email messages that keep me up to date on current events. I sent a small standard definition DV camera to them as well, so they could shoot video of matters they felt were important. They have filmed the Occupy Portland action, the R2D2 settlement and personal stories, and they have sent me back the tapes. Not only does this help me keep current with distant events, but it helps some of the villagers, especially Dave Samson and Ptery, record important movements and events associated with their housing activism. For me, extending the authority of data collection to actual informants helps to include the voice of the informant in the construction of knowledge. This is not to say that I am absent from the mediation of their image-taking in the final products but, rather, I am suggesting that in continuing to gather information that they deemed important, they have had direct influence on what stories I tell, and how I tell them.

[34] The use of personal experience and friendship is well explored in various essays that examine how we do research in our cultures, and how we can identify the "ethnographic self as resource" in P. Collins and A. Gallinat eds. *The Ethnographic Self as Resource* (New York: Berghahn, 2010).

Dave also filmed the elections of the new council in December. This year there was a positive regime change. Mitch is the new chairman and Brad G. is the vice-chair. Looks like Brad finally decided to get back in the saddle. Lisa Larson, who has been there the longest of the group, and a newcomer who came just after I got there (who incidentally was the complainant in Jay's 86 case) are also council members. Ptery is on council too and in charge of outreach. It is the perfect job for him. Because he has a regular paying job as well, he could, if he wanted to, find some low-rent, rundown, subsidized place to live, if he gets on a housing list. However, the village is something better than these rundown crackvilles, and he relishes the opportunity to do outreach. For Ptery, doing outreach for the village is a perfect way to carry on his conversation.

I look forward to chatting with Ptery. We talk about once a month. Recently, he was excited about the positive vibe in the village. "Mitch is probably the biggest reason things seem to be turning around. He isn't putting up with the petty Incident Reports, the babbling bullshit. Decisions are getting made and maybe some people don't agree with them, but at least things are getting done. And it's been good for me too. Brad and me go to Right to Survive meetings and a bunch of us went to the Western Regional Advocacy Project (WRAP) general meeting.[35] I've been able to get some of my organizer friends from Portland to come in and shake things up again. The psycho bullshit has quieted down a lot, so people are starting to have the conversations here again."

"Conversations? What exactly do you mean by that, conversations?"

"Yeah, you know, like, what's next? Where do we go now that we know what we need to know — about fixing the place and carrying the message to the outside? You know, our whole conversation as a species with each other is messed up. We need to change that. It's like people here are ready to understand the shift. You know we are a really destructive species. Human beings have to shift right now. People here are saying I want to be part of this shift. I don't just want to get back out there into the messy stuff, I want to be part of the change."

"Everyone there is an activist now?"

"Well in a—"

"I mean more than living there is a kind of activism?" I interjected.

Dave Samson films Ptery as he joins with members of Occupy Portland and Right 2 Dream Too. Scan the QR, or go to: www.tinyurl.com/ProtestLaws

[35] www.wraphome.org

"No, but the vibe here is more positive so people are willing to at least listen. And it's not like there are easy answers. You know, this world is so fear-based. Society tells people what to do and how to do it in order to be normal. We do so many bad things to ourselves and to this planet because we are afraid of being marked good or bad. It tells us, fit into this, fit into that. When we don't fit in, we are mentally challenged or we blame ourselves. The system uses stigma to mark us as defects, rejects and unworthy. So, there are many conversations that need to be had. But they all are kind of spiritual. We need to be on a spiritual path. I can't tell you what to do, because I am not you or where you are. I treat people like plants. You know, some plants are food plants, some are medicine plants, some are sacred and some are building plants. You see what I mean? There is no one way for all plants, but they all need sun and air and rain. And well, look, society makes us think we are living a dignified life when it really is just separating us from the creator because it has to disconnect us from our own sense of dignity, for what that might mean for each of us. Otherwise the rich can't stay rich. Otherwise the holes in the earth's skin don't get dug. You know, the water would be cleaner if we were really about dignity. You *know* what I mean? Anyway, people here, some of the people at least, are starting to see that we are the ones who can carry the conversation."

Listening to Ptery, part of me wanted to see all this positive change for myself. I told him this, and he reminded me that, at least, we could talk on the phone.

"Funny that we are talking like this, over the computer, the phone, isn't it?" I ask.

"Well, I don't know." He offers, "Isn't this how people talk to each other? You know, outside – in the good world?"

"What do you mean 'the good world?'"

"Well, you know, the whole part of the system is that people need to be afraid. You have to be *afraid* of the homeless. Things are good, or bad. If you are homeless, you must be bad. Homeless folks don't have computers and cellphones. That's too close to good. I am here to try and expose the mechanisms that makes us think in terms of good or bad."

Around the same time, I received some urgent texts from Rocky, asking me to call her. Reconnecting with her, in particular, was important because I learned from her that shortly after my departure, while I thought she was embarked on a cross-country voyage, she had moved back to the village. She stayed in a dorm vacated by a villager who had found work as a mechanic. This fellow was staying at the garage owner's place. But there were no guarantees. It was very likely that he would return, as many of the villagers do. A

few villagers, who had been waiting to hear, finally got on social security and were in various stages of waiting for subsidized housing. And two other villagers had died; Fred from natural causes, and Steve-O from liver failure. Sad news, but in their departures new structures became available for other folks who'd been stuck in the tiny dorms. And in the transition, even that young man with the camper and the cats had found a place in the village. He is the first Afro-American to live there in some time. So in addition to changes on the council, there were alterations to where people were living within the village. Earlier, I argued that changing spaces imposes important psychic and identity shifts for villagers who transited from the couch, to a dorm, or from a dorm to a structure, or from being single to being hooked up or, more rarely, from the village proper into housing.

Moving *back* to the village imposed other psychic shifts. I had always been thinking of the village from the perspective of people moving from the streets or homelessness into housing, as if the village were an obvious step up from some dark and dangerous place. I hadn't met anyone who had just returned from housing to the village without experiencing homelessness, that is, someone who had returned by choice, and Rocky presented such a case.

Rocky had moved in during October 2011. Now some months later, she told me she was working as the "bean counter" in the village – the one who keeps track of the sweat equity hours that each resident is supposed to put in. "Ten hours a week, or you can do 20, but you have to do a total of ten per week for every week in a month – five weeks if it was, like, last March." She really has the job down, and it sounds like she is taking pride in it. I read to her the first two pages of her section from this book. She choked up, but she was content with it. "It's honest. I like what you said about me, thank you."

To me, those were important words. "Thank you" suggested to me that I had honored the person, much as Nigel's photos did, as multi-dimensional and important people, living characters. And Rocky, above all the others, seems to enter my work as an icon of very basic values – respect, honor and dignity. However, I had to know.

"Why did you move back to Dignity?"

A pause.

"Well, you know, back in April [2011], my good friend in Vancouver, Washington, died. He was a vet. Like me. He was an African American, and I didn't want anything from him, or him from me. He was just special people and we was good friends. His family used to say I was the oddest white woman they ever met. They had no idea I was gay. Unlike the other

white women he had in his life, I didn't want *anything* from him. We was just buds. And he died. The VA missed diagnosing his cancer."

"They got the wrong one?"

"What's that, you say?"

"I said they diagnosed him with the wrong cancer?"

"No, I said they missed diagnosing his cancer, completely. And when they rediscovered it, they didn't offer him any treatment. They just told him to let go and accept it. And I was pretty choked by that. I see these athletes hurt their fingers and get MRIs the same day. I had to wait eight weeks at the VA for mine. He waited three and six months for his. They treat us like shit. We were both vets, and they should've done him some goodness. When he died back then, and that's before you and me, when we met, but I was, well, I realized that there was nothing for me in Vancouver so I drove over the bridge and starting coming to the village more."

This was quite a revelation to me. Rocky and I talked for hours on camera about her entire life while I lived at the village. We had traced her life and environs on our many car rides to her old 'hoods. Yet, this important fact she didn't seem to mention.

"You never told me this."

"No, you're probably the first person to know this. I only figured it out a few weeks ago. I've been working with Michelle, the therapist who comes out here. And we just kind of worked it out the other day, actually. She has helped me understand my choices. All my choices."

"Well, you know, Rocky, seems like a good—"

"I was just running, I think, from, to and nowhere, but at least I knew people here. And I bought the camper and convinced myself I was going to travel the country again, but… I still had people here even though they didn't know anything. You know Rocky, 'She can smile through anything.' Anyway, I got here in October and now I'm the bean counter and I really like it. I'm fair, you know, not like them before. I don't cut one person slack and not another, just 'cause they're a friend or not. We're all villagers. Time was a person could be short 15 minutes on their hours and if the bean counter didn't like them they could get a notice. Get written up. A letter, you know, if you are short on hours you get a letter, if you're a member that is… You get a letter and then a second and, if you get a third, you are out for non-compliance. Guests and residents don't get three chances, but I am fair to everyone. But before, non-compliance was a big issue. I mean, there is nothing wrong with the

non-compliance rule, but it has to be done fair. I am fair. I give everyone the same credit, even Mitch."

"Mitch? You say that with a bit of cynicism," I suggested.

She has some trouble hearing me. "What's that now?"

"I say you sound angry?"

"Well, now that he is the CEO of the village, he's got that God thing. It happens to a lot of people here. Once they get to be Chair, they start acting all different. Mitch has kind of become God now. You can't be God here. A lot of people get a big head and I call it the God syndrome – where you think your word is *it*. And then it becomes, like, *I* am going to do this, or *I* think the right thing to do is, or *I* – you become an "I" person. Mitch is becoming an "I" person. And I am really tossed about it. Because on the one hand he is doing things that are good for us, like dealing with the city and making hard decisions, but on a personal level he is rude, and doesn't listen to us and treats villagers like shit. And the village runs things not him, so he could be out if he is not careful. We could vote him out. You know, one day he called me a bitch and he called me a fucking thief and a liar. And that's grounds for an I.R. right there. I was really tossed. But I let it slide, and a lot of folks wanted me to bring it up, 'cause they don't like being treated like shit. And also, there was some issue about him not reporting his hours one time and I could have written him up on that, but I didn't. Because I am a fair person. I'm really tossed about Mitch."

I asked Rocky how things were going at the village. She reminded me that it was spring and the weather was getting better, so it was hard to tell if any of the positive action going on in the village was because of the positive directions that the leadership was taking, or if it was just because the sun was out, finally. Rocky was planning to attend classes at Portland Community College in the fall of 2012. She wanted to study management. She wanted to volunteer at the Salvation Army or Red Cross, and, "Sometimes having management skills helps ya get involved in those places." *So does bean counting*, I am thinking to myself.

Rocky had developed some serious opinions about Mitch. I wanted to understand his position better. Mitch and I talk frequently.

"So what? Do I call you Kaiser Mitch now?" I asked him the other day.

"Better than Adolf. I got Adolf from one of the freaks a couple of days ago. Adolf? Me?"

"Adolf Grebic. Sounds like an interesting hybridization."

"Whatever. As long as my mind is in the right place, I think they see that what I am doing is fair."

I had to ask him if maybe some of the villagers might be right, that maybe he was taking his role too personally. I suggested that maybe it was not about him, maybe it was about the village?

"Yeah, but it's not them that's being judged on his performance, it is me. So yeah, I do say Me. I, I'm the one doing and getting blamed or, I don't mind saying it, praised too…"

"What do you say to the feeling that maybe you are rude?" I asked.

"Fuck it, nothing." He pauses. Then, "Actually, it's not true. Anyone who really knows me knows I am generous and nice but it makes me angry because people, especially new people here, don't know what it is I have to do here. Not only do I have to do my straight-up business with the city and the bills, and all the bureaucratic stuff – cleaning up the books and keeping the authorities off our back, you know, and with no emotional attachment, straight up." He paused, waiting for a reply.

"And many of the villagers applaud you on that," I offer.

"Yeah, well, most of the time I do this robotic work that other leaders have let slide for, for, forever, really, and I never get credit for it. But then I walk out on the tarmac or in the village and I have to deal with people's emotional crap and grievances too. And this stuff asks you to be emotionally involved. How can you not be? Anyway, I think I have a lot of emotional attachment to the village and that's why I get angry – especially when I see other villagers not taking their role to help other homeless people seriously. You know, sometimes people here squabble about absolute crap – about towels, or about leaving a computer on. And the same idiots can be on duty or on council and they have power to influence the lives of fucked-up people who just came in from the street, and they spend a lot of time trying to make their adaptation to the place harder not easier, and that gets me frustrated, angry."

It was a rant. "Do you feel better now? That was pretty intense."

"Yeah, I'm fine, I'm fine."

"How's Michelle?" I asked. Mitch and Michelle came into the village around the same time and had become members the same time, and they'd both been into carpentry. When I left the village, I had joked with him that I had one prediction about the place and that had been that, in no time at all, the two of them would be moving in together. He had laughed it off, but they had been together officially for about seven months by this time.

"She's pretty pissed at me. Since I became chairman, she pretty much feels like she lost

me to the village. And we had plans to get out of here. But that's on hold now. She is starting to do well with her vintage clothing business. She buys stuff at the Goodwill outlet store for 15 or 20 bucks and they have great stuff, Eric, great stuff. She made a hundred bucks today reselling it to various stores. Big market for that stuff here. I mean, it's not a lot of money, but we don't get much more than food stamps so it really helps. Anyway, we were supposed to do this together a few days ago because she needs, help, you know, and I fucked up, I had so many things to do for the village. I just figured she'd understand it. Dude, when she's angry she's a wild cat. When she's pissed, it's not pretty for me."

When I met Brad Powell in 2010, as chairman, he had had immediate long-term goals for the village and for himself. He had wanted to get the village up to snuff so it would pass their annual fire inspection. Long term, he'd wanted to help the newcomers to learn how to make good decisions for the village in case he departed. Unfortunately, as I mentioned earlier, Brad Powell's story had not gone in any of the directions he'd wanted. In 2011, JD, the acting Chair who'd replaced Jon Boy, did not speak of short- or long-term plans. He had just wanted to manage the faction fighting that sprung up after Jon Boy had been kicked out. He had also acknowledged that the meth use in the village had become intolerable, and that he'd hoped to at least mediate the bullshit so that the village could have addressed the very real need to "clean up and get its feet on the ground." Back then, the city was looking very seriously at following the recommendations of the 2009 assessment. Among other things, the assessment suggested moving the village to a permanent location, bringing in outside educators and advisors to help the village generate income, and, lastly, encouraging residents to seek subsidized housing at some point, so that the village would be able to help more people in need of emergency transitional housing.

None of that had happened. However, since Mitch became Chairman, Brad, Ptery and a few other newcomers to the council have helped generate a more positive buzz. Mitch was often maligned by other residents as being rude and harsh. That was his personality. Nevertheless, I think it was also the reality of the job. Being a Chair in a village of damaged identities and people, who were used to the unstructured lawlessness of the streets, required a certain degree of arbitrariness and, sometimes, it sounded rude. More importantly, Mitch has been focused on short-term and long-term goals.

In the short term, most importantly he wanted to help the village craft industry get going again. "Well, it's a lofty idea," he said, "'bent boxes.' You know what those are? The Indians here used to make them. You soak a large board and notch the edges, and when

it's wet you bend it into a box. But so many of the people here are artists, I mean it's a no-brainer. And people will buy these. It's part of the area heritage. I think we could sell them at markets and stuff. Anyway, that's one of the ideas to get the village working together and maybe make some cash. I have lots of ideas. Stay tuned. Long term? Long term, I have this thing going with Nike. Nike came out and wanted to build us a new commons area building. And I brought it up to the city and they have agreed to lift all building restrictions on us to do this, so that's something I am waiting to hear about."

However, I want to know about Mitch. What are *his* plans?

"Personally, me? Short term? Survive the slings and arrows." He laughs. "No, seriously. Long term, I have no idea. I really don't know. I'm kind of leaning towards activism. I dunno. I dunno what to do with my life, dude!"

Chapter Five ~ Conclusions

I said earlier that I was motivated by several points of inquiry. One was an interest to understand the degree to which the village is really an alternative to existing professional housing programs. As a socially and materially constructed community space, did it provide villagers with a dignified life and a meaningful transition from the streets? I also wanted to know how free the villagers were to pursue their goals within the context of neo-liberal governmentalities that tend to impose legal and political limitations on the extent and manner of achieving these. So, having read these stories one might again ask, does the village produce a dignified living experience for the people I have written about? Have these stories brought me any closer to understanding how governmentality, which Foucault said quite literally was the "art of government," produces a self-governed citizen, even from amongst the worst-off poor? Can the story of the village and the homeless people I have met be told without discussing drugs and alcohol? And of course, there is a need to know what lies ahead for the village and the villagers. It was perhaps an arbitrary decision, but I decided some weeks ago that as soon as Dave Samson was ready, he and I would have a bull session – what he liked to call, "a sort of state of the union address" to conclude this study.

In the last few months Dave has sounded far more optimistic about the village. His own depression and anxiety has been somewhat alleviated by his participation in the civic life of the village. With unusual faith in the leadership, he has become the village chef and prepares communal meals for the village. And he has also become the donations officer. The distribution of food and material goods in the village had been a source of corruption and faction building in the village. I asked him why he had so dramatically changed his opinion about things.

"Well, the strategy that Mitch, Ptery and me and others had was that one of the best ways to alleviate tension in the village was to just start and provide more community meals for them, and we figured if we alleviated that anxiety for them they would start being more better behaved with one another and more civil. It's taken us three months. Remember how

when food donations would come in, people would just stockpile it up and stack it up on their plates like it was free for all without thinking about anyone else? Well, now they actually wait politely in line because they know I'm making sure everyone gets their share. So we alleviated that anxiety and that has put less pressure on the council 'cause now they don't complain to council so much about things. And, you know, I have taken over donations, and the villagers have turned to me with a sense of trust because they know I am going to give them what they're fairly entitled to."

"How do you decide what *fairly* distributed is?"

"Well, like making sure that everyone gets fed before people start taking more than they need."

"But donations isn't just about food. It's about clothing and material things that have meaning too."

"Yeah, yup, yup, and that I am working on now too. By basically being casual and friendly about it, the villagers are beginning to trust me and my judgment about what's fair and not fair. "

"But it can't all rely on you, David. There has to be…"

"Oh, I know, I know. My strategy has been pretty much staying out of the political aspect of it, and all I been doing, I figured if they weren't listening to my political ideas, then what I could do is just lead by example and provide a good steady consistent attitude and application of principle."

"And what's the principle?"

"And it's starting to help." He didn't hear me, his earpiece on the brink again.

"What's the principle?" I asked again louder.

"Ah, fair distribution. Helping them understand finally that, look, you're going to get what you need – you might not get what you want – but we will make sure you will get what you need. And that's starting to put a lot of the conflict to bed because donations and access to things is one of the great tension spots."

"And what are the other tension spots?"

"Ah, right now, communications."

"Between people?"

"Between council. Between membership."

"But why is that? How is the council functioning if there are still communication issues?"

"Ah, it's functioning well. We had a membership meeting today and it went smooth as punch. We talked about a lot of things we wouldn't talk about before. We were voting on a couple of VIC members, issues, and we were discussing the activist activities we have been engaging in."

"So, who's participating in the activist activities?" I wanted to know because, based on their stories, I have had the sense that if more people got involved that the village will start to breathe life again.

"Ah, me, Larry – he's a new guy – Ptery, Mitch, Michelle, Brad, Chuck. About eight of us, more than double when you were here. We've been involved with the VBC, the village building convergence here in Portland."

"What does that mean?"

"Well, it develops community centers that work for people. We work with other activists who want to provide housing for people. We work with people, for example, who want to downsize their homes into smaller places, who want to live in sane living spaces, living in comfortable living spaces without leaving a huge carbon footprint."

"And how realistic is this?"

"It's very realistic. Right now the village is connecting with thousands of people. We go to the meetings and make connections. We are establishing new lines of communications with other groups and re-establishing lines of communications that were lost here over the years with other groups, and with emerging groups."

"What are the emerging groups?"

"Well, one is Rethinking Psychiatry, which is the anti-medication group which is, like, the answer for human psychiatric needs is not medication to control, it's cognitive therapy and helping people re-establish communication and their sense of place. And then there is the VBC, which we talked about, and then we are working with Paint the Pavement, that creates beautiful painted spaces for people to gather in. And then we are working with the Depave group, which is active in taking over abandoned lots and properties and removing the concrete and asphalt and replanting it with earth and trees and plants and gardens, and we are involved with R2D2. In fact, this weekend we are having a big barbeque and they are invited and we painted a big flower box for them."

"How are they doing down there at R2D2?"

"Not too bad. Of course, when I was down there two weeks ago to paint one of the doors, you know, that make up the fence, while I was painting the Dignity Village door, I saw

two of the guys from there go down the street a few hundred feet and buy crack and then just waltz back into the site with crack rocks the size of marbles. That less than impressed me."

"But that goes on in your own village, dude. What are you guys going to do about that in the village?"

"Well, we're starting to have dialogues about that. And, you know, I have been one of the leaders in talking about that and admitting my own problem. And my own culpability with that problem. You know, like Steve-O's death. We allowed that man to drink himself to death by turning a blind eye. And, as a community, we can no longer do that."

"And how in the world are you culpable in all this?"

"Well, in the past, I participated in drugs and alcohol at the village. So I am owning up to my responsibility and saying, 'Look, I know where you're at, I have been there, but there is a better way. We can fix this.' And by alleviating the tension over resources and food we're lessening their anxiety which, you know, eventually will hopefully lessen their need for self-medication. You know, so that days are worth having rather than obliterating." Dave sounds completely convinced that this will work.

"So, the drugs don't necessarily have to be part of the picture?" A pause. Maybe, he didn't hear me again. I went on. "Well, you know, I have been arguing in my book that the drugs really aren't the big defining feature of the village. The drugs are there because people were beaten up, they went to jail, they were raped, they lost their jobs and homes, they were on the streets and that fucks you up really bad."

"Yeah, yeah," he agreed.

I added: "But the system doesn't afford them psychiatrists and doctors and barring that, since that is just another way of controlling them, the system doesn't really allow them places to live their lives independently, or to find ways to excel, so they are left haunted by all these memories with no choice but to get a quick fix. To get high. Right? Is that accurate?"

"Yeah, and then there is the fact that the drugs addict them. Once they are there. I mean, you tried kicking hard drugs. You know what it's like."

"I did."

"Yeah, right."

"It wasn't easy. I had supports. And so, so you're saying that if it became more of a community, then people might be more willing to address their drug use?"

"Absolutely. Absolutely, and we have seen people in the village start to turn away from that. You know like Melissa and TC? I was really impressed a few weeks ago when I heard

they approached Outside In [a non-profit street health group] and said, 'Look, we have a methamphetamine problem and we would like some help with that.' And as more of us are doing that for ourselves, and self-directing, we are encouraging and empowering others to do the same. At their own pace. You know, ideas happen, someone acts, and then they stick to other people."

Since Dave has been so forthcoming, I decided to put it out there. "Look, you've been there twice now, and I was there. And you and I both recognize that when I was there it was in the shits, correct?"

"Right. Absolutely, absolutely."

"And why was it in the shits?"

"Well, because of the entropy that had set in," he said, as if it was crystal clear.

"So, do I have this correct? The entropy had set in because people had been impeached and the people who knew how to do things were long gone, had moved on to other things, and so it was basically—"

"Basically they voted in incompetent people. Like, well, you saw Jon Boy. You know he was the one who invited you there and he wasn't able to carry on with what he promised because his violence and drug problems got him kicked out of the village because he got violent with somebody."

"But once again, Dave, we are coming back to drugs and alcohol and I am really trying to stay away from it. Are you telling me I can't tell the story of this village without talking about drugs and alcohol?"

"I don't think you can tell the story about homelessness at all without talking about the truth about drugs and alcohol. And, you know, that's one thing I have been telling the villagers – you know I am going to tell the truth 'bout the situation whether you find it painful and uncomfortable or not – it has to be discussed. I tell them that. You know, because even though drugs and alcohol aren't the cause of most of their problems, they're the major symptoms. As much as I want to say it isn't a big deal, it is a big deal. I mean, you were there. Geez, you heard a heroin deal going on behind your own house."

"And two ODs," I added.

"And the ODs, too."

"But I see heroin deals and other drug shit where I live here in Montreal too. So what does that mean?"

"I dunno. What *does* that mean? Maybe those folks aren't too happy either. And not everyone here does drugs; Ptery, Mitch, me, and a bunch of others don't do it. So it doesn't have to be. You know pot and beer. That's not the issue really. And when you got there, I was in a very low state and just starting in a very difficult transition out of the fog and into my own path of recovery and you got to see just the beginning of me waking up. You know, and people see me now walking and laughing and getting things done, and I think for some of those I was in the same boat with, it says they can do it too. It gives people some hope that they can get themselves out of the shit. I mean, I am way more confident, and for the first time in years I am operating on all eight cylinders."

And it was true that the times when I had seen Dave smoking up with Brad P., or when he had disappeared with his close friend Jay to drink, had been disappointing. He'd always returned looking worse for the wear and had sounded regretful. He'd also sounded defeated and often he had remarked that it was "hard not to get too high when things were so low in the village." The most recent shakeup of the village leadership had really inspired Dave. With faith in them, he had started having faith that his own efforts at the village might bear fruit.

I had to yell again. "What other positive things are happening?"

"Well, the greenhouse is up and running, and the store is getting people motivated. But I think the activating that people like Ptery, Michelle, Larry, new Larry, and Chuck and Brad G. are doing, it really helps. They might not comprehend what we say about meetings and activist stuff, but people see the change in us and it really helps. You know, they are seeing our behavior and our action, you know, like, we are having a little meeting discussing what we are doing and we're laughing our asses off. And they are attracted to that, they want that happiness. People are willing to enter that conversation. And one conversation leads to others and..."

"So, how do you get the village back in stride?"

"Well, we have to bring other voices from the outside into the conversation. You know, we aren't really good bookkeepers or nutritionists. But there are others who are."

"From the city offices you mean?"

"From wherever. You know, a lot of other people have been homeless, too. And some who haven't can help with the problems we have. Activists and non-activists, doctors, lawyers, artists, whoever..."

"So, you have to bring outside help into the village?"

"Absolutely. And we are sort of doing that already. By reaching out to other groups, they are reaching back in."

"So, should there be other Dignity Villages, or should the government give people housing?" I asked him.

"Yes, I think yes – but I think that the activist community has to make sure that the infrastructures are set up and firmly in place. Not just leave after the place is set up. Make sure there is a transitional process for leadership set so that there is consistency in application of programs – inconsistency is one of the biggest problems for the village. People have to know how to do things before others leave."

"So, in other words, you are saying that systems of learning have to be in place so that people can learn the required behaviors and skills, so they can learn how to run the village? So, you need advocates and teachers to introduce informal processes for learning these things?"

"Yeah, yeah. That's it."

I had to ask: "So, the other question is, should the government be building more Bud Clark Commons or should it give people money to build Dignity Villages?"

"Ah, yeah, well… you know, there have been numerous ODs at the Bud Clark Commons, the police are there frequently, so I would have to say, 47 million dollars to build the Bud Clark Commons to have people go there, get arrested, die, is a bad investment. Ah… The village model offers the cheapest alternative. In an era when everyone argues about cost, they can't touch what we do. And rather than invest 47 million in a single joint in one area, why not do what the village does, you know – $200,000 start-up money. Hey, check this out. Did you know the city claims on their books that the village costs them $200,000 a year? That's bullshit. But they do. They basically pay someone or people $200,000 a year to study us and talk about the village, but that money never gets here."

I am astonished. "I had no idea. Are you sure? Can I print that?"

"Absolutely – absolutely."

"I read it was 2.34 per person per day."

"It is. The 200k were what they initially spent to make the site usable, but the city continues to claim that expense on the books each year. Word. That money goes to bureaucrats to think about the village." He laughed hard.

A long pause.

"Did you fall off your chair?" he asked me.

"No. I just am trying to figure out what my point is in writing about this."

"I think the point of your work as an anthropologist, as a social scientist, is to tell the story, to understand the problem, show the dialogue and to show how people communicate, where the problem is and how we can improve ourselves as people. There, did I get it? Doesn't that sound accurate?"

"I dunno, dude. I'm just trying to write this story and it's funny, you know, but I start off this book saying I don't want to focus on drugs and alcohol, but everybody, almost everybody ends up talking about drugs and alcohol – and I don't show any images of it, but we talk about it. It's in the writing and it's in the stories and I try not to show pictures of it, but what you were kind of saying is that in a way I am showing images of drug and alcohol because the village I saw and the people I met were all there, were symptomatic in some way of the drug problem. Most of them. But even the ones who don't use, because they live with those who did use and they lived in a village that was fucking suffering, were kind of reflections of the drug and alcohol use around them."

"Yeah, I mean, it shouldn't be a focus. But it is a part of the conversation. I look at the bigger picture. Your denying any aspects of the problem really doesn't help people dealing with the problems. And if the villagers and the community and the homeless community aren't going to have an honest conversation about the drugs and alcohol, then, basically, the discussions are moot."

"Okay, Dave. Final question. The village was formed as a site of housing activism. And it was to carry the message that you seem to have finally now started to carry again. Part of this design was to ensure the villager's right to freedom of expression, shelter, and also their duties and obligations to the community and so on. And villagers were supposed to get out of the village and carry the message, correct?"

"Right!"

"So, how vital is it for its survival, for the people who live there, to become activists like you few have done again?"

"I think it is vitally important. But even if it is a tacit role, it should be a supporting role. Because not everyone is going to want to go and charge into the lion's den."

I generally see activism as an outward engagement with issues, but this puts a bit of a subtle twist on what an activist is. "So how do they support without being active?"

"By not tearing it down. By cooperating with the people that are trying to help them. You know, this place has short-term and long-term residents. Some people are here long

enough to make a difference to the "cause" and others just are not. It has to be both transitional and permanent. Those who have the courage and strength to move on and find it out there should be encouraged to do so, but those that are so damaged and ruined, and just need a safe place to live out what they have left, should be encouraged to stay. I mean, we are working with other housing activists now to set up villages like this one that have different goals — some are transitional, some are migratory like camp hostels, and some would be permanent. A single village can't meet all the unique needs of everyone. You know, some of the camps could have rehab or mental health treatments in them. I can tell you none of them would cost 47 million dollars. Did you know that the safest place to be in Portland is *in* the village? You are 97 times more likely to be mugged, raped, broken into or injured outside of the village than anywhere else. Just saying."

"So, what's in the future for Dave?"

"Well, at this time I am very optimistic, but you know the best laid plans of mice and men. You know, at the VBC — you know, it's a group of people concerned with bringing a sense of dignity and communal living back to inner city living places, and that kind of thing, and the other night, Starhawk[36] was speaking and she wanted to know why is it that activist communities come together, build up enthusiasm, come up with a plan, and six months to a year down the road they can't stand each other and the plan has fallen apart. And that's just from my perspective about keeping the dialogue open and then being willing to keep the conversation open because even if we don't agree on certain things we all agree on the endgame. The endgame is more camps, more alternative forms, you know like sanctuaries and healing centers and for the people who are broken down and old, just creating a little space where they can live with dignity and freedom without feeling like they are pieces of shit and throwaway people."

"Where do you want to be in a year, David?"

"You mean, aside from save the whole planet in general and myself?"

"How long will you be in the village?"

"I am thinking a year. And then a bunch of us are trying to build a new intentional community. I don't want to live in Rome anymore. Our civilization is Rome and it's gonna fall. But to carry the message, first you have to build it, not just building it, living it. My carbon footprint is small. I don't want to contribute to the garbage and consumerism culture. I

36 Starhawk is a well-known activist, "the Goddess movement and earth-based feminist spirituality" — see www.starhawk.org

want to contribute to healthy, positive, sane, sober living. Sane behavior. People treating each other with dignity and respect. Human beings and animals are not trash, they are not disposable items."

"Okay, okay. So beyond the rhetoric, which I don't disagree with, what can the village do for people in the short term?"

"Relieve survival anxieties."

"And in the long term? Maybe some of them get jobs, some might get housing, and some will go back to the streets?"

"Yeah. I hate to say it," Dave concedes, "but some of them can't be saved. But as long as we offer safe communities for people, a great number more can be saved than the current system model offers."

"David, let's end this right now. What is dignity?"

"Well... having or getting the sense returned to you that you are a human being, you are worthy of time and place and community."

"Okay. Leave it on that, Dave."

"Alrighty. Love you, bro."

"Love you, too."

EPILOGUE ~ NEW DIVISIONS

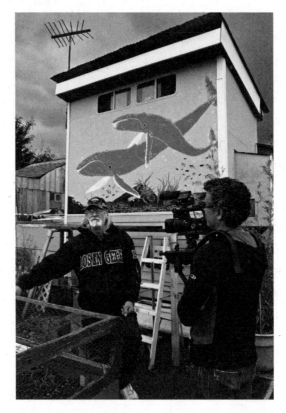

The author at work with HD camera and Dave Sullivan,
long-term resident, at his structure. Dave painted the whales. July 2011.

For Rocky, Brian, Bobby Jo, Mary, the Brads, and most of the others who are still there, life goes on much as it did before. They tell me, "You know, the village, same shit, different day." It is hard to actually know what is going on without being there. I receive news blasts by phone or email. In June of 2012, Dave had finally received new hearing aids. They were worth $5,500 and were supplied by the Lions Club. It took over a year to be considered for the aid because, lacking health insurance, he couldn't see a doctor. Finally, Outside In helped him get medical attention ahead of the hearing aid program. He feels like a whole new world has opened up for him. But now, he has to listen to the incredibly stupid things

people say. What used to be a low rattle is now a loud roar of mean and often counter-productive statements. He feels that, regardless of the aural assault, he is more capable now that he can hear clearly. I asked him to write me a note about that, but he had broken his glasses and it was going to take at least three weeks before he was eligible *to be considered* for a new pair.

In his world you win some, you lose some.

Until very recently, Steve and Carol were living together while they struggled with ways of getting clean. But she had found a new boyfriend. Steve and Carol maintained their structure as friends, they had nowhere else to go. But as of a few weeks ago, Steve was back in jail. Seems he never managed to fulfill the requirements of the Diversion program. No one will share exactly what happened or how long he will be in jail, but it is expected to be about a year. I spoke with Carol the other day and she told me that she had just talked by phone with Steve. He had been made a trustee and was allowed to phone out, though he could not receive calls. She felt he was doing well and they were "still really tight." The new boyfriend had been living in the village as a "guest," as I was, but he was kicked out recently for disturbing the peace.

Over a year ago, Jay and Shannon got an apartment with the first installment of her disability money, but recently they were kicked out for loudness and other disturbances. I am told they are living in a car, in various places in and around Montana, waiting for another cash installment so they can get a place again. JD has left Ruthie in charge of Shakedown Street for the summer. He has headed off on temporary leave to Colorado where he does seasonal work as a ranch hand and hay farmer. It must be hard for him to go just now, since the city recently has introduced a controversial new contract to the villagers. The fight for its life is at hand.

Dave Samson had for months told leadership to craft its own proposal and send it off to the city. They did not do this. This has allowed the city to serve up its extremely austere and threatening contract to the village. Along with tightening various building and fire codes, as a means to leverage their position, the city has changed the language of the village charter. The new contract will impose a strict two-year limit on residency, in keeping with the dominant definition of "transitional" in various other programs nation-wide.

The new rules inhere the expectation that people are to be on waiting lists for housing or otherwise prepared for transition to shelters or other programs in two years. This is like

asking a person to fall without hitting the ground. Even if one is on a wait list for housing, it can take years, not months, and, even then, going from a shelter or even the village directly into housing is frought with perils. First Step to Home, in Toronto, is a transitional housing program that knows first-time residency in housing is tough on once homeless people. They have a four-year program with on-site supports that help street-engaged homeless men actually transit from the disorder of the streets into a mainstream housing unit. They never kick someone out or graduate someone without finding them a housing unit, usually an apartment. The new tenet of the Dignity Village contract does not make the village transitional simply by calling it transitional.

As Shorty, the last remaining original member of the village says: "You know, this place has been many things. It was a camp, then a shantytown. They called us transitional to fit into the language of their laws, but they never enforced it. So, people are used to living here. It's our homes. And even last year, when the contract came up for renewal, they suggested taking out the word transitional because, for sure, it wasn't working like, to get folks back into houses. So they was content to keep it as was. They even wanted to take 'transitional' out. And this is what is really scary to us... you know, they have the power. They can tell us what we are and how we are, uh, how we should be. Someone somewhere doesn't like what we are doing here, and maybe they are afraid that too many of us, places like this are popping up, or will. But now they are gonna tell us that we are nothing more than a shelter. They are turning us into a part of their shelter system. Not only are they telling us we have to be transitional, they told us it has to be in two years. It's scary. Scary, you know. Most of us won't be able to find a place, and the few that do will end up in shit holes."

It is not just the present population of the village that is in jeopardy. If the city rotates the population every two years as the city suggests in the contract, then the city really is turning the village into a holding tank and nothing more, because the city itself does not have housing for these people once they are kicked out. As Samson and the other activists have said, the only real solution to people on the streets seems to be more camps.

The contract also says that the city can come in without cause and shut them down. Scott is alarmed by this and wonders why others don't see this as a major problem. "If we sign the contract the way it is, they can just come down and close us, or take us over at any time." He thinks that maybe it is because they know that this is a viable way of managing

the flow of homeless people, but that, if they don't play hardball, they will be seen as losing control to poor people. "All this," he adds, "all this has been a trick, if they do that. If they can tell us now, arbitrarily, that they have that power over us. What about freedom, what about our rights? We never had them."

It would be easy to rest on that point. But the story doesn't end there. After I spoke to Scott, I spoke again to Samson. He was in a group meditation. Dave and ten or so residents meet in the center of the village these days and sit down, breathe deeply, hold hands and meditate. They do this, inspired by the teachings of Sharif Abdullah, founder of the Commonway Institute.[37] For some time now, Ptery and the other activists in the village have entertained the philosophies of the Institute and have been trying to sway other villagers. I have no opinion about this. But other villagers do. They call it "bullshit," period.

And while this alternative spiritual alignment is growing, so too is the Christian right taking a stronger foothold in the village. A bible study class now has as many as 20 villagers participating in it. I have not spoken much about religion in this book because, in the village proper, religion and other spiritual practices were implicitly confined to the privacy of one's structure, or outside of the village. I reiterated personal points of view about God and religion, but beneath the shadows of the Stars and Stripes, religion seemed to matter less. In fact, all public spiritualism was stigmatized there. A sign which one person had posted inviting people to participate in an AA meeting was torn off in seconds after it was hung. Beyond the drug factions, the personality clashes and the cliques, villagers are now divided across spiritual lines. Some villagers pretend that it doesn't bother them. Others, who are more savvy with how neo-liberal downloading works, know that, as is the case in most other cities where emergency camps are tolerated, the presence of the church in the village may be a prelude to its being signed on as administrator of the facility. The public displays of religious fervor by both sides seem to me to be a key divisive factor in the village at a time when it must be most united.

I called again. Shorty was on duty and answered the phone. He said something that underscores the truth about people who have spent years in that odd array of spaces I call the streets; living that way is traumatic. People usually just aren't ready to "deal" with the

[37] www.commonway.org. "Commonway Institute is a non-profit organization dedicated to the creation of a society that is in line with our deepest spiritual values – a global society that includes all peoples." The reader is invited to examine this statement online. As noted in text, many of the villagers are opposed to the Institute's involvement in the village, others are all for it.

mainstream, even if they dream about it. "I been here for 11 years, I told you that, 11. It's been progressing here, slowly, slowly, but it has never been a transitional place. Most of us go right back to where we come from if we get booted out. I'd be the first to go. I have been here the longest. But I couldn't go back to a hostel or the streets. My nerves couldn't take it. I can't take too many people. This place has had me locked in for so long. Everyday I waited for the mail to come, because that's my job, so everyday I was here. I get out maybe once a month to my friend Tim's. I'd be the last to get housing too, because in the past, before here, I was evicted three times. No one will rent me a place with that record. If I get booted outta here, I will go to Tim's for a bit, then I will head into the mountains and get my head back. My nerves are just shot. This is my home. What now?"

Samson got on the phone and said, "Look, it's not over yet. The contract is draconian and mean. But, we are working with Mark Lakeman[38] and VBC to protect our rights. We still haven't sent off a counter offer – the contract isn't law just because they say so. And if people here believe that, then it might as well be law. If we believe we don't have rights, then we don't have rights. I expect, we expect, a strong outcry of resistance from the activist community to the new contract. Rome is burning, maybe, but it ain't cinders yet."

So I leave Dignity Village much as I entered it, not entirely sure how to define it – the village perched somewhere on this imaginary continuum of debate between the rights of rugged individuals and the political will of governments. As the city moves to control the lives of villagers, I wait to see how the relationships between state governances and emerging intentional homeless communities in other parts of the U.S. play out.

I know that the villagers have many skills and talents. But I also understand that in Dignity a group of people, some with long histories of addiction, some with extreme cases of post-traumatic stress, all with little or no health care and few realistic options for conventional housing, have managed, as precarious as this has been, to maintain a fragile community. Yet, a specter of uncertainty, in part the fault of the city and in part their own, undermines their confidence and tears at morale. With no assurances about basic things such as food, shelter and health, they struggle on a daily basis to find self-worth on their own individualized terms. Establishing stronger bonds between members of the village might be the only way to ensure its survival going forward. It seems very likely that by returning to its activist roots in the fight for the rights of the homeless in the village and abroad, the village

[38] Lakeman is a key proponent of sustainable public places. See www.marklakeman.net

might better guarantee that self-worth and dignity are not so grudgingly realized by its membership.

In 1785, Immanuel Kant[39] proposed that dignity was the value on which all others were purchased. Having lived with poor villagers in various stages of reinventing themselves, I am certain that this value transcends the mantle of indifference cast upon the worst-off poor by those who choose to see them as undeserving. As I was talking to Samson on the phone, the city began an inspection of the village and Samson said, "If I leave now, before they kick us out, at least I leave with my dignity. That, they can't have."

[39] In *Groundwork of the Metaphysics of Morals* (Cambridge: Cambridge University Press, 1991), Kant argued that morality *stemmed* from the "Categorical Imperative" that we treat all others and ourselves as "ends" in themselves, and not as a means. This became the basis for modern concepts of dignity. It suggests that we must consider the *other's* well being in all our actions. See also, Kolnai, A., "Dignity" in *Philosophy* Vol. 51, No. 197 (July 1976): 251-271 for an in-depth discussion of the problems with etymologizing the word.

Selected Bibliography

Anderson N. *The American Hobo. An Autobiography*. Leiden: E. J. Brill, 1975.

—— *The Hobo. The Sociology of the Homeless Man*. Chicago: Phoenix Books, 1923.

Bakhtin, M. *Toward a Philosophy of the Act*. Eds. Vadim Liapunov and Michael Holquist. Trans. Vadim Liapunov. Austin: University of Texas Press, 1993.

—— *The Dialogic Imagination*. Trans. C. Emerson and M. Holquist. Austin: University of Texas Press, 1981.

Bahr, H.M. *Skid Row. An Introduction to Disaffiliation*. New York: Oxford University Press, 1973.

Bourdieu, P. *Science of Science and Reflexivity*. Chicago: Polity, 2004.

—— *Outline of a Theory of Practice*. Cambridge: Cambridge University Press, 1977.

—— *The Algerians*. Boston: Beacon Press, 1958.

Bourgois P. and Schonberg, J. *Righteous Dopefiend*. Berkley: University of California Press, 2009.

Burchell G., C. Gordon and Peter Miller, eds. *The Foucault Effect: Studies in Governmentality*. Chicago: University of Chicago Press, 1991.

Church, K. *Forbidden Narratives*. Amsterdam: Gordon and Breach, 1995.

Clifford, J. and G.E. Marcus. *Writing Culture: The Poetics and Politics of Ethnography*. Berkeley: University of California Press, 1986.

Collins P. and A. Gallinat, eds. *The Ethnographic Self as Resource*. New York: Berghahn, 2010.

Davis, M. *Planet of Slums*. London: Verso, 2006.

Dean, M. *Governmentality, Power and Rule in Modern Society*. London: Sage, 1999.

Denzin, N. K. *Interpretive Ethnography: Ethnographic Practices for the 21st Century*. Thousand Oaks California: Sage, 1977.

DePastino, T. *Citizen Hobo*. Chicago: University of Chicago Press, 2003.

Fabian, J. *Time and the Other: How Anthropology Makes Its Object*. New York: Columbia University Press, 1983.

Foucault, M. "Governmentality," trans. Rosi Braidotti and revised by Colin Gordon, in Graham Burchell, Colin Gordon and Peter Miller, eds, *The Foucault Effect: Studies in Governmentality*, pp. 87–104. University of Chicago Press: Chicago. 1991.

—— *Discipline and Punish: The Birth of the Prison*. Trans. by A. Sheridan. New York: Random House, 1975.

—— *The Birth of Biopolitcs. Lectures at the College de France, 1978-9*. New York: Palgrave, 2008.

—— *The History of Sexuality Vol. 1: The Will to Knowledge*. London: Penguin, [1976] 1998.

Goffman, E. *Stigma*. New York: Anchor, 1963.

—— *The Presentation of Self in Everyday Life*. New York: Anchor, 1959.

Halstead, N., E. Hirsch and J. Okely, eds. *Knowing How to Know. Fieldwork and the Ethnographic Present*. New York: Bergham, 2008.

Harvey, D. (1989) *The Condition of Postmodernity*. Blackwell, New York.

HUD, *The 2009 Annual Homeless Assessment Report to Congress*. U.S. Department of Housing and Urban Development.

Isin, E.F. and Nielsen, G., eds. Acts *Of Citizenship*. London: Zed, 2008.

Kant, I. *The Metaphysics of Morals*. Trans. Mary J. Gregor. Cambridge: Cambridge University Press, 1993.

Kolnai, A. "Dignity." *Philosophy* Vol. 51, No. 197 (July 1976): 251-271, for a very in-depth discussion of the problems with etymologizing the word.

Krauss, C. "Amid Prosperity, Toronto Shows Signs of Fraying." *The New York Times*, Sunday June 16, 2002.

Lacan, J. *Ecrits* trans. Alan Sheridan. London: Routledge, 2001.

Latour, B. *We Have Never Been Modern*. Cambridge: Harvard University Press, 1993.

—— *Reassembling the Social*. New York: Oxford University Press, 2005.

Lefebvre, H. *The Production of Space*. Oxford: Editions Anthropos, 1974,1991.

Lewis, O. "The Culture of Poverty." G. Gmelch and W. Zenner, eds. *Urban Life*. Longrove, Ill.: Waveland Press, 1996 (1966)).

Malinowski, B. *Argonauts of the Western Pacific*, London: Routledge, 1922.

——A *Diary in the Strict Sense of the Term*. Stanford: Stanford University Press, 1967.

Mead, G. H. *Mind, Self, and Society*. Chicago: University of Chicago Press, 1934.

Sanjek, R. "The Ethnographic Present." *Man, New Series* Vol. 26, no. 4: 609-628, 1991.

Sibley, D. *Geographies of Exclusion*. New York: Routledge, 1995.

State or Oregon, (2009) *A Home for Hope: a 10-year plan to end homelessness status report, year one*. Ending Homelessness Advisory Council.

Street Health. "Homelessness, Drug Use and Health Risks in Toronto: The Need for Harm Reduction Housing." TDRC, Toronto, 1998.

Tully, J. *Shanty Irish*. Kent: Kent State University Press, 2009.

Wagner, D. *Checkerboard Square: Culture and Resistance in a Homeless Community*. San Francisco: Westview Press, 1993.

Wright, T. *Out Of Place. Homeless Mobilizations, Subcities, and Contested Landscapes*. Albany: State University of New York Press, 1992.

Films

Dark Days. (2000). USA. 94 (81) mins. Black and White. English. Directed by Marc Singer. Produced by Marc Singer.

Subtex: real stories (2002, versions 2 - 4: 2005; 2008; 2011) Canada. 62 (52) mins. Color. Various formats. Directed by Eric Weissman. Produced by Subtext Productions. www.subtextproductions.ca

Online Resources

Columbia Eco-Village: www.columbiaecovillage.org

Homeless figures CBC: www.tinyurl.com/cbc-homeless-numbers

Intentional Communities: www.ic.org

Kwamba Productions: www.kwamba.com

Mark Lakeman, sustainable communities: www.marklakeman.net

Portland Housing Bureau Village Assessment: www.tinyurl.com/villageassessment

Right 2 Survive, Portland: www.tinyurl.com/R2D2-Portland

Sharewheel: www.sharewheel.org

Shanty definitions: www.tinyurl.com/shantydefinition

Starhawk, activist: www.starhawk.org

The Wellesley Institute: www.tinyurl.com/Toronto-numbers-homeless

US Birth and other rates: www.tinyurl.com/US-Vital-Stats
 See also Centres for Disease Control www.cdc.gov/nchs/births.htm

Western Regional Advocacy Project: www.wraphome.org

WoodGreen Community Services—First Step to Home: www.tinyurl.com/WoodGreen-FSTH

Born in Toronto in 1961, Eric Weissman lives in Montreal, completing a interdisciplinary Ph.D. in the social sciences as part of the Special Individualized Programs (S.I.P.) at Concordia University in Montreal, and concurrently teaches courses in sociology and anthropology. As discussed in many of his works, he struggled with life-threatening addictions after receiving his Masters in Sociology at the University of Toronto in 1986. It was a decade later, with great effort and the support of friends and family, that he overcame his addictions. The insights he gained from his dark period are notable in how it influenced his career as writer, researcher and videographer. In 2002 his screenplay for a short film "The Horseman" won the C.E. Award of Merit at Ryerson University, and his videography of Tent City in Toronto became a central focus which led to *Subtext: real stories*, a video-documentation effort that now spans 11 years, and embraces stories of ex-homeless people as they adapt to housing in Toronto, Montreal and other cities. In 2008-9 *Subtext: real stories* was featured as part of the Royal Ontario Museum's exhibition HousePaint Phase II. His current research examines how different kinds of housing impact the dignity and self-worth of ex-street people.

www.subtextproductions.ca

Nigel Dickson, of Toronto, was born and raised in England, moved to Canada in 1974, and began a prolific career in which he has produced some of the most provocative and arresting portraits of many famous, and ordinary, people. In 2009, a 32-photograph retrospective was presented at the Royal Ontario Museum. "His photographs are beautifully composed, the work of a photographer who might have been a painter," said John Macfarlane, Editor-in-Chief of *The Walrus*. "His camera sees inside his subjects; his photographs reveal their truths." www.nigeldickson.com